Becoming A Beauty Queen
The Complete Guide

BARBARA PETERSON BURWELL
POLLY PETERSON BOWLES

Foreword by Bob Barker

PRENTICE HALL PRESS ♦ NEW YORK

We dedicate this book, with love and gratitude, to our parents, Justice C. Donald and Gretchen Peterson, who taught us, by their example, to set high goals and to work to attain them, whatever the goals may be. They have loved, guided, and supported us, not only as we reached for our pageant dreams but throughout our lives.

Copyright © 1987 by Barbara Peterson Burwell and Polly Peterson Bowles
All rights reserved, including the right of reproduction
in whole or in part in any form.

Published by Prentice Hall Press
A Division of Simon & Schuster, Inc.
Gulf+Western Building
One Gulf+Western Plaza
New York, NY 10023

PRENTICE HALL PRESS is a trademark of Simon & Schuster, Inc.

Library of Congress Cataloging-in-Publication Data

Burwell, Barbara Peterson.
 Becoming a beauty queen.

 1. Beauty contests—United States—Handbooks,
manuals, etc. I. Bowles, Polly Peterson. II. Title.
HQ1220.U5B87 1987 305.4′079 86–43101
ISBN 0–13–071747–9

Manufactured in the United States of America

10 9 8 7 6 5 4 3 2 1

First Edition

Acknowledgments

The seed of this book was first planted in 1973 when we started competing in pageants. During our years of pageant competition, many people helped us to reach our pageant goals, which ultimately made this book possible. The people who have stood beside us through our pageant experiences, and those who have extended pageant opportunities to us are numerous, indeed too numerous to name individually. There are a handful of people and organizations that we do, however, need to acknowledge.

In addition to our parents, to whom this book has been dedicated, we must thank our brothers, Craig, Mark, Todd, and Scott Peterson, who listened and contributed to countless pageant discussions. Although each one is a high achiever in his own right, each brother patiently stood in the wings while we each took our turn in the spotlight.

Our husbands, Rodney P. Burwell and Daniel L. Bowles, entered our lives after our pageant competition had ended, but have been with us through many years of continued pageant involvement. They have recognized the valuable role pageants have played in our lives. We thank them for their support, interest, and patience during the many pageant activities and the writing of this book.

We must also thank the many organizations that have afforded us pageant opportunities, and have provided us with scholarships and countless memories. Our special thanks go to Miss Universe, Inc., sponsor of the Miss USA Pageant; Dr. Pepper, former sponsor of the Miss Teenage America Pageant (now sponsored by 'Teen magazine); the Minneapolis Aquatennial Association, sponsor of the Queen of the Lakes contest; the Svenskarnas Dag Committee, sponsor of Miss Svenskarnas

ACKNOWLEDGMENTS

Dag; and the Minneapolis Fire Department, former sponsor of the Miss Fire Fighter contest.

We wish we could acknowledge all of the individuals who touched our lives during our pageant involvement, many of whom have become dear friends, but our limited space precludes such individual recognition. We will simply say a collective thank you.

Finally, we want to thank three people who have directly contributed to making this book possible. Many thanks go to our literary agent, Jeanne Hanson, for helping us get this project off the ground. We appreciate her guidance and advice, and are grateful for the many years of friendship between the Peterson and Hanson families.

We also want to thank PJ Dempsey, our editor at Prentice Hall Press. Her constructive comments and enthusiasm for this project made the editing process run smoothly. We also want to extend our appreciation to Jason Friedman for his many hours of work. The result of their assistance is a final product of which we are proud. We believe this finished book will accomplish the purpose for which it was written—to inform the public about the various facets of pageant competitions, to guide the reader in developing her own potential in the areas judged in pageant competition, and to help and encourage her as she reaches for her pageant dream.

Contents

FOREWORD BY BOB BARKER ix
PREFACE xi
INTRODUCTION: SHADOWS OF PROTEST xiii

Part I: Here a Pageant, There a Pageant

1 BIRTH OF A BEAUTY PAGEANT 3
 The Birth of the Grandmother of Today's Pageants 3
 Miss America Gives Birth to a Rival Pageant 5
 Teen Pageants 9
 Kiddie Pageants 12
 Other Pageants 13

2 THE PAGEANT BUSINESS: BEAUTY YOU CAN BANK ON 15
 Corporate Profits 15
 The Race for Television Viewers and Advertising Dollars 16
 Prize Structures 17

3 WHICH PAGEANT IS RIGHT FOR YOU? 23
 Get All the Facts 25
 Making Your Personal Pageant Choice 31

Part II: Pageant Competition

4 ENTERING A BEAUTY PAGEANT 39
 The Entry Form 39
 Your Photograph 40
 Sponsors 41
 Do You Need a Coach? 43
 Make Yourself a Pageant Winner 46

CONTENTS

5 THE JUDGING	**50**
The Judging Procedure	50
What the Judges Look For	55
Who Are the Judges?	63

Part III: Preparing for Pageant Competition

6 INTERVIEW AND AWARENESS PREPARATION	**69**
Social Awareness Testing	69
The Interview	70
7 THE TALENT COMPETITION	**84**
8 GETTING INTO PHYSICAL SHAPE	**91**
Balancing Your Weight	91
Don't Go Overboard in Your Weight Loss!	94
Exercise for Muscle Tone	96
9 HELPING MOTHER NATURE WITH COSMETIC SURGERY	**101**
10 PUTTING ON A WINNING FACE	**105**
Start with Beautiful Skin	106
General Makeup Tips	108
Makeup Tips for the Interview	118
Makeup Tips for the Stage	119
Makeup Tips for Television	120
Your Smile	121
11 HAIR: YOUR CROWNING GLORY	**124**
12 TAKING CARE OF DETAILS	**131**
Tanning	131
Nail Care	133
Unwanted Hair	134
Perfumes	136
Sleep	136
13 WITH QUEENLY GRACE	**137**
Stand Like a Queen	137
Walk Like a Queen	140
Sit Like a Queen	146
14 YOUR WARDROBE	**148**
What Clothes Will You Need?	148
Rehearsal Wear	151
Choosing an Appropriate Interview Outfit	152
Selecting a Flattering Swimsuit	153

CONTENTS

Tasteful Talent Togs	156
Choosing a State Costume	157
The Ultimate Evening Gown	160
Wardrobe Expenses	164
15 TRAVELING TIPS	**167**
What to Pack	167
How to Pack	173
Make the Most of Your Time	175
16 POISE: HANDLING DISASTER WITH GRACE	**176**

Part IV: Tips for the Titleholder

17 THE QUEEN'S GUIDEBOOK	**181**
Your Formal Regalia	181
Public Appearances	187
Mind Your Manners	192
Relationships	195
Keep Your Perspective	198
A Year Worth Remembering	199
Relinquishing the Crown	200

Part V: Living the Dream

18 BEHIND THE SCENES AT THE MISS USA PAGEANT	**205**
Pageant Week Kick-off	206
Pretaped Segments	210
Rehearsals	212
Press Coverage	216
The Public	216
The Discipline Continues	217
Judging Week	218
Dress Rehearsal	219
The Miss USA Pageant Telecast	222
19 VIEW FROM THE THRONE: A LOOK AT THE WINNER'S REIGN	**226**
Miss USA's Reign	226
The State and Local Titleholders' Reign	234
20 THERE ARE NO LOSERS IN PAGEANT COMPETITION	**236**
21 PAGEANT EPILOGUE: THERE *IS* LIFE AFTER PAGEANTS	**238**
APPENDIX	**247**
Pageant Addresses	249
Past Pageant Winners	250

CONTENTS

Sample Official Entry Form to Compete for the Titles
 Miss USA and Miss Universe 254
Miss USA Information Form 260
Comparison of the Miss USA Award Packages for 1976, 1981, and 1986 263

Foreword

If you want to win a pageant, I would like to make a couple of suggestions. First, arrange to be born as beautiful and intelligent as Barbara and Polly. Second, read their book.

For Barbara and Polly to have fared as well as they have in pageants, they must know what they are talking about, and, if you want to be a winner, you are going to need all the help you can get, because the competition is fierce.

Of course, whether you win or not, participating in a pageant can help you in the battle to survive while growing up.

Experts will help you with your hair and makeup, they will teach you to walk and pose attractively, you will learn what types of clothes do the most for you, and, if you are really lucky, you will meet a naval aviator from the splendid Naval Air Command Chorale that performs on the Miss USA Pageant.

Read *Becoming a Beauty Queen,* and, if you win a pageant, write to me and tell me how much you appreciate my suggestion.

If you do not win, write to your congressman. If yours is anything like mine, he will have a letter in his files that will cover the situation.

Even if you have no intention of entering a pageant, I think you should read *Becoming a Beauty Queen,* and then you will not go through life wondering what you missed because the whole story is in the book.

—Bob Barker

Preface

In 1921, beauty pageants were considered immoral. In the 1960s, they were accused of being racist. The 1970s were marked by a vocal protest against pageants, which feminist groups berated as being sexist. In the 1980s, however, women continue to flock to pageant competition. The numbers of contestants and of pageants continue to increase. Why? What attracts young women to these competitions? Why do pageants survive—even flourish—despite their detractors? The answer is simple. Everyone loves a contest. Everyone wants to be, or know, a winner.

While supporting the worthiness of pageant competition, one must also keep it in perspective. In comparison to concerns such as world hunger, nuclear weapons, and terrorism, beauty pageants are of little, even controversial, importance. Pageants are often attacked as setting inappropriate priorities. The world applauds beauty queens and sports heroes while too often forgetting to give a deserved standing ovation to the courageous people who go through life battling physical disabilities. The answer to this imbalance is not to eliminate pageants, but rather to keep them in perspective.

The results of beauty pageants are not going to greatly alter the course of world history. The same can be said about the Super Bowl and the World Series, most movies and books, the circus, and small-town celebrations, but few people would argue to abolish these events. They provide pleasant diversions from the normal routine. To most of society, pageants are an entertaining television show, a two-hour Cinderella story. The women who compete are people viewers can cheer for, and perhaps meet—perhaps the only "celebrities" they will ever meet. For charities, pageants are sources of millions of dollars

PREFACE

of revenue. They also provide dedicated spokespersons for the charities' causes. For corporate sponsors, pageants and titleholders sell products in the same way that athletes and movie stars do. For the contestants, pageants provide opportunities for scholarships, travel, exposure to new people and experiences, and a chance to develop special communication skills.

We personally have learned the value of pageant competition. Barbara was crowned Miss USA in May 1976. Six months later, both of us came to national attention when Polly was selected as Miss Teenage Minnesota and became second runner-up to Miss Teenage America. The media focused on our story again in 1981 when Polly competed for Barbara's former Miss USA title.

Competing in the same path has brought each of us rich rewards, demonstrating to us the value of pageant competition. Since our success in the pageants was not always the same, the experiences also taught us the need to keep the pageants in perspective as only one aspect of our personal lives. Today we have each stepped up to meet new challenges, both professional and personal. Barbara completed a triple major at St. Olaf College and is now a professional in the corporate business world. She also sits on numerous civic and charitable boards. In 1982, she married Rodney P. Burwell, chairman of the board of a company that manufactures advanced composite products. Polly graduated from law school with honors and joined the Los Angeles law firm of Gibson, Dunn & Crutcher. In 1986, she moved back to Minneapolis to marry Daniel L. Bowles, an attorney, and she is now associated with the Faegre & Benson law firm.

Both of us cherish our pageant memories. We credit the pageants with helping us attain many subsequent goals. We believe that pageant competition can help any woman develop her potential, even one who does not actually win the title. This book is written out of that belief. This is not a beauty book. It is a pageant book. Its purpose is to give you a clearer view of what is involved in pageant competition. It is also designed to help women who want to compete in a pageant prepare for this challenge. It is a challenge that does require significant preparation and dedication, but it is also a challenge worth the effort.

Introduction: Shadows of Protest

In the late 1960s and early 1970s pageants were brought under attack by feminist protesters. These protests have continued into the 1980s but have had little effect. Pageants not only continue, they flourish. More and more pageants continue to appear, and more and more women flock to participate. Pageant support is widespread, but it is quieter than the critics' voices. Supporters voice their opinions by participating in pageants or by watching them. It should be noted that every year, the Miss USA, Miss Universe, and Miss America telecasts are among the most heavily viewed television shows. In 1985, the state-owned British Broadcasting Corporation decided to discontinue televising beauty pageants, saying, "[Beauty contests] are an anachronism in this day and age of equality and verge on the offensive." Great Britain's privately owned, commercial Independent Television Network snatched up the rights to telecast the Miss World Contest. Pageant support was considered strong enough to make the telecast profitable.

Feminist critics try to paint a sinister picture of the kind of effect pageants have on society in general and on women in particular. Pageants are said to exploit women. Harold Glasser, former president of Miss Universe, Inc., countered that argument saying, "We do not exploit women. We give women an opportunity to do something with their lives. . . . We are frankly a business venture. We don't pretend to be philanthropic. . . . What we try to do is give these contestants something of value." The ultimate statement is made by the fact that women freely choose to enter the competition. They compete for themselves, hoping to get something out of the pageant. Gary Collins, emcee of the Miss America Pageant and husband of Mary Ann Mobley, Miss America 1959, noted a change

INTRODUCTION

in pageant contestants over the years. "They're more career-oriented. They're using [the pageant]—very effectively—as a jumping-off place for their careers." They are, in effect, exploiting the pageants for their own ends.

Phil Donahue's talk show has addressed the topic of beauty pageants more than once. In 1984, Mr. Donahue opined that "strutting" around a stage "teaches women to compete with each other, and that the prize is men." This statement argues that competition between women is in some way detrimental. There is nothing wrong with fair competition. Our entire society is based on competition. People want to achieve something that makes them feel good—something they've worked for and can say "look what I've done." People choose to compete for many things that provide direct and indirect benefits. Students compete for grades—at the same time they gain an education. Young people compete for positions on athletic teams, parts in school plays, and student council offices—and each of these experiences adds to their abilities. Adults compete in the job market, honing the skills that will bring them financial success and personal satisfaction. In many of these areas women compete with women as well as men. Beauty pageants merely provide another arena in which women can compete if they so choose. Through this competition, women gain recognition and improve skills that can also be utilized to achieve other goals.

The real question in competition is whether the goal is worth the effort. This brings up another flaw in Mr. Donahue's statement. Pageant participants are not competing for men. Most contestants would consider such a suggestion laughable. The women compete for themselves—for the satisfaction of reaching a personal goal, to showcase and further develop personal attributes that go beyond the physical, to gain scholarship dollars and tangible prizes, to gain visibility that will make them stand out in a society filled with talented, ambitious women. They also compete simply for the fun and experiences that pageants afford. The pageants are just one avenue of competition available for women.

If contestants want to attract men, competing in a beauty pageant is the wrong way to do it. According to articles in *Forbes* and *Advertising Age,* demographic studies have revealed that pageants are predominantly watched by women, ages 18 to

INTRODUCTION

65. Pageant winners must dedicate a year of their lives to pageant responsibilities, which leaves little free time for men. Titleholders commonly find that men are intimidated by their titles and recognition. Men may watch pageants, but they certainly are not considered the prize by the women who compete.

Pageants are cursed as putting too much emphasis on physical attributes and on beauty. Pageants do not create the societal interest in beauty and the physical form, they reflect it. Thousands of people flock to health clubs, tennis courts, and swimming pools, not just for their health, but to improve their physical image. Television newscasters are selected not only on the basis of their journalistic talents, but also for their physical appearance. Sports personalities are selected to promote products. Those athletes who are attractive, as well as being superior athletes, are apt to be more in demand to fulfill the role of corporate spokesperson.

Pageants operate along the same lines. Public relations is a major part of being a titleholder. The pageant queen sells the sponsors' products. This is as true for Miss USA and Miss America as it is for the Pork Queen, Princess Kay of the Milky Way (representing the dairy industry), and Miss Honey Bee. Contestants are actually auditioning for a job. They are selected on the basis of their communication and social skills, as well as for their appearance. Contrary to the common stereotype (in the words of Mary Ann Mobley, Miss America 1959), "You can't become Miss America without having a little gray matter." The same is true of all pageant winners.

Pageant critics tend to have a closed view of pageants. While pageant supporters will concede that pageants may have their flaws, critics are unwilling to admit that there are positive aspects to be found in pageants. Their narrow focus was revealed clearly shortly after *Penthouse* published explicit nude photos of a Miss America. Critics argued that the pageant was being hypocritical in its negative reaction to the photos. They claimed that Miss America differs from *Penthouse* "in degree, but not kind." In a September 1984 *National Review* article, "The Decline of Shame," Mona Charen aptly pointed out that, "This is rather like saying that electrolysis differs from electrocution 'in degree, but not in kind.'"

Pageants are not the blot on womanhood that some feminists

INTRODUCTION

allege. When Polly was in law school, several feminist classmates refused to speak to her (not even a civil "hello"), apparently because she had committed the "unforgivable sin" of competing in beauty pageants. One afternoon, this tiny handful of classmates picketed the Miss Minnesota–USA Pageant. Unbeknownst to them, Polly was inside judging it. Each side was working in its own way to promote opportunities for women. Ironically, the picketers actually helped the cause of the pageant. While the pageant was unlikely to have made a big splash in the media, the picketers had informed the press of the pending protest. Every television channel turned out to catch the story. What they found was a packed house inside and about a half-dozen protesters outside. The result was greater coverage of the pageant with an aside comment about the pickets outside.

What Polly's classmates refused to realize was that Polly's supposed "sin against the women's cause" had paid for her law school education. The pageant prize wardrobe also came in handy when she interviewed with top law firms around the country. The pageant experiences had developed her interviewing skills and had taught her how to present herself in a positive manner during job interviews. Similarly, Barbara's experiences have landed her in the corporate world. There are countless examples such as Polly's and Barbara's. A competition that fosters such advancement is actually a boon to the feminist cause.

The attitude of women toward pageants is changing. On August 18, 1983, *USA Today* reported that a survey of women that asked such questions as "Is Miss America someone you usually can be proud of?" and "Is the program done in good taste?" received 91 percent positive answers. Most of the women surveyed indicated that they would be pleased to have their daughters enter the contest. An example of this change in attitude is reflected by the mother of Allison Brown, Miss Teen USA 1986. Allison's mother is a feminist writer who used to picket beauty pageants. As Miss Teen Oklahoma, Allison stated on national television that it was her mother who started her in pageants. And yes, Miss Teen USA does include a swimsuit competition.

The change in attitude is also spreading around the globe. Pageants are appearing or reappearing in unlikely countries. In 1983, Poland became the first Soviet bloc country to hold

INTRODUCTION

a pageant since the Soviet Union's invasion of Czechoslovakia in 1968. Eleven male judges selected Lidia Wasiak from 343 contestants to compete in the Miss World competition. Not only did Poland conduct the pageant, it went beyond the bounds set by Miss World and had the women compete in bikinis. Political change was also apparent when a beauty pageant, the first in the history of the People's Republic of China, was held in Guangzhou (Canton) in 1985.

Pageants have withstood the years of protest. They will continue to do so. The September 17–23, 1983, *TV Guide* contained an article titled, "I Can Scarcely Bear to Watch, But I Do." In it, Jane O'Reilly admits to a fascination with the pageants she claims she dislikes. She also states, "While I never wanted to be Miss America, honesty forces me to admit that somewhere deep inside me stirs a yearning to ride on top of a float covered with paper flowers. Especially if I could wear sequins." It is this fascination, and Cinderella quality, that perpetuates pageants.

Diane Sawyer, a highly respected journalist, was America's Junior Miss in 1963. Looking back on her year, she stated, "Junior Miss forced me to do things I did not believe I could do, to collect myself in a way I probably wouldn't otherwise. It was an exercise, an experiment in humanity . . . in a lovely way. It gave me a sense of possibility and enlarged my capacity to dream."

Pageants are an avenue to a dream—a goal. Not all women share this goal. More important, not all women have the courage or drive to seek it. Ms. O'Reilly, like many other pageant critics, lampoons the organization and the dream, while saluting the women who strive for it. She says about the contestants, ". . . each one still makes us believe that winning the title is a dignified ambition. The pageant people call it 'personality' and 'congeniality,' but what it really is that we are watching is diligence, hope, courage, and tenacity. It is the television program that is awful. The women are wonderful." It is the pageant organization that gives these wonderful women a chance to reach for their dreams—a pageant title and all the opportunities it bestows for the future.

PART I

Here a Pageant, There a Pageant

1
Birth of a Beauty Pageant

From a very tender age, young girls start watching beauty pageants on television. Many become fascinated with the Cinderella story created by pageants, and continue to watch the pageants year after year. Even the people who berate pageants will sometimes admit to a "morbid compulsion" to watch the proceedings. As the years pass, one generation of viewers spills over to another generation.

Today's viewers do not remember how pageants came to be in America. Like Aphrodite, the pageants seem to have sprung forth fully grown at their inception. Even loyal pageant viewers may not understand that the biggest pageants of all, Miss USA and Miss America, are not the same pageant. They just turn on their television sets to see this year's winner crowned, not remembering that they just watched one of these pageants six months ago. Just how did pageants come to be in the United States and what are some of the differences between pageant systems? This chapter will briefly trace the history of today's major pageant systems.

The Birth of the Grandmother of Today's Pageants

The oldest continuing pageant in America is the Miss America Pageant. This system has given birth, directly and indirectly, to the myriad of pageants being conducted today. In its early years, however, it did not always appear that the Miss America Pageant would survive.

Miss America was conceived as a commercial venture. The concept was created by individuals in Atlantic City, New Jersey,

HERE A PAGEANT

as a method to extend that resort city's tourist season past the Labor Day weekend. The first "Inter-City Beauty Contest" (which was later to become known as the Miss America Pageant) was held in 1921 on the boardwalk in Atlantic City. Its eight contestants were selected from hundreds of photographs. Margaret Gorman has the distinction of being the first Miss America and remains the shortest one ever (5'1"). She represented Washington, D.C. (the District of Columbia's participation was later eliminated). Margaret, who was just short of her sixteenth birthday, was discovered in a park, shooting marbles in the dirt—hardly the image expected of a Miss America today.

Throughout its existence, the Miss America Pageant has survived many ups and downs. It even came back to life after being dormant from 1928 to 1932, the Depression years. Here are some interesting facts about the pageant and its winners.

- The small boardwalk spectacle grew quickly to include eighty-three contestants in 1924. The number of contestants did not stabilize at its current number of fifty—one per state—until 1965.
- In the early years, a winner was allowed to compete again to defend her title. Mary Katherine Campbell, Miss America 1922 and 1923, was the only successful defender. Winners can no longer compete a second time.
- Rosemary LaPlanche was second runner-up to Miss America 1940. The next year she returned to Atlantic City to capture the 1941 crown. After that episode, the rules were changed so that no former Miss America contestant could compete in the pageant again.
- The first American Indian contestant competed as Miss Oklahoma in 1941.
- The idea of awarding a scholarship was suggested by members of the student council at the University of Minnesota in 1943. A scholarship was first awarded to Miss America 1945, Bess Myerson, who later went on to become Commissioner of Consumer Affairs for New York City. Bess was also the only Jewish Miss America.
- During the first few years of the pageant, everyone involved, including the police force, wore swimming attire

during the pageant festivities. The spectators and organizers soon gave up their swimwear, leaving such attire to the contestants. Until 1947, Miss America was actually crowned while wearing a swimsuit. When the coronation attire was changed to an evening gown, the press threatened to boycott the pageant.

- There originally was no rule against a Miss America getting married during her reign. Jacque Mercer, Miss America 1949, was the last to do so. The rules now prohibit marriage both before and during the reign.
- In 1950, the pageant changed its title dating system so that Miss America 1951 was crowned at the 1950 Miss America Pageant (there never was a Miss America 1950).
- The first pageant telecast was aired in 1954, when Lee Meriwether was crowned Miss America 1955.
- "There She Is," written by Bernie Wayne, was first sung at the 1955 pageant. Due to a money dispute, its use was discontinued after the 1981 pageant. In 1983, "Look at Her" was introduced as the official song, but "There She Is" was reinstated in 1985.
- The first black contestant competed as Miss Iowa in 1970.
- In September 1983, Vanessa Williams was the first black to be selected as Miss America. In July 1984, she became one of the most famous Miss Americas when she was compelled to relinquish her crown in the wake of a *Penthouse* photo spread that revealed nude photographs of Vanessa taken prior to her reign.

Miss America Gives Birth to a Rival Pageant

The Miss USA Pageant was born in 1952. It was created directly by the actions of two Miss Americas and Catalina, a former Miss America sponsor. In 1950, the reigning Miss America, Yolande Betbeze, refused to pose in a swimsuit. One of the pageant's major sponsors was Catalina, a swimsuit manufacturer. Catalina's president, E. B. Stewart, was furious at Miss America's refusal to wear the company's product. A few months

HERE A PAGEANT

later Jacque Mercer, Miss America 1949, suggested to Stewart that he should start his own Miss United Nations Pageant. That became the working title for the pageant that was to be first held in Long Beach, California, in 1952 under the new title of Miss Universe. Rosemary LaPlanche, Miss America 1941, placed the crown on the head of the first Miss Universe. The next Miss Universe Pageant was moved to Miami, Florida, and has since been hosted by countries around the world.

The first pageant consisted of sixty-eight contestants—thirty-nine from the United States and twenty-nine from other countries. During the early years, the Miss USA (originally called Miss United States) and Miss Universe pageants were held during the same week. The contestants in both pageants would compete together for certain categories, such as "Most Photogenic" and "Miss Popularity." Contestants from the United States would compete among themselves for the Miss USA title. Three days later, the winner of that title would be considered, along with the international contestants, for the Miss Universe title. This meant it was possible for a woman to win both the Miss USA and Miss Universe titles in the same week. This in fact happened when Miriam Stevenson won in 1955, when Carol Morris won in 1957, and again when Linda Bement won in 1960.

The dual pageant schedule was too hectic. In 1965, the pageants were separated, and the Miss USA Pageant was held in May, approximately six weeks before the Miss Universe Pageant in July. In 1987, the schedule was again changed. Miss USA is now crowned in February. Miss Universe is selected in May.

What started as a spin-off pageant has grown into the largest international beauty pageant competition. The number of nations represented by contestants each year ranges between seventy and eighty (as many as thirty-five national languages or dialects may be spoken among the contestants). These contestants have been selected in preliminary pageants in their own countries, many of which are televised. The Miss Universe Pageant is viewed live, via satellite, by 600 million people in approximately fifty countries. The Miss USA Pageant is also seen on television around the world.

The Miss USA and Miss Universe pageants have a history

BIRTH OF A BEAUTY PAGEANT

as colorful as that of Miss America. A few tidbits of history are listed below.

♦ While Miss USA and Miss Universe have never included a judging category for performing talent, an optional talent competition was held in the early years. Scholarships were given for dance, drama, and singing. Awards were also presented for the best speeches given by contestants from each of the four participating continents.

♦ The most infamous event in Miss USA's history was the selection of Leona Gage as Miss USA 1957. After her selection, a woman in Maryland bragged to the press that her daughter-in-law had just been crowned Miss USA. It was revealed that Leona was actually 18, not 21 as her application said, and that she was married for the second time. She also had two children from her first marriage to a 28-year-old man whom she married when she was 14. The crown was taken from Leona and bestowed upon the first runner-up, Charlotte Sheffield. Charlotte, however, was not allowed to compete in the Miss Universe Pageant. The pageant skipped over all of the fifteen semifinalists, and designated the woman who placed sixteenth in the Miss USA Pageant, a previously unrevealed non-semifinalist, to compete in the Miss Universe Pageant. Charlotte also did not get any prizes as Miss USA since Leona Gage had run off with the awarded prizes.

♦ The Miss USA and Miss Universe crowns used in 1958 were reportedly valued at $500,000. They consisted of approximately 1,000 Oriental cultured and black pearls set in a solid gold and platinum frame, and weighed 1.25 pounds. The winners only wore the crowns three times during their reign—their coronation, their successor's coronation, and one other unspecified time. When the crown was worn, the titleholder was shadowed by a bodyguard. Needless to say, the titleholders were not allowed to keep their crowns. The current crowns are made of rhinestones, and are still worth a significant amount, but not as much as the 1958 crowns. The winners now are allowed to keep their crowns.

♦ The first black contestant competed in the Miss USA Pageant in 1960 as Miss Ohio. In 1977, Janelle Commissiong, Miss

Trinidad and Tobago, became the first black to be crowned Miss Universe.

♦ The year 1963 marked the first time a naturalized citizen became Miss USA. Marite Ozers, formerly Miss Illinois-USA, had immigrated to the United States from Latvia. Two subsequent Miss USAs were also naturalized citizens. Maria Remenyi was born in Denmark and raised in Budapest, Hungary. She became Miss California-USA and then Miss USA in 1966. In 1985, Mexican-born Laura Herring-Martinez became the second Miss Texas-USA to capture the Miss USA crown.

♦ The first time two state titleholders from the same state consecutively won the Miss USA title occurred when Debbie Shelton, Miss USA 1970, succeeded Wendy Dascomb, Miss USA 1969. They had both competed as Miss Virginia-USA. Back-to-back winners can also be claimed by Illinois (Amanda Jones, 1973, and Karen Morrison, 1974) and Texas (Laura Herring-Martinez, 1985, and Christy Fichtner, 1986).

♦ Miss Universe 1974 did not appear to crown her successor. She had been stripped of her duties shortly before the end of her stormy reign. The former Miss Spain had an explosive temper that caused problems throughout her year. The last straw came when she punched her chaperone. The 1975 pageant was simply conducted without any reference to the previous year's queen.

♦ In 1976, Rina Messinger, a member of the Israeli army was selected as Miss Universe. Due to the political situation in Israel, Rina was accompanied by bodyguards at all times. While Miss USA and Miss Universe are normally roommates during their reigns, an exception was made in 1976 to protect both Rina and Barbara (Miss USA 1976) in case of an attack on the former Miss Israel.

♦ In 1980, all of the Miss USA contestants were offered an all-expense paid trip to Seoul, Korea, as the special guests of the Miss Universe Pageant Committee of Seoul. This unique offer resulted in Jineane Ford, Miss Arizona-USA and first runner-up to Miss USA 1980, being in the audience in Korea when Shawn Weatherly was crowned Miss Universe. This new title

BIRTH OF A BEAUTY PAGEANT

required Shawn to relinquish her duties and crown as Miss USA. As Bob Barker states at the end of every Miss USA Pageant, "If for any reason the winner is unable to fulfill her duties as Miss USA, the first runner-up will become Miss USA." Shawn's rise from Miss USA 1980 to Miss Universe 1980 automatically passed the Miss USA crown to Jineane. Jineane was formally crowned on the Miss Universe stage after the Miss Universe Pageant telecast, making her the only woman to actually have been crowned Miss USA in a foreign country. (Michele McDonald, Miss USA 1971, was crowned in Puerto Rico when the Miss USA Pageant was televised live from that U.S. territory.)

♦ Shawn Weatherly was the fifth Miss USA to capture the Miss Universe title and was the second Miss Universe to come from South Carolina. The other Miss South Carolina-USA to become Miss Universe was Miriam Stevenson, Miss USA 1954. Miriam was the first Miss USA to win the Miss Universe title.

♦ In 1983, Miss Universe, Inc., created a third pageant, Miss Teen USA, which runs along the same judging lines as Miss USA but is limited to teenage contestants.

♦ The Miss Universe, Inc., headquarters moved from New York City to Los Angeles, California in 1985.

Teen Pageants

Teen pageants recognize girls who have excelled in academic pursuits, developed a special area of interest (talent), and contributed to their community. The image sought is less one of sophistication than it is of wholesomeness—the all-American girl next door. While teen pageants may not formally be considered beauty pageants, they are similar to the adult pageants in many respects (i.e., interviews, evening gown and talent competition), and the preparation for them is the same.

The first major teen pageant was formed in 1958. That pageant, America's Junior Miss, is still one of the foremost teen pageants. It is only open to girls in their senior year of high school. Contestants are judged in the usual interview, appear-

ance and poise, and talent competitions. There are also categories for physical fitness and scholastic achievement. Separate (nonjudged) competitions are held for special activities such as party planning, photography, and sewing. These may change each year depending on the products of the pageant's sponsors. Contestants at the national pageant compete in Mobile, Alabama, for two weeks, during which time they live with host families. As the original teen pageant, America's Junior Miss has set very high standards for subsequent teen pageants to emulate.

The teen pageants have tried to avoid the "queen" concept. Miss Teenage America was the first to take strides away from the traditional beauty queen symbols. Instead of bestowing a crown on the winner, the Miss Teenage America Pageant presents a beautiful medal which is inscribed with the pageant's motto, "Achievement, Knowledge, Integrity, Honor, and Leadership." The official medal is worn during each winner's reign and then passed on to successors. An exact duplicate of the medal is then presented to the outgoing titleholder. Such a system allows each girl to keep the most special memento of her year while also creating the tradition of having each winner wear the same official symbol of recognition that has been worn by her predecessors. The use of medals has been adopted for the winners of the America's Junior Miss Pageant (who used to wear a crown) and the Miss Teen of America Scholarship and Recognition Pageant (a program patterned heavily after the Miss Teenage America Pageant).

For many years Miss Teenage America was one of the most coveted teen titles. The pageant was started in 1961. A soft drink company owned and operated the pageant, and utilized the winner as a special company public relations person, in addition to having her involved in the community. As Miss Teenage Minnesota, Polly won a year's supply of the company's soft drink (a year's supply meant "when you've finished the last load, call us for more")—a prize her four brothers found most enjoyable. As second runner-up at the national pageant in 1977, her prizes included a $4,000 scholarship, a set of encyclopedias, and a life insurance policy. The titleholder that year, Becky Reid from Dallas, Texas, won a $12,000 scholarship.

Miss Teenage America contestants used to be selected to rep-

BIRTH OF A BEAUTY PAGEANT

resent various areas. Some states had more than one representative (for example, Texas had six during Polly's year), and some states would not have any. For girls who lived in areas without a preliminary competition, there was a Candidate-At-Large program by which they could apply directly to the national headquarters to earn a spot at the national pageant. There was also an overseas candidate category for American girls living abroad. Preliminary winners were given city titles corresponding to the city in which their preliminary competition was held or, for At-Large Candidates, where they lived. At the national pageant, Polly was known as Miss Teenage Minneapolis-St. Paul. Since she was the only representative from Minnesota, her preliminary pageant also gave her the title of Miss Teenage Minnesota.

In the late 1970s, the soft drink company changed its advertising direction and Miss Teenage America became a dormant program. Several years later, the pageant was purchased by *'Teen* magazine. It was sold with the provision that the pageant be operated according to the same standards under which the original Miss Teenage America Pageant was held. While the judging categories have remained the same, the procedures have been changed. Now, girls between the ages of 13 and 18 submit applications to the magazine. Twelve finalists are picked on the basis of written applications. In 1986, the twelve girls, who were picked from a field of 9,000 applicants, were gathered in Los Angeles. The final pageant was held at Disneyland. Miss Teenage America 1986, Lisa Morgan, won a $20,000 scholarship, a car, and assorted prizes.

One of the newest and fastest-growing teen pageants is Miss Teen USA, which was started in 1983. This pageant consists of the same judging categories as the Miss USA Pageant, including the swimsuit competition. Contestants considering the Miss Teen USA Pageant should realize that this is one of the few teen pageants that has a swimsuit category. During its first year, this "teen" pageant had the same look and feel as its adult sister pageant. Since then, the pageant has changed its flavor to reflect a more youthful image. The videotaped swimsuit segment now shows the teen contestants involved in various youthful activities, such as building sandcastles, rather than only showing them modeling swimsuits. The revised format is

more appropriate for teen contestants than the one originally adopted.

Kiddie Pageants

The most controversial pageants are those held for children. These pageants attract millions of girls (and boys) for a variety of age divisions, such as infants, toddlers, petites, little ladies, and junior misses. The judging categories may include poise and appearance, party dress and sportswear modeling, interview, talent, and even swimsuit. The prizes range from trophies (which may be taller than the children) and cash awards, to cars and promises of major movie studio interviews (which hold no guarantees for future contracts).

A major concern regarding these pageants is that the contestants may not be competing out of their own choosing, but rather because their parents have insisted on it. This is the wrong reason for anyone to enter a pageant. Pageant participation should be based on the participant's desire. If the child is too young to make the decision to enter, she or he should not be competing.

Young children should be allowed to play—there is plenty of time to compete in pageants if and when they personally choose to do so. Although Susan Akins, Miss America 1986, had previously competed in 100 pageants and was Little Miss America 1970, early competition is not necessary to win pageants later on in life. Kellye Cash, Miss America 1987, had never entered a pageant before competing in the Miss America system. She stated that she did not think girls should concentrate on pageants throughout their childhood, saying, "I can't say that pageants for children are wrong, but I think you have to be so cautious. What happens is that some of them are what we call 'pageant professionals' and that is it."

Early life should emphasize socialization skills, how to share and get along. Sports, pageants, and school grades can later encourage the individual's drive to excel. If asked for an ideal age to first compete in a pageant, we would answer—(1) not until the girl personally wants to compete, and (2) not before

the age of 15 or 16 (the chances of winning a teen pageant at a younger age are slim).

Other Pageants

Pageants are held for different purposes. Pageants have been held as part of town festivals, to promote products, to celebrate ethnic pride or a special cause, to recognize those who have lost a certain amount of weight, or merely to create a television special that cashes in on the popularity of pageants. The following is a sample list (by no means exhaustive) of other pageants:

- Miss Black America
- Mrs. America (married women were formerly judged on homemaking skills, but are now judged in the same categories as Miss USA, including swimsuit)
- Mother-Daughter Pageant (mothers and daughters compete as a team in the same categories as Miss USA, including swimsuit)
- The Tournament of Roses Queen (reigns over the Rose Bowl)
- Miss Wheelchair America
- Miss Rodeo America
- Miss Tall International (can be married and have children)
- Miss Oktoberfest (held in Canada, but Americans may compete)
- Miss World
- Pork Queen (sponsored by the pork industry)
- Miss Hawaiian Tropic International (essentially a competition to find a highly paid model for this company's product, it involves extensive appearances in bikinis)
- The Most Beautiful Girl in the World (winner is selected by television viewers who call in their votes after seeing the finalists appear repeatedly in bikinis and assorted skimpy outfits)

- Ultimate Showgirl (a city by city search is conducted to find very tall finalists to compete for a one-year contract for a Las Vegas revue—stage experience is not necessary, but makes the competition easier)
- Super Model of the World (women compete extensively in swimwear for a $250,000 guaranteed modeling contract with a major New York modeling agency)
- Miss Hollywood (the emphasis is on acting talents; 100 videotaped finalists are narrowed to twenty-five finalists who compete for two weeks for $100,000 in prizes)
- Miss Nude World
- Dream Girl USA (introduced in 1986, four contestants—including married women—compete weekly on this network series; the weekly winners later compete against each other for the "Dream Girl USA" title)

There is a steady stream of new pageants. Some of them catch on and grow; others die quietly. Some pageants merely exist without ever gaining any significant publicity. Among these lesser-known pageants are the "Miss Man Made" pageant for transsexuals and Mr. Gay America.

Right. *Five-year-old Barbara practices for the swimsuit competition. (Hats and handbags have never been used in the official judging.)*

Below. *As a four-year-old, Polly's runway was a dock on a lake in Minnesota. Eighteen years later, the runway was part of the Miss USA Pageant stage on the Gulf Coast of Mississippi.*

Above left. *Barbara won her first pageant title, Miss Svenskarnas Dag 1973, when she was nineteen years old. This was her official photograph.*

Above right. *As Miss Fire Fighter 1980, Polly not only rode in parades on the fire trucks, she accompanied them to fire sites (without the crown and banner, of course) to learn more about fire prevention.*

Right. *Polly first appeared before the 1981 Miss USA judges in this state costume, which represented "Minnesota: The Land of Ice and Snow."*

Top. *Polly competes in the talent competition of the Miss Teenage Minnesota pageant.*

Bottom. *Polly in the evening gown competition at the Miss USA pageant.*

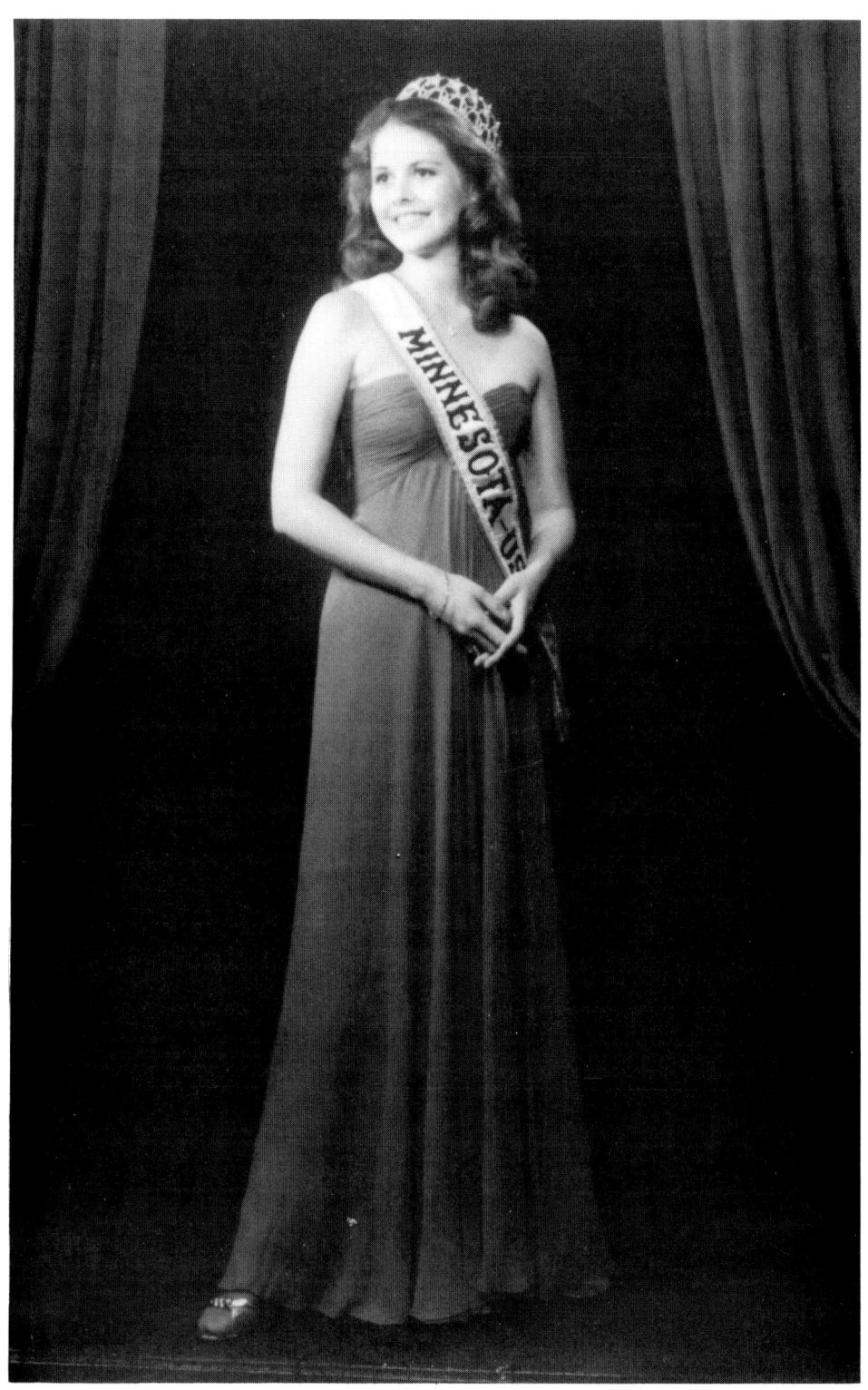

Polly as Miss Minnesota-USA 1981.

Barbara as Miss USA 1976.

Above. ***The crowning of a new Miss USA is only the beginning of an exciting year and a new way of life for one lucky woman. This moment was a turning point in Barbara's life.***

Opposite page, left. ***Barbara, on the morning of the first day of her reign as Miss USA 1976.***

Opposite page, right. ***A highlight of Barbara's reign as Miss USA was meeting President Gerald Ford in the Oval Office.***

Opposite page, bottom. ***Miss USA may be a national title, but it involves a significant amount of international travel. Barbara remembers especially her trip to Hong Kong to compete in the 1976 Miss Universe pageant.***

Top. *The Miss Texas-USA Pageant is an elaborate production. From left to right, Rina Messinger (Miss Universe 1976), Candace Gray (Miss Texas-USA 1976), and Barbara (Miss USA 1976) made their entrance at this 1977 state preliminary by being lowered from the ceiling in glittering stars.*

Bottom. *To celebrate its thirty-fifth anniversary, in 1986, the Miss USA Pageant organization invited back, as its guests, all of the former titleholders. Some of the past winners are gathered here. From left to right, beginning in the first row, they are: Bob Barker, pageant emcee; Christy Fichtner, 1986; George Honchar, President of Miss Universe, Inc; Cheryl-Ann Patton, 1967; Kim Tomes, 1977; Laura Martinez-Herring, 1985; Mary Therese Fried, 1979; Summer Bartholomew, 1975; Charlotte Sheffield, 1957; Barbara Peterson, 1976; Julie Hayek, 1983; Marite Ozers, 1963; Bobbie Johnson, 1964; Sue Ann Downey, 1965; Linda Bement, 1960 (also Miss Universe 1960); Terri Utley, 1982; and Judi Andersen, 1978.*

2

The Pageant Business: Beauty You Can Bank On

We have already addressed the common question of why young women choose to enter beauty pageants. The bigger question may be why civic groups and corporations choose to organize and/or sponsor such pageants. If these groups were questioned about their motives, their answers would run the gamut from "pageants promote community spirit," to "it is a scholarship program that benefits women," to "pageants make money." In reality, the bottom line as to why pageants are sponsored is the bottom line.

Corporate Profits

Beauty pageants have grown into a big business. While any given pageant may be an isolated event (i.e., selecting a homecoming queen), most pageants are part of a large pageant ladder that extends from the small-town or local organization to a national or international level. At the local level, conducting a pageant may not be a big money maker. Revenues are confined to ticket sales, candidate sponsorship fees, and a limited amount of advertising in the program booklet. The purpose of these lower-rung pageants is to select a hometown girl who can represent the community at other small-town festivals, and maybe, just maybe, bring some glory to her town by winning a pageant higher up on the ladder. Those pageants that sit on higher rungs generate increasingly higher revenues. By the time one reaches the highest rung in a given pageant ladder (for example, Miss Universe), the profits can be considerable.

Miss Universe, Inc., which runs Miss Universe, Miss USA, and Miss Teen USA, is run as a profitable business enterprise.

It does not try to hide this fact. Indeed, there is nothing wrong with a pageant making money—as long as its star, the title-holder, is fairly compensated for her role, as Miss Universe, Miss USA, and Miss Teen USA are. Miss Universe, Inc., derives its revenue from many sources. Procter & Gamble, its sole television sponsor since 1959, gives the organization a seven-figure sum annually. Other corporations pay licensing fees to sell products connected to the pageants. For example, J. C. Penny is licensed to sell the Miss USA swimwear line that is made by Catalina. The pageant's host city pays a fee for the privilege of hosting the event, and for getting several minutes of telecast time to showcase the city. The host city fee has reached $500,000 in the past. State and local preliminary pageants also pay a franchising fee to the national organization. Miss Universe, Inc., also receives appearance fees of about $2,000 per day for Miss Universe, and $1,500 per day for Miss USA, plus expenses.

In contrast to Miss Universe, Inc., the Miss America Pageant is proud of its nonprofit status, as well as its combined $5 million per year contribution to scholarships at all of its levels of competition. It is so careful about not making a profit that it sells its television rights for a mere $250,000, a very small sum for a heavily viewed commercial show. It also commands appearance fees of only $1,250, plus expenses.

The Race for Television Viewers and Advertising Dollars

The profitability of any pageant depends on the number of its viewers. At local pageants this translates into ticket sales. For televised pageants, viewership, as measured by the Nielsen ratings, greatly influences the size of network and advertising dollars.

Pageants, as well as other television shows, must capture a high enough Nielsen rating to survive. In recent years, Miss America's ratings have slipped drastically. Albert A. Marks, Jr., the pageant's long-time director, has said that while he loves positive publicity and hates negative publicity, he would take both. The reason for this sentiment becomes apparent when

it is noted that Miss America's ratings temporarily increased for the 1984 pageant, which followed closely on the heels of the nude photographs scandal involving its recently resigned queen, Vanessa Williams. Publicity of any kind that increases viewership will increase the value of the show for its advertising sponsors.

While Miss America has slipped in the ratings, Miss Universe, Inc.'s pageants have done very well. The 1986 Miss Universe Pageant was viewed by 600 million people in fifty-four countries. Approximately 82 million of these viewers were in the United States. Since 1980, Miss USA has been televised abroad, and is now seen in approximately forty other countries. Even the relatively new Miss Teen USA Pageant is now broadcast outside the United States.

The demographics of the viewing audience may be even more important to advertisers than the audience's size. Here too Miss Universe, Inc., wins out over Miss America. Miss Universe, Inc.'s pageants attract more female viewers in the prime consumer age bracket of 18 to 49, which makes its advertising slots more valuable. Miss America tends to attract relatively young and old viewers.

Advertising sponsors love beauty pageants. First, the pageants provide them with a large viewing audience. Miss USA consistently rates among the top few shows for its week. Lately, the only close rival for Miss Universe during its week has been Major League Baseball's All-Star game (everyone loves a contest!). The pageant still ranks 74 percent higher than the average prime-time network show. The second reason pageants are popular with sponsors is that they provide relatively cheap commercial slots. A thirty-second spot on the Super Bowl can run around $600,000. A popular network series will cost approximately $75,000 per thirty-second commercial. Miss America's sponsors pay about $20,000 to $25,000 for thirty seconds. The small dollar cost combined with a pageant's high television rating makes pageant advertising a great investment.

Prize Structures

While pageants generate much revenue, they are also expensive to stage and promote all year. A telecast such as the Miss USA

HERE A PAGEANT

Pageant costs approximately $1 million to produce. Another major expense is that of compensating the titleholder. Pageants vary greatly in the methods and amounts of compensation given. A potential contestant should know what type of prize package is being offered to the winner before she enters. While the exact prizes vary from year to year, and it is impossible to find out exactly what will be awarded at each level prior to reaching that level, one can get an idea of what the approximate value of the package will be for the year. (See Awards Appendix for an example of how prizes have increased over time.)

Miss Universe, Inc., does not award "scholarships" limited to educational use. It gives a personal appearance contract and cash awards that the winner can utilize in any way she desires, including to further her education. Miss Universe's personal appearance contract and cash awards will put more than $95,000 cash into her pocket. The cash awards are accompanied by a substantial prize package. The prizes usually include:

a sporty car

a full-length mink coat

a speedboat

a first-class trip for two to a destination of the winner's choice

a screen test

a camera package

diamond jewelry

a five-year supply of cosmetics

The total prize package for Miss Universe 1986 was $200,000. Miss USA and Miss Teen USA each win about $175,000. They also each receive about $25 million worth of publicity.

In addition, the prize packages for Miss Universe and Miss USA include the following:

- ♦ They are moved to Los Angeles where they share a paid-for apartment, which comes complete with a maid and a chaperone.
- ♦ A complete wardrobe—everything they will need to wear during their reigns.

♦ All of their expenses paid for during their reign, both while on the road and in their Los Angeles apartment.

Barbara's apartment was in New York City (the pageant moved to Los Angeles in 1985). She was on a complete expense account that covered her every expense down to buying her pantyhose. Even her long-distance phone calls to friends and family were paid for by the pageant. The value of her prize package was significantly more than advertised because she was not required to use any of her winnings to support herself during her reign.

Miss America's prizes include a share in the $5 million that are awarded down the pageant ladder. Miss America 1987's share consisted of a $30,000 scholarship. Smaller scholarships were awarded as follows to the runners-up and preliminary winners:

First runner-up	$17,000
Second runner-up	11,000
Third runner-up	8,000
Fourth runner-up	6,000
Swimsuit winners	2,500
Talent winners	3,500

One catch a contestant in the Miss America Pageant should be aware of is that the scholarship dollars are restricted. The total dollar amount may not be awarded unless it is used to further the winner's education. In the past, a woman who did not want to continue her education would not receive the money the public thought she was receiving. Today it is easier to claim scholarship dollars since educational pursuits are now defined to include things like singing and acting lessons. Even traveling may be considered a "furthering of one's education" that will justify the awarding of the scholarship.

Miss America also shares in the personal appearance fees she generates. Maria Beale Fletcher, Miss America 1962, replaced her $85 per week salary as a Rockette with $1,500 per week as the reigning Miss America. Twenty years later, Debra Maffet, Miss America 1982, earned $105,000 in addition to her $20,000 scholarship. Susan Akins, Miss America 1986,

earned a record $150,000 to $175,000 in appearance fees and scholarships. A Miss America potentially can make a lot of money, but winnings will vary depending on the popularity of the winner. Since her earnings will depend on how much people want her at their functions, Miss Americas have learned to keep their opinions to themselves. Queens who have been outspoken in the past have suffered lost appearance bookings and consequently have made less money. This is also true for state titleholders. In fact, Miss Montana 1970 was forced to resign her title due to controversial views.

The Miss America appearance fee system is different from that used by Miss Universe, Inc. The latter guarantees its titleholders a specific amount of money in the form of a personal appearance contract. If the winner is unpopular, the pageant loses out; if she is an extra-popular queen, the pageant gets the bonus.

Another difference between Miss Universe, Inc., and the Miss America Pageant's method of compensating titleholders is that the former pays all its titleholder's expenses at her home-base apartment as well as on the road. Miss America's basic traveling expenses (i.e., transportation, food, lodging, and tips) are paid for only while on the road. Unlike Miss USA, Miss America must purchase her own wardrobe—a huge, but partially tax-deductible expense.

The teenage pageants, including the previously mentioned Miss Teen USA, can also be lucrative for their winners. Again, scholarship dollars in these pageants may be contingent on your furthering your education. The education requirements are more stringent than for the Miss America Pageant. When Polly won a $4,000 scholarship as Second Alternate to Miss Teenage America 1977, she could only collect a portion of it per semester after providing proof that she was registered for sufficient college credits. The entire scholarship had to be claimed within five years of her graduating from high school.

The Junior Miss contest is the oldest, and one of the finest, teen programs. The organization distributes about $100,000 in scholarships in various categories. As part of her prize package, America's Junior Miss for 1986 received a college scholarship of $25,000. This greatly exceeds the $10,000 scholarship awarded to Miss National Teenager in 1985. The runners-up

and preliminary winners to the 1986 America's Junior Miss received the following scholarships:

First runner-up	$10,000
Second runner-up	7,000
Talent winner	5,000
Scholastic winner	5,000
Spirit Award winner (contestants select the contestant who best reflects the spirit of the Junior Miss program)	5,000
Party Notebook winner	3,000

Miss Teenage America is now sponsored by *'Teen* magazine. The 1986 titleholder received:

$20,000 scholarship

1986 Renault Alliance convertible

a K-Mart apparel wardrobe

travel and television appearances

an appearance on the cover of *'Teen* magazine, and a chance to author a monthly column in *'Teen.*

The prizes awarded at state preliminaries for any pageant vary widely. Some state winners may only be given an expense-paid trip to the national pageant and her crown (awards which are required of franchise holders in the major pageant systems). In other states, the titleholder may win a prize package similar to those won by national winners. Miss Texas-USA is an example of how a state titleholder can earn great financial rewards.

Miss Texas-USA is crowned on a televised show which culminates a ten-day pageant which includes more than 100 contestants. While the tab for a contestant to prepare for that particular contest has been estimated at $2,500, the value of the winner's prize package has approached $90,000. One past prize package included the following:

$15,000 in cash

$6,000 daytime wardrobe, and an evening gown collection from Guyrex

a western boot collection, swimwear collection, a jean wardrobe, Catalina sportswear, and lingerie

a fur coat

a tour of Texas

a fully loaded AMC Cherokee jeep

use of a $30,000 jewelry collection during her reign

a designer watch and official Miss Texas-USA crown ring

a photograph portfolio

limousine service

$5,000 worth of air travel

Miss Texas-USA is also moved to El Paso, home of the pageant, to be available to train for the national pageant. The size and quality of this state pageant explain why Miss Texas-USA consistently places among the top at the national pageant. The difference between the Miss Texas-USA type of prize package and those commonly found in smaller state pageants also explains why some contestants "shop around" before deciding which state pageant to enter (i.e., one can enter the pageant in one's home state or in the state in which she goes to school, and one can select from a wide array of pageants within a given state).

3

Which Pageant Is Right for You?

You have always dreamed about winning a pageant. Entering a pageant is a step that could change your life. Since you now know the costs and benefits of pursuing that goal, you must decide which way the balance tips for you. If you enter you must be prepared to win and to fulfill the commitments of the title once the crown is placed on your head.

Before you leap into competition, ask yourself the following questions.

- Is the timing right or should I wait until I am a year or two older, or have another year of college?
- Does the pageant fit into my school or work plan?
- Will the benefits outweigh the financial costs for me?
- Am I ready to sacrifice my time and energy to meet the demands of the title?
- Do I have the energy and stamina it will take to fulfill the duties of this particular title?
- Will I personally benefit from the experience?
- Will my family and friends be supportive? (Do not let other people stop you from pursuing a goal, but be aware that the support of loved ones will help you immensely.)

When you answer yes to these questions, it might be the right time for you to compete in a pageant, but remember that winning is more than a night of fantasy. Fulfilling the title is a *job*—a fun and rewarding one, but nevertheless, a job. A title, whether it be Miss USA or Miss Small Town,

HERE A PAGEANT

goes with you to school, on dates, to the grocery store—everywhere you go. It stays with you even after you have passed on the crown. It is a twenty-four-hour-a-day responsibility to live up to it. That one time when you are in a hurry and think you can run to the store in your sweatpants and no makeup often is the time you will run into someone who recognizes you as "Miss Somebody." You have to remember that everything you do from now on, both good and bad, will reflect on the title and all previous and potential titleholders.

The pageant competition can benefit you even if you do not win the crown. The pageant experience will enhance your personal appearance. The interviews and stage experience will develop your self-confidence and speaking abilities. The public contact will introduce you to new friends and potential career contacts. To reap the personal growth benefits of pageant competition, however, you must always enter a pageant prepared to do your best. If you do this, you have a good chance of winning, so go into the competition prepared to accept the duties of the titleholder.

You've weighed the pros and cons and decided that you want to enter a pageant. You look around and find that there are many pageants to choose from. How do you decide which one to enter? The answer is, "Very carefully." You must be selective. Getting involved with a pageant may affect not only the next year of your life, but also the rest of your life. That is not an overstatement. Before you allow your name and reputation to be linked up with a pageant, be sure that you will be proud of that association.

You already know that the pageant business is a serious business. Many individuals and groups sponsor pageants at local, state, and national levels. You want to make sure that the one you get involved with is reputable—not all of them are. Many of the pageant titles sound the same, so make sure you know exactly which pageant you are talking about. For instance, are you looking at Miss Teenage America, Miss Teen USA, Miss T.E.E.N., America's Junior Miss, Miss National Teenager, Miss American Teenager, Miss U.S. Teen, Miss Teen of America, Miss Teen All-American, or Miss United Teenager? Yes, these all exist, and there are more.

WHICH PAGEANT IS RIGHT?

Get All the Facts

No two pageants are the same, so before you make a final decision, consider all aspects of your possible pageant choices. Ask questions about each pageant. Find out as much of the following information as possible:

Who is the state director? What is his or her reputation? How long has he or she been involved in this or other pageants? Where is the national headquarters?

Are the pageant sponsors and suppliers satisfied? Have businesses that have had dealings with the pageant ever had problems with it? Ask whether the pageant has ever left them with unpaid bills. If you have any questions about the legitimacy of a pageant, call your local Better Business Bureau to see if any complaints have been filed.

Are former contestants satisfied? Ask former contestants how they feel about their experience with that particular pageant. Ask whether all promised prizes were awarded. Be aware that a bad experience with one pageant promoter may have soured past contestants on the idea of pageants all together. Do not let that attitude deter you from entering a different pageant.

If you are serving as a local titleholder of one pageant, utilize the contacts you make with other queens to find out what is involved in their pageants. You may find another system that you want to compete in after you relinquish your current title.

How many contestants are allowed to enter the pageant? Steer clear of pageants that have more than 100 contestants—the pageant organizers are probably just out for as many sponsorship fees as they can collect.

How much is the sponsor's fee? Do you have to find your own sponsor? Ask about the pageant production to assess whether the fee is reasonable for the quality of the production and pageant activities. Ask whether you will be responsible for any other expenses.

HERE A PAGEANT

If you win, will you have to sign a contract? If so, what rights and obligations do you and the pageant organization each have.

How does the judging work? Ask what the judging categories are. Find out the weight of each of the categories at each stage of the competition. Talent may be worth 50 percent in the preliminary judging, but only worth 25 to 33 percent in the final determination. Evaluate your strong and weak areas to determine in which pageant you will be most competitive. Also ask who some of the past judges have been and what qualifications they possessed.

Is there a talent requirement? Some pageants require a performing talent and others do not. Miss America is based 50 percent on performing talent. Miss USA does not judge such a category; instead, it places more emphasis on the interview. If you have a performing talent, a contest with a heavy judging emphasis in that area will increase your chances of winning.

Choosing to compete in a pageant that does not have a specific judging category for performing talent does not indicate that you have no such talent. Frequently, women who have competed in the Miss America or Miss USA pageant cross over and compete in the other pageant, as either one provides a vehicle to develop and promote a talent into a career. Suzanne Plummer is one example of a cross-over contestant. Suzanne represented the District of Columbia in the Miss USA Pageant in 1972 and was one of the twelve semifinalists. She also was Miss New Jersey and second runner-up to Miss America 1974, Rebecca Ann King. Laurie Saarinen did not place in the 1981 Miss USA Pageant as Miss North Dakota-USA, but in 1982 she made the top ten at the Miss America Pageant as Miss Minnesota. Debra Sue Maffet, who won the 1982 Miss America Pageant, had tried three times to capture the Miss Texas-USA crown to qualify for the Miss USA Pageant. After these unsuccessful attempts, she moved to California, made some changes in her appearance, and won the Miss Anaheim and Miss California titles, which took her on to win the Miss America Pageant.

The best example of a cross-over contestant is Debbie Davis. Debbie was Miss West Virginia-USA in the 1978 Miss USA Pageant and did not place. She was also Miss West Virginia in

WHICH PAGEANT IS RIGHT?

the 1980 Miss America Pageant where she made the top ten. In 1984, she became Mrs. America after representing—you guessed it—West Virginia.

Will you have to compete in a swimsuit? Another common judging category is the swimsuit. Miss America and Miss USA both require their contestants to compete in this area. It is this segment that places both the Miss USA and the Miss America Pageants equally in the beauty pageant category. Miss Teen USA is one major teenage pageant that has this category. That pageant is more similar to the "grown-up" pageants than it is to the traditional teen pageants.

The swimsuit competition is probably the most difficult portion of the competition for most contestants. This category shows poise, grace, and how well the contestant takes care of herself physically. You do not have to be an Olympic athlete, but you do have to have muscle tone.

What scholastic requirements must you meet? The only pageants that can truly claim the "scholarship" distinction are those that consider the contestants' academic performance as part of the judging criteria. The teen pageants are the ones that really stress the scholastic aspect. Most of these will require a school transcript to verify your grade-point average. They may also have a minimum grade-point average that you must meet before being allowed to enter. In fact, many of the teen pageants go even further and require the contestants to take a written test that covers academic subjects, current events, and knowledge of arts and literature. This test is often designed by an encyclopedia company or by college professors and is quite challenging. This criterion was first used in the Miss Teenage America Pageant but has since been adopted by others.

None of the "grown-up" pageants specifically look at one's grade-point average, but some do require that you be enrolled in a college at the time you compete. When this is a requirement, it is common to find contestants who have enrolled in one or two courses for one quarter, just to qualify for the pageant. Claiming that all the contestants in a pageant are or must be students is, therefore, misleading.

The requirement that all contestants be college students led to a highly publicized court battle over who was entitled to

HERE A PAGEANT

wear the crown as Miss New Jersey 1985. Toni Georgiana lived in Philadelphia, Pennsylvania. She enrolled for one class at a New Jersey college eleven days before she was to compete in the Miss Mercer County Pageant, but never showed up in class. When she was later crowned Miss New Jersey, her first runner-up took her to court claiming she had not met the qualifications to enter the pageant. The court held that she had, and she was allowed to keep the title. The interesting fact is that Georgiana, who already had won twelve other pageants, had competed in the Miss Pennsylvania Pageant in 1984. She was first runner-up in that pageant, which was won by a contestant from Cherry Hill, New Jersey.

What amount of scholarship is offered? Some pageants, such as Miss America, deny the label of "beauty pageant," claiming instead to be a scholarship program for women. Every major pageant is a scholarship program for women in the sense that they provide monetary "scholarships" or cash awards. It is the large monetary scholarships which attract most contestants to these pageants.

Is the scholarship contingent on it being used for academic pursuits? The Miss USA system awards its monetary prizes in all cases and lets the contestants decide how to spend or invest it. In contrast, some contests, such as Miss America, will not pay out the monetary prize unless the woman is enrolled in a course of study. Acceptable educational pursuits may include acting, voice lessons, and, perhaps, traveling. There also may be a time limit, usually five years, in which you have to use your scholarship. If you have already completed your schooling, such a restricted monetary prize may be worthless to you. Also some pageants (i.e., America's Junior Miss) may prevent scholarship winners from competing in another pageant for a period of time (i.e., one year) without the pageant's approval. Know what restrictions are placed on the awarding of a scholarship to ensure that the scholarship you win will be awarded to you.

Can the scholarship awarded be used at the school of your choice? Some pageants will announce that they give a large scholarship, but it may only be good at a specific college. Usually these are for small colleges that you probably have no interest

WHICH PAGEANT IS RIGHT?

in attending. All major national pageants will award scholarships for the school of your choice.

What other prizes are offered? If you are motivated by the monetary rewards of pageant competition, look closely at the prize package offered at the various levels of competition. These rewards can be great. Miss Universe, Miss USA, and Miss America, together compete for a cash and prize package in the area of $500,000.

What types of appearances will the titleholder make? Contestants should be as interested in what personal challenges and experiences the year will offer as in what prizes are awarded. It is the personal appearance schedule that offers opportunities that extend beyond the reign. Know what kind of appearances will be required of you (i.e., parades, luncheons, fashion shows, speeches, television interviews, etc.). Evaluate how well the pageant director and sponsors will promote you.

Will the pageant give you media exposure? If the local pageant will qualify you for a national competition, consider whether the national pageant is large enough to have major media exposure. What kind of ratings does its telecast draw?

Does the pageant offer the opportunity for travel? Extensive travel is not involved in all pageant competitions. While Miss USA logs thousands of miles worldwide, some other national titleholders may not travel anywhere except home after winning their pageants.

How much time will be required of you? Find out, *before* you enter the pageant, what kind of time commitment is involved because after you win the title, thereby accepting its responsibilities, it is too late to decide you do not want to make the sacrifices necessary to fulfill the title. If you win, you may not be able to see your boyfriend or other friends as often as you would like, you certainly will not be able to get married during your reign, and you may have to temporarily suspend your education.

Each level of competition demands differing amounts of time. Winning a national pageant will often require full-time commitment and perhaps a move to another city. Even some local

titles may require that you take time off from school and work. Barbara had to take a year off from college to serve as the Minneapolis Aquatennial Queen of the Lakes. Her busy schedule also made holding a job difficult, so the Aquatennial organization had to arrange a job for her that would accommodate her heavy travel schedule. Some pageants may require only a concentrated time commitment for a short period. For instance, the Tournament of Roses Queen is kept very busy for only ninety days.

Think carefully about the time commitment that would be involved if you won at the local level. Also consider whether winning the pageant will qualify you to compete in a state or national pageant and what responsibilities you would have at those levels. Barbara's winning the Miss Svenskarnas Dag Contest in 1973 eventually led her to winning the Minneapolis Aquatennial Queen of the Lakes (in 1973), Miss Minnesota-USA (in 1975), and Miss USA (in 1976) pageants. Sue Ann Downey was selected Miss Columbus 1965, a week later she was crowned Miss Ohio-USA, and three weeks later she won the Miss USA title. Within a month, she became second runner-up to Miss Universe. Sylvia Hitchcock entered the University of Alabama Homecoming Queen contest, which led to enormous responsibilities as she went on to compete in, and win, the 1967 Miss Alabama-USA, Miss USA, and Miss Universe titles.

Winning consecutive titles like this can lengthen your commitment from one year to two or three, depending on how long you serve with each title before competing at the next level. Everyone who reaches the top level has started at the local level, just where you are starting. You must be prepared to accept the time commitment for the highest pageant of the pageant ladder on which you are competing.

Will the pageant be responsible for your care and safety while you are fulfilling the responsibilities of the title? If they do not accept this responsibility, do not enter that pageant. Make sure that the pageant supplies a competent, female adult chaperone to accompany you on all appearances. A male companion alone is not acceptable. If you travel with a male companion, there must also be a suitable female companion. For

WHICH PAGEANT IS RIGHT?

instance, the Minneapolis Aquatennial Queen of the Lakes is often escorted by a male festival official, but he is always joined by his wife or a female festival representative.

The chaperone's job is not to keep you in line, but to serve as an intermediary between you and the public. She can arrange last-minute details and play the "heavy" when time is short and autograph requests are numerous. She can politely terminate your appearance while letting you continue to be gracious to the public at all times. As a traveling companion, she can also make your appearances more fun. It should be remembered that your chaperone is there to help you, but she is not your servant. She should be treated with respect and consideration at all times. Barbara found a life-long friend in her chaperone, Jewel Baxter.

At the national level, full-time traveling companions are provided. Several women may take turns traveling with Miss USA for a period of time. Often at the local level, titleholders' mothers, aunts, or adult friends may serve as chaperones. Polly's Alpha Gamma Delta sorority housemother, Ruth Anderson, served as her Miss Minnesota-USA chaperone. Winning the title allowed Polly to share exciting experiences, like meeting Bob Hope and other celebrities, with a woman who was, and always will be, very special to her.

What will your financial obligations be as a titleholder? Have a firm understanding of the financial responsibilities the pageant organization will assume and which ones you will be expected to bear, i.e., who pays the expenses for an appropriate appearance wardrobe and dry cleaning, makeup, mileage, meals, lodging, thank-you note stationery and postage, etc. You do not want any surprises in this area. At a minimum, make sure that the pageant organization covers both your and your chaperone's traveling expenses (including meals, lodging, and mileage).

Making Your Personal Pageant Choice

When you have all the facts you can possibly gather, you are ready to choose the pageant organization that is right for you.

HERE A PAGEANT

Sit down and make a list of each facet of the pageants you are considering. The decision should be a thoughtful one. Polly looked very carefully at both the Miss USA and Miss America systems before choosing to enter the Miss USA preliminary.

Polly had the unique chance of seeing the Miss USA organization from the inside when Barbara won the Miss USA title. Since Polly had already done well in a national contest that involved a talent category, she knew that she had the option of competing in the Miss America Pageant. The talent requirement was not a deterrent, but neither was it an enhancement as she did not plan to pursue a performing career.

Like Barbara, Polly consciously chose the Miss USA Pageant over the Miss America Pageant. As an international relations major, Polly considered the possibility of competing in the Miss Universe Pageant with women from all over the world to be a real benefit. Also, Miss USA travels more extensively throughout the world than does Miss America, who, except for the USO tour, stays almost exclusively within the United States. It was also important to Polly that the Miss USA organization considers the interview category—the personality, attitudes, and speaking ability evaluation—to be more important than does the Miss America organization. Miss America lumps the interview judging in the same one-third as the evening gown judging. The Miss America judges never hear the contestants speak spontaneously in public. Polly also liked the fact that Miss USA was upfront in calling itself a beauty pageant while Miss America vehemently denies that label. In any pageant, appearance is undeniably important. Finally, Polly considered complete credibility to be essential in the organization with which she would be associated. There are frequent rumors of pageants being rigged. Polly had seen the Miss USA Pageant from within. She knew that whether she won or lost the Miss USA Pageant, it would be on her own merits. For all of these reasons, Polly preferred the Miss USA Pageant.

Should You Enter Again?

A common concern is whether one should re-enter a pageant one has competed in before. Before entering or re-entering any preliminary pageant, check the rules for that pageant sys-

tem. You want to be sure that if you win the preliminary competition you will be eligible to compete at the higher levels.

In most preliminary contests, if you have not previously won the pageant, you have the option of re-entering. If you have previously won a preliminary title which took you to a final pageant, it may be against the rules for that particular pageant for you to compete again under a new preliminary title. For example, one may compete more than once in the Miss Minnesota preliminary for the Miss America Pageant by winning different local preliminaries; however, a contestant cannot compete in the Miss America Pageant as Miss Minnesota and, if she loses, return the next year as Miss North Dakota. You only get one chance to be in the Miss America Pageant. The same is true for the Miss USA Pageant.

Most pageant systems, however, do not have any rule that prohibits one from crossing over to participate in a different pageant. For instance, you may compete as Miss Minnesota-USA in the Miss USA Pageant and then compete as Miss Minnesota, Miss Wisconsin, or any other state titleholder, in the Miss America Pageant. Not only is this allowed, it is very common. For instance, the women who represented North Carolina, South Carolina, the District of Columbia, Mississippi, Tennessee, and Missouri in the 1986 Miss USA Pageant, had competed under different state titles in the Miss America Pageant nine months earlier.

The decision to re-enter a pageant is especially difficult if you have previously placed as runner-up. Returning as last year's runner-up places you in a delicate position. The other contestants are bound to learn that you were a strong contender the previous year. Most of the contestants probably will not treat you any differently, but there may be a few that treat you as the person to beat. If you do re-enter, be prepared for this possibility and do not let it sway your confidence or spoil your enjoyment.

Polly was first runner-up to Miss Teenage Minnesota in 1976. She thought long and hard before re-entering that pageant the next year. There was a good chance that a second panel of judges would view her less favorably or that the new field of contestants would be stronger than the previous year's. Re-entering was a gamble. Polly chose to compete again because

she did not want to risk being haunted by the unanswered question of whether she could have won the second time. Her philosophy was that it was better to try and not win, than not to try at all. For her, the gamble paid off. She won the Miss Teenage Minnesota title in 1977.

Carolyn Mattson is an example of a woman who was willing to work for what she wanted and risk disappointment to achieve it. In 1980, Carolyn was first runner-up to Miss Minnesota-USA. In 1981, she was second runner-up. In 1982, she was named first runner-up. Undaunted, she competed again in 1983 and won the title she sought. By not giving up on her dream, Carolyn was able to experience competing in the Miss USA Pageant.

Only you can decide whether you are willing to risk the disappointment of placing lower than you have in an earlier contest. It is perhaps better to be disappointed, a feeling that time will heal, than to be left forever without an answer as to whether or not you could have won. Many national titleholders have not reached the top on their first trip up the pageant ladder. Many of them have competed in their local or state preliminaries more than once. Having competed in the pageant before may give you the added insight which will make you a winner the next year.

If you decide to re-enter a pageant, remember that judging is very subjective. Keep the judges' decision in perspective. You will be judged by a different panel, one that may be looking for something very different in the winner they select than the previous year's panel. If you happen to place lower than you did before, you should not consider it an embarrassment or a reflection of your personal progress. You should congratulate yourself for having the courage and determination to try again. You may even enter a third time.

Pageants—They Can Get in Your Blood

Many contestants find that pageant competition "gets in their blood." There always seems to be one more pageant to enter, one more title to win. Susan Akins won the title of Miss America 1986 in her 100th pageant competition. Debra Sue Maffet competed in sixteen pageants (winning $10,000 in scholarships)

before she captured the 1982 Miss America crown. Pageant competition can also become a family affair. Several sisters have tried to compete in the same pageant arenas. Many sisters, besides us, have shared a state title and competed in the same national pageant. For example, in 1986, Laura Bach, Miss Illinois-USA 1985 and second runner-up to Miss USA 1985, relinquished her crown to her younger sister, Tricia, who became a semifinalist in the 1986 Miss USA Pageant. Bobbie Johnson, Miss USA 1964, watched her younger sister compete for the Miss USA title in 1967. One Massachusetts family has survived having four sisters compete in, and win, pageants: Lisa Matte was a Miss Massachusetts; Linda Matte represented Massachusetts in the American Beauty and Talent Search, while Lori Matte represented New Hampshire in the same pageant; and Lesli Matte represented Massachusetts in America's Miss Charm contest.

Pageant competition can also cut across generations. More and more daughters are following their mothers into pageant competition. For example, Lori Jo Smith won the 1986 America's Junior Miss Pageant. Her mother had competed in the same pageant years before as Washington's Junior Miss. Paula Lane Muckleroy competed in the Miss America Pageant as Miss Texas 1953. Her daughter, Leigh Ann Medaris, competed in the Miss USA Pageant as Miss Texas-USA 1983. Shannon Curran competed in the 1976 Miss Teenage America Pageant as Miss Teenage Phoenix. Her mother was Jacque Mercer, Miss America 1949. There is even a pageant in which mothers and daughters compete as a team, aptly called the "Mother-Daughter Pageant."

PART II

Pageant Competition

4

Entering a Beauty Pageant

Although many pageants may be operating in your area, it may be difficult to find out how to become a contestant. Try the following avenues:

1. Write directly to the pageant's state director or to the national headquarters to request information. Check the Appendix of this book for a partial listing of the national headquarters for some of the more prominent, well-established pageants.

2. Your local Chamber of Commerce is an excellent source of information about local competition opportunities.

3. Watch the newspapers of your town and of your closest metropolitan area for advertisements. Since pageants are held at different times throughout the country, ads are usually placed in local newspapers to tell you when and where to send for entry forms. Specifically watch the life-style, variety, fashion, and miscellaneous want ads sections.

4. The newspapers of large universities are also good places to check.

5. Try calling a reputable self-improvement school or modeling agency. They are often informed of upcoming pageant competitions.

The Entry Form

You will be asked to fill out a preliminary entry form and include a picture of yourself. This application should be neatly typed. Answer all the questions honestly. If asked for your weight, do not fill in the amount you wish you weighed or

the amount you hope to weigh at the time of the competition. You may also be asked for a certified copy of your birth certificate to prove your age and one of your grade transcript to verify your grade-point average.

Before you send in your application, read the pageant's rules carefully to see if you qualify. The age requirement will vary from pageant to pageant. Most teen pageants will require that you be under eighteen years of age when you attend the national pageant. You also must be over thirteen years old. (If you are this young wait for a few more years—your chances of winning are greater when you are 16–18 years old.) Some pageants will require that you still be in high school. America's Junior Miss is only open to high school seniors.

Once you reach 18, you will qualify for adult pageants. Again, you may not want to enter immediately upon reaching the minimum age. Your chances increase as you reach the middle qualifying age (usually 20–22), and then start decreasing as you reach the maximum age (usually 25–26).

Some pageants limit the number of participants each year. You may have an initial telephone screening interview conducted by a pageant staff member. Not all pageants follow this procedure. Miss National Teenager, Miss Teenage America, and some Miss USA preliminaries have been known to use telephone interviews.

If you are selected to compete in the pageant, you will have to complete a more thorough questionnaire. This will be used by the judges when interviewing you and by the pageant emcee when interviewing you onstage. A sample biographical questionnaire can be found in the Appendix.

Your Photograph

Usually the pageant will specify whether or not to submit a black-and-white or a color photograph and the size requirement. The photograph must have been taken recently (within three to six months). If you have made a significant change in your appearance, such as a change in hairstyle or a noticeable weight loss, have a new photograph taken.

For most local and state teen pageants, a standard school

ENTERING A BEAUTY PAGEANT

photograph, such as a senior picture, is sufficient. A photograph showing a happy, pleasant face should be used, not one with a serious or high-fashion modeling look. Do not spend a fortune getting modeling-type pictures taken just for the pageant. While the national competition will probably require high-quality eight-by-ten-inch photographs, in black-and-white and in color, the state pageant sponsor should pay for these.

Remember, the photograph you send will be the first impression made on the selection committee, and later on the judges will refer to this photograph in making their selection. It is, therefore, important to have a good head shot that reflects you at your best. Choose a photograph that shows your face straight on or in a three-quarter view. Do not use a profile shot. Do not wear any unusual hair ornaments, a hat, or obviously heavy makeup. Use a photograph in which your smile shows softly at your mouth and sparkles in your eyes.

Pick your outfit carefully. You can never go wrong with simplicity. Wear simple jewelry, if any. Pay close attention to your neckline. Consider where your outfit will be cut off from the picture. While most photographers will tell you to avoid totally white outfits, a white collar on a brightly colored top may frame your face well if you have very dark hair. Do not wear black near your face. Never use a dark background as it will not reprint well for the pageant program booklet and newspapers. Also, avoid cloud backgrounds.

Sponsors

If you are accepted as a contestant, your first requirement, in almost all pageants, is to find a sponsor or sponsors. Producing a pageant is expensive and, in most cases, is run on a profit basis. Some local competitions may be part of a community celebration and, thus, are nonprofit, but they still will usually require you to have a sponsor. In some cases, the pageant may already have sponsors lined up who will be assigned to contestants, but this system is rare.

The sponsorship fee will cover your expenses as a contestant. These expenses include the pageant organization's costs of housing and feeding you during the pageant weekend, and a

pro rata share of the cost of the actual pageant production (i.e., auditorium rental, sound equipment, entertainers' talent fees, printing costs, etc.). The sponsorship fees, and the money raised by selling pageant admission tickets and advertising in the souvenir program, cover pageant expenses, including scholarships, and may include a profit if the pageant organization is for profit.

The sponsorship fee will vary depending on the level of the pageant and on the part of the country in which you are competing. The fee can run from around fifty dollars up to several hundreds of dollars. If the pageant is not well established and well known and requires an exorbitant sponsorship fee, be wary of entering it. It may be run by someone merely looking for a quick profit.

You should never have to pay the sponsorship fee out of your own pocket. In most pageants, separate sponsors are mandatory, so you will not be allowed to sponsor yourself. You must find a business or community organization that will sponsor you as a contestant.

Finding a Sponsor

The pageant headquarters should send you information and ideas on how to begin lining up sponsors. You can get a head start on this step by making a list of the people you know who are in the business world. These individuals can serve as contacts within their companies. Pageant sponsorship can be a form of advertising and community relations for any sponsor since the name of the sponsoring individual or corporation is listed in the pageant program booklet and, perhaps, in the media if you win.

If you run out of personal contacts, you will have to make cold calls on businesses. This is a business proposition. Handle the transaction step by step.

1. Make an appointment to meet in-person with the advertising or community relations contact for the company.

2. Dress appropriately for the meeting in a business suit or tailored dress. (Your prospective sponsor is your first pageant judge so dress with the same care you would take in

dressing for your pageant interview. Pay attention to every detail of your appearance.)

3. Arrive at your meeting promptly. In the business world, time is money. Do not waste your prospective sponsor's time.

4. Come armed with a professional-looking résumé that clearly presents your major accomplishments.

5. Be prepared to answer questions about why you want to enter the pageant.

6. Be ready to tell this particular company why it should want to sponsor you. (This will be easier if you call on businesses whose products or services have some natural connection with pageants.)

While construction companies have been known to be sponsors, it is usually easier to enlist the support of a clothing or jewelry store. Service providers are also good prospects. You could try restaurants, beauty salons, law firms, and so forth. Civic organizations such as the Exchange Club or Lion's Club also may be willing to sponsor a contestant, especially if the pageant and the club support a common charity. Avoid using any type of liquor establishment as it will not go well with the image you want to create.

When the pageant is over, whether you win or lose, do not forget to write your sponsor a thank-you note. You might also send them a copy of the program booklet which lists their name. Remember, it is your sponsor that made your pageant experience possible. If you deal with them in a professional manner, they also may be willing to sponsor you in the future should you decide to compete again.

Do You Need a Coach?

You have passed the biggest hurdles. You have decided to enter and have turned in all your forms and documents, and you have found a sponsor. Now you have to go about winning the crown.

One of the questions we are most frequently asked by women

who have decided to compete is, "Do I need help?" Some contestants turn to professional coaches. Most do not. The professional advice and critical appraisal can be helpful—up to a point.

What if you live in areas where professional coaches are not available? Or if professional training is out of reach for you financially? Don't give up on your dream. You can win without having the most expensive or extensive wardrobe, and you can win without a coach.

Barbara is a good example of a woman who entered her state pageant and went on to win the Miss USA title without extensive coaching. She knew what she wanted and she went after it on her own. Barbara's training secrets were simple—daily self-discipline and a positive mental attitude.

Coaches certainly can be helpful in giving pointers on such things as how to walk the runway, sit properly, and apply makeup correctly. They can help you design an exercise program and suggest reading material. They can share their knowledge and experience and give you helpful insight from another person's point of view.

There are a wide variety of coaches. Many, but not all, run self-improvement and modeling agencies. Joe Rinelli is a stockbroker who spends his spare time coaching young women. He found and coached Lisa Allred, Miss Texas-USA and first runner-up to Miss USA in 1982. In 1983, he worked with twenty-eight of the Miss Texas-USA contestants. Rinelli is careful to meet the parents of the women he works with and to keep his involvement above board.

Briggs and Pat Hopson serve as the volunteer "pageant couple" for Miss Mississippi. They take the new state titleholder into their home to groom her for the Miss America competition. They supervise a training schedule that starts at 6:30 every morning and consists of watching news shows, exercising, shopping for a pageant wardrobe, making public appearances, practicing pageant walks, and rehearsing the talent routines on various local high school stages. The fact that coaches can sometimes be helpful is demonstrated by the Hopsons' record, which includes a series of four consecutive top ten finalists. They also helped Cheryl Prewitt, Miss America 1979, and Susan Akins, Miss America 1986, win their crowns.

ENTERING A BEAUTY PAGEANT

If you are approached by anyone who claims to be a pageant coach, modeling agent, or photographer, proceed very cautiously. Do not give out your name or telephone number. Ask him or her for a business card and then investigate to see if the person is who or what he or she claims to be. Find out what kind of expertise the coach can offer you and what is expected in return. The story of young women being taken in by such offers made by unethical people is far too common. Be careful!

Coaching can take various forms. Some state contestants meet with their coaches privately or in a class for a few hours a week. Some state winners move in with their coaches for twenty-four-hour-a-day training. In some of these cases, the women do not make a move or take a bite of food without the approval of their coaches. This situation is extreme and can be harmful to some women, both as contestants and as private individuals.

Perhaps the most extreme example of the potentially harmful effects of coaching involved Miss Illinois 1979, Shanna McNeill. Within a few weeks of undergoing coaching, the pressure seemed to overwhelm her. Shanna smashed her fist through a plate glass door. Her hand was severely injured. Because her talent was playing the piano, Shanna's injury prevented her from competing in the Miss America Pageant. Because she was unable to fulfill her competition duties, the crown was taken away from her and the first runner-up went to Atlantic City.

There is a limit to what coaches can and should do. They cannot make you someone you are not. You must be yourself during and after the pageant, so do not let them try to mold you into someone you are not. Remember that coaches cannot help you unless you are ready and willing to put in the effort to improve. Only you can motivate and prepare yourself mentally. You must remain in control of your pageant enterprise. No coach can send you to the pageant to win—you have to do that yourself.

Judges are turned off by women who appear to be overcoached. These are the contestants who obviously do everything by the numbers. The woman who wins will also do everything right. The difference is that she will have the essential ability to make it look natural—that is because by the time she appears

before the judges, the right moves have become a natural part of her style. The judges will not feel that she is putting on an act for them because she will not be acting.

Make Yourself a Pageant Winner

The making of a pageant winner really starts long before you ever enter a competition. It has a lot to do with your motivation and how you see yourself. Even so, much personal growth can be stimulated in the months immediately preceding the competition. This development, however, has to be generated within you. A professional coach may be able to help you improve your outward appearance, but you have to do the major inside construction work. This preparation phase requires great dedication and physical and mental work. Are you serious about the challenge before you? Are you ready to go to work? Are you prepared to work harder for this goal than you have for any other?

Adjusting Your Attitude

The key to winning any pageant, whether local or international, is creating and maintaining a winning attitude. This may sound simplistic, but it is crucial, and often overlooked. Thus, the first step in your training must be to understand and adopt the following attitudes:

1. To win the title, you have to want the title. You have to *really* want it. A strong level of desire will enable you to pursue the goal with the essential dedication and enthusiasm. You have to be willing to forgo less important things in your life to obtain the greater goal.

Sacrificing less important things first requires that you know your priorities and how much things are really worth to you. Is winning a title more important than tasting that piece of chocolate, skipping your exercise routine for one day, or staying up late to watch that old repeat late movie? Winning a pageant title is certainly *not* worth damaging family relationships, stepping on other people, compromising personal values, mortgag-

ing the house, or permanently forgoing your education (it may be worth postponing it).

If you will do absolutely anything to win—including sabotaging other contestants' chances—you will never be a winner. A true winner prepares everything reasonably and fairly in her power to reach the goal without hurting other people in the process. She will not use such rumored pageant tactics as stepping on another contestant's dress hoping to tear it, or smearing lipstick on someone else's costume. She will be like Lisa Lynn Moss, Miss Louisiana-USA 1981, who readily lent her electric curlers to a sister contestant whose curlers went on the fritz thirty minutes before the preliminary judging.

A winner plays the game within the bounds of fair competition. Miss USA contestants specifically agree to abide by this ideal of fairness by adopting the Miss USA Creed, which states:

> We, representing the people of the United States in the Miss USA Pageant, in order to further the cause of peace, justice and mutual understanding, do solemnly dedicate ourselves to the highest ideals of sportsmanship, friendship, and good will among all the people of the United States and the Universe.

2. Besides wanting to win, you have to believe you can win. The act of entering a pageant is in essence a statement of your belief that you can win. Every contestant has a chance of winning. Since you will have fully prepared for the competition, your chances are probably much better than most of the contestants.

Just as you will be exercising to develop your body, you must also develop your mind. Read Dr. Norman Vincent Peale's books *The Power of Positive Thinking* and *Imaging*. Periodically throughout the day, imagine the result you desire, the crown being placed on your head. This process helps you to keep your goal in focus as you prepare to reach it.

One of the greatest pieces of encouragement and motivation that Barbara gave Polly in her competitions was derived from a children's book. When Polly checked into her hotel for the Minneapolis Aquatennial Queen of the Lakes Contest, she found a small flat package waiting for her. Inside was a book written by Watty Piper, titled *The Little Engine That Could.*

PAGEANT COMPETITION

This book tells the story of a tiny train that pulled an incredible load over a mountain simply by repeating to itself, "I think I can. I think I can." In your quest to reach your pageant mountaintop, just keep reminding yourself of that little train. You have prepared thoroughly, and know that you can do it.

3. If you appear conceited instead of confident, you will not win. The belief that you can win is called "confidence." There is a very fine line separating confidence and conceit. Confidence is the healthy belief that you are capable of winning. Conceit crosses the line to become the belief that it is inconceivable that you may lose.

The paradox in preparing mentally for a pageant is that you have to go in thinking like a winner, but prepared to be an "also ran" (i.e., "a loser"). You must realize that even with the fullest preparation you may not win the crown. Remember that only one of the contestants will win the crown. Invariably many of the contestants could make a satisfactory queen, if given the opportunity, but the judges have to select *one*. A different panel of judges may pick a different winner. The judges' decision is often so close that even the same panel of judges, if deciding on a different day, would choose a different winner.

4. Keep the pageant in perspective. Competing in pageants can be a wonderful learning experience and lots of fun. Winning the title can be a personally and financially rewarding achievement. A pageant title is a valuable goal for which to strive. Remember, however, that in the larger scheme of life, pageants are only one of many experiences you will have. Pageants should be one step in a lifetime of striving. They are not the end goal.

Remember, too, there are no guarantees in pageant competition. The closest thing to a guarantee is that you will not win unless you (1) enter the pageant, (2) really want the title, and (3) are prepared for the competition.

Be Your Own Coach

Let the next twelve chapters function as your own personal coaching guide. These chapters should be used as tools for

ENTERING A BEAUTY PAGEANT

personal development, as well as for pageant preparation. They can be the difference between your being a first runner-up or the winner. The information can be applied with some adjustments to any local, state, or national pageant.

How much this information helps you in your pageant quest, your career, or your personal growth will depend on how dedicated you are and how seriously you apply the information. If you are going to enter a pageant, go in so fully prepared that, whatever the outcome, you will never have to look back and say, "If only I had lost ten more pounds," "If only I had practiced harder," "If only I had been more fully prepared." Prepare yourself now. You only get one first impression, and that is the impression that counts with the judges.

5

The Judging

As you begin your pageant preparation, remember that each step of your program must be geared toward the judges. To tailor your program, you must have a thorough understanding of the judging process and what the judges are looking for in the winner. Find out as much as you can about who the judges are and what procedure is followed. If the pageant materials do not give you enough information, talk to a former contestant, a past winner, the state director, or a past judge for that particular contest. Ask for specifics on the judging criteria, the interview procedure, and what the judges' qualifications are (they are usually more qualified at the local levels where the emphasis is not on securing celebrity judges).

The Judging Procedure

There are almost as many different judging procedures as there are pageants. The procedure used will depend on the level of competition, the number of candidates, and the categories to be judged. To give you an idea of some of the procedures used, let's look at a few possible systems.

The Miss USA System

The judging panel always has an odd number of judges, usually nine or eleven. The judges only see the contestants at designated judging times. The first event is the Presentation Show (also called the Preliminary Judging). The contestants are first seen, but not judged, in their state costumes. (Miss America contestants do not have state costumes.) They then walk the

THE JUDGING

runway for the judges in their evening gowns. After seeing each contestant, the judges electronically lock her scores in a computer terminal. The scores can range from 1.0 to 9.9. The same procedure is followed after each contestant walks the runway in her swimsuit.

The Miss America system differs from that of Miss USA in that preliminary judging takes place at three shows. One-third of the contestants compete in evening gown, another one-third in swimsuit, and the final one-third in talent. The groups rotate for the next two judging nights. Preliminary talent and swimsuit winners are announced each night. The Miss USA Pageant does not announce winners of any individual judging category. It does announce the winners of the best state costume and Miss Photogenic awards prior to the telecast; however, neither of these categories affects the selection of Miss USA.

Later in the week, the Miss USA judges meet one-on-one with each contestant for seven minutes. If there are eleven judges, the contestants will be interviewed for a total of seventy-seven minutes. The one-on-one interviews mean that each judge will hear a different interview than that heard by the others. Each judge has a chance to ask seven minutes' worth of questions to elicit information that he or she considers important in selecting a queen. The judges will not know what the other judges are asking or how the contestant has answered those questions. The Miss America contestants, in contrast, are interviewed for a total of seven minutes by a collective panel of judges, thus answering fewer questions, the answers to all of which are heard by the judges. Until 1970, Miss America contestants were interviewed by the judging panel in groups of three contestants.

The Miss USA interviews are conducted over a two-night period—half the contestants are interviewed one night, and half the next. The contestants enter a large room in groups that number the same as the number of judges (i.e., if there are eleven judges, eleven contestants will enter the interview room at one time). Each one sits at a separate table opposite one judge. At the end of each interview, the contestants rotate around the room until they have spoken with each judge individually. At the completion of each timed interview, the judge signs a sheet with a picture of each judge on it. This sheet

PAGEANT COMPETITION

proves that the contestant has spoken with each judge and also serves as a special souvenir for the contestant. This memento carries autographs of nine or eleven celebrities whose undivided attention she has had for seven minutes, and with whom she now feels a special bond.

The interview scores are recorded on paper and later fed into the computer. The three preliminary scores are tabulated electronically and averaged by the number of participating judges. The twelve contestants with the highest average scores will be announced as semifinalists on the live telecast. (Miss America names ten finalists.) The difference between a semifinalist's and a nonsemifinalist's score may be a hundredth of a point. Realizing this will help you keep the outcome in perspective. Judging is very subjective and usually very close.

Once the semifinalists are named, their scores are canceled. Each one now starts from zero. It is possible for a contestant to be twelfth going into the semifinals, and to come out the winner. This is possible in theory, but is unlikely to happen since the judges usually narrow down their favorites early in the competition and loyally vote for them throughout the competition.

The final judging consists of electronically voting for each semifinalist in three categories—the on-stage interview, swimsuit, and evening gown. Again, the scores range from 1.0 to 9.9. If there is a tie, a tie-breaking vote is taken by paper ballot. The judges are given only the names of the tied contestants, not the position which is tied. No one in the auditorium, including the judges, knows the contestants' composite scores, but the home audience sees them on the television screen. (Miss America does not reveal any scores.)

The five highest point scorers are the finalists. (Miss America no longer reduces the field to five, but chooses the runners-up and the winner directly from the original ten finalists.) After the five finalists are named, the judges rank them in their preferred order. It is the first time they actually vote for who they want to be Miss USA. As each contestant is brought to a certain spot on stage, the judges must specify in the computer what rank she should be given. Points are assigned for the order of preference.

THE JUDGING

Winner	Five points
First runner-up	Two points
Second runner-up	One point
Third runner-up	One-half point
Fourth runner-up	Zero points

It is very unlikely that anyone would win the title without receiving a single first-place vote.

The judges never officially confer with each other about their individual opinions on the contestants. The pageant's goal is to have a winner picked by a composite score, not a consensus score. Panel discussions are discouraged, but as the judges socialize during the week, they are apt to discuss their evaluations. Names of particular contestants may not be used in the early discussions, but identities are likely to be discernible as the judging progresses.

Teen Pageants

While Miss Teen USA follows the Miss USA system, the other teen pageants use many different systems, as well as judging criteria. The preliminary judging may be conducted by several different judging panels. Scholastic and service records may be assessed by one panel. Interviews may be held in front of another panel (or several others). Talent may be judged by even another group. The semifinalists are selected by these various panels.

If the contestants have not yet met with the final judging panel, the semifinalists may be selected prior to the telecast. They then meet extensively with the final judging panel. The Miss Teenage America Pageant used this system when Polly competed in it. (The pageant has since been purchased by *'Teen* magazine and finalists are now picked by written questionnaires.) Polly was named as one of the eight semifinalists on a Thursday morning (Thanksgiving Day). The announcement was taped and shown as part of the telecast. From Thursday until the final pageant on Saturday, the semifinalists met with the judges, both one-on-one and in groups, whenever they

PAGEANT COMPETITION

were not on stage rehearsing (this included being judged during Thanksgiving dinner). The judges also watched the semifinalists as they rehearsed. This system was rare among national pageants and is even more rare today. Most teen pageants follow the more traditional method of announcing the semifinalists on stage. Teen pageants also use the point system to choose a composite winner.

A contestant at a national teen pageant may represent her state, a smaller designated area (resulting in more than one contestant from some states), an overseas category, or be selected at large if there is not a preliminary pageant in her area. To facilitate judging at the state level contestants may be divided into three groups with a designated number of semifinalists being selected from each group. If one group has more strong candidates than its allotted number of semifinalists, some strong contestants may not be named as semifinalists, but the ultimate selection of the winner is not greatly affected by this division of contestants. The strongest contestant will usually rise to the top.

Local Pageants

Small-town festivals and organizations are more likely to pick a consensus winner. This means that the point system is not used in the final decision. Instead, the judges discuss their impressions of the contestants. A consensus decision is reached. To agree on a winner, judges often have to compromise their own choice of who should win.

Local pageants may interview contestants by a panel or a one-on-one system. They also may give the judges greater access to the contestants, allowing them to eat meals with the contestants or watch them rehearse. The judging often includes observing the contestants in a parade or fashion show.

The Minneapolis Aquatennial is an example of a very thorough judging system. The contestants meet the judges late in the competition in a one-on-one interview similar to that used by the Miss USA Pageant. The contestants do not know who the judges are until they enter the interview room. Prior to the interviews, the judges attend luncheons, parades, and a fashion show with the contestants, but since many other people

are there, the contestants do not know who the judges are. This system allows the judges to watch how the contestants react in public. They can talk to the contestants without the contestants realizing that they are meeting with a judge. This guards against the selection of a winner who "turns on" for the judges and "turns off" for everyone else.

What the Judges Look For

In 1979, George Miller and Chipei Tseng of Northern Illinois University studied the statistics of the Miss America Pageant to put together a composite of the ideal Miss America. The composite indicated that Miss America was most likely to be 20½ years old, a tall brunette with green eyes, born in April. Her waist would measure twelve inches smaller than her bust and hips. She would have a plain name, play the piano or sing, and live in a small town in California. If the judges were looking only for this contestant, they would have difficulty finding her. Contestants do not easily fit a mold.

Contestants will differ widely, but there are certain traits that are required to be a winner. The winner must be intelligent with a high awareness of the world around her. She must have self-confidence, poise and personality, good eye contact, appropriate makeup and hairstyle, a well-proportioned figure, good carriage, and strong interview and speaking skills, including a broad vocabulary, good grammar, and a pleasant speaking voice. She will need to be patient, sympathetic, and considerate. She must have physical stamina, and like people and new places. In other words, Miss Somebody must have the personality of the girl next door, the forensic skills of a member of Congress, and the shape of a model. She is demure, but has well-considered opinions. She is pretty, but not overly glamorous or overtly sexy. She is also herself at all times.

Pageants do not want their titleholders to be copies of each other. They are looking for individuals. Shawn Weatherly took the Miss USA judges and then the Miss Universe judges by storm in 1980. She was an overwhelming favorite. The next year, Miss Hawaii arrived at the Miss USA Pageant looking like Shawn's twin sister. Everybody noticed the similarity. How

PAGEANT COMPETITION

much of it was natural and how much was a studied recreation of Shawn's success was unclear. While Shawn was loved for her look and warm personality, her "twin" was not greeted with equal success. She did place as fourth runner-up, but she did not win. The similarity to the previous winner may have helped gain her some attention, but it undoubtedly hurt her in the end.

Remember, do not try to copy a previous winner. It is all right to study the traits of people you admire and apply what you can to develop your own style. Consider what is right for you. You want to impress the judges, but, more important, you must satisfy yourself and make yourself proud. As an Aquatennial Queen of the Lakes contestant, Barbara received some memorable advice from Maureen Wagner, a former Aquatennial Queen. Maureen told the contestants, "Don't be someone you're not because if you should win being someone else, you really will have lost. It will not be you who has won, but rather a fake." Magnify those things within you that are special and unique.

The judges take their responsibilities very seriously. After judging the 1976 Miss USA Pageant, Ernest Borgnine said,

> When I agreed to judge, I thought it would be an interesting and fun experience. It is interesting, but suddenly I realized I was about to change the life of an individual. That's an enormous responsibility.

This is not an understatement. The judges' decision will change the course of the winner's life, and perhaps those of her runners-up. Since the runners-up are in direct line of succession, they must also possess the attributes of the winner and be selected with care. The judging task is extremely difficult because beauty is highly subjective, but a decision has to be made. The judges must look to factors other than beauty to pick a winner.

The duties and responsibilities of the winner are carefully explained to the judges so they will appreciate the impact of their decision. This briefing also informs them of what qualities a winner should possess. The Miss USA briefing includes the following general guidelines:

THE JUDGING

1. Do not be influenced by applause, demonstrations, or political considerations.

2. There may be a tendency to vote for a contestant because she is of the same ethnic or general background as you, or from your state. Please do not let these factors influence your selection.

3. A beautiful woman should be considered on the basis of her total beauty, not only one particular feature.

4. Judging is based on beauty of face, beauty of figure, poise, and personality. Poise is an essential of beauty.

5. A contestant's grace, or lack of it, in walking, should be carefully observed. Her movements, head, arms, and legs should be noted.

6. Miss USA should possess a high degree of intelligence.

The judges are carefully instructed on the judging procedure and the criteria. The formal judging categories and the weights given to each category vary from pageant to pageant. The categories and weights for some are as follows:

MISS USA AND MISS UNIVERSE
swimsuit (one-third)

evening gown (one-third)

poise and personality (one-third)

MISS AMERICA
swimsuit (25 percent)

evening gown and interview (25 percent combined)

performing talent (50 percent)

AMERICA'S JUNIOR MISS
physical fitness (15 percent)

scholastic achievement (15 percent)

poise and appearance (15 percent)

creative and performing talent (20 percent)

interview (35 percent)

PAGEANT COMPETITION

MISS TEEN OF AMERICA
interview (25 percent)

service and achievement to one's school and community (15 percent)

scholastic record (15 percent)

personal development of talents, abilities, and interests (15 percent)

general awareness (a written test) (15 percent)

teen image/poise and appearance in formal wear (15 percent)

While judging the formal categories, judges at any level of competition look for some general qualities. As the judges view each candidate they must ask themselves:

1. Is she a potential Miss Somebody?

2. If the winner goes on to compete at another level, can this candidate be a potential winner at that higher level?

3. Will she be a good representative of her organization, city, state, or country? Is she a good public relations emissary?

4. Is she capable of handling the duties and assignments required of the titleholder?

In some respects, the judges do not select the winner. The contestant who wins is the woman who has performed at a consistently high level. The contestants are presented to the judges so quickly, one after another, that the judges tend to notice what a contestant has done wrong, rather than what she has done right. Contestants, in effect, eliminate themselves from the competition. Eventually the winner rises to the top, emerging from the flock of contestants to stand out on her own. The judges are merely there to recognize the winner.

The Scholastic and Service Competition

These categories are only found in teen pageants. For the service competition, the contestant fills out an extensive questionnaire about her school and community involvement (including church or synagogue). A screening panel or members of the

THE JUDGING

pageant staff will evaluate the extent and years of participation and honors received, and assign a score for this category which will later be factored into the judges' final score.

A grade transcript is often required in teen pageants. A contestant's grade-point average, class size and rank, and significant test scores may be considered. Attention may be given to the specific classes taken and their relative difficulty.

Some contests judge a contestant's awareness as part of the interview category, but in some contests a written test may be given. These tests may be the most challenging portion of the judging. Chapter 6 describes the written tests in more detail.

The Interview Competition

While the Miss USA Pageant holds one-on-one interviews, Miss America uses the panel interview. The state preliminary competitions will normally follow the same system as their particular national pageant. Other festival or organization pageants may use either the one-on-one interview procedure or the panel interview procedure. Find out which one is used in the pageant you enter. The pageant, however, may not tell you exactly what to expect so that judges can determine how well you handle unexpected situations. For instance, Minneapolis Aquatennial contestants are called into a final interview in which they are asked to present the judges with an impromptu speech to an imaginary group. If you cannot find out which interview format will be used, be prepared for either format.

If a panel is used, don't let it intimidate you. There may be five or even nine judges and only one of you, but you have to be the one in control. Here are some tips on how to appear in control:

- Remember, the judges are there because they want to meet you.
- Speak to the judges in a friendly, conversational way.
- Make periodic eye contact with each of the judges.
- When one judge asks you a question, look at that judge while you listen to and start to answer the question, but then shift your eyes to make contact with various members of the panel, including them in your answer.

PAGEANT COMPETITION

- Make sure your eyes are not constantly flitting from one judge to another, and do not move right down the line making contact.
- Try to behave as you would when conversing in a comfortable, but semiformal social setting (for example, a dinner table).

The length of the interview also varies with the pageant. Miss USA contestants are usually interviewed for seventy-seven minutes (eleven seven-minute interviews). Contestants for the title of America's Junior Miss are interviewed for ten minutes. Miss America contestants are interviewed for seven minutes. As judges, Barbara and Polly have learned that they can discern an amazing amount in a three-to-seven-minute interview.

Scores in this category will be based on your overall appearance, posture, grooming, personality, intelligence, and sincerity. The judges will be listening and observing your attitude, clarity of expression and verbal command, friendliness, maturity, composure, perception, and sense of values. An overall public relations ability is crucial. They will consider your makeup, hairstyle, and attire. Do you look natural, not overdone? Is your appearance appropriate for someone your age (this is especially important in teen pageants) and for this particular setting?

The Swimsuit Competition

The judges will consider your overall figure. If you do not have a large bust measurement, do not let it sap your self-confidence. You do not need to be "well-endowed" to win. If any particular feature will make or break your chances in this category it is your legs. Contestants with well-toned legs do well in this category.

Confidence and good carriage are essential. Frank Sweeney, a longtime Miss USA official, has stated that in the swimsuit competition a contestant must be "as natural as she can be in an unnatural setting." Contestants can lose many points in this category if a lack of self-confidence is apparent in their walk and if they do not make eye-contact with the judges and the

THE JUDGING

audience. Your movements must be graceful and assured. You must project a healthy, active, and confident image.

The Talent Competition

Any ability, hobby, or interest that you have pursued or developed can be creatively presented as a pageant talent. You do not necessarily need a performing talent. If the winner must perform her talent throughout her reign, as does Miss America, a "transportable" talent (i.e., singing or playing the piano versus a trampoline act) may have an advantage (but trampoline acts can and have won). For further talent suggestions, refer to chapter 7.

Your presentation must be entertaining. This category should reveal a special aspect of your personality. Whatever you do, you must look good. Your costume must be appropriate for your talent, but also flattering to you. Your expression throughout the performance must be lively and confident. The judges will enjoy your talent more, and give you additional points, if you appear to be enjoying yourself.

The Evening Gown Competition

Grace and carriage are again essential. You will be judged on your personality projection, poise, and naturalness. The image must be that of grace, elegance, and class. Remember, the judges are looking for a queen—a lady.

The dress you select will be considered a reflection of your taste. It should be a beautiful addition to yourself in terms of its design, color, and fabric. (The cost of the gown is not considered by the judges.) The dress must be appropriate for your age category. If you are in a teen pageant, avoid tight-fitting sequined dresses; if you are in an adult pageant, do not wear youthful ruffles.

The Judges' Personal Criteria

Every pageant has official judging criteria. Every pageant judge has his or her own unofficial judging criteria. Judges come to their position with their own ideas of what a queen should be

PAGEANT COMPETITION

like. They too have watched pageants on television. As "armchair" judges, they have probably been exasperated when the television judging panel did not pick their favorite contestant. Now they have the opportunity to find the queen that they personally like. They bring to their judging their own tastes and biases. They may be looking for general or specific qualities. Some of the Miss USA judges for Polly's year articulated their own criteria as follows:

Wesley Eure (actor on "Days of Our Lives") was looking for a contestant who "has spark and makes [him] go crazy."

Jim Fowler (animal expert on "Wild Kingdom") wanted the winner to have a "natural quality," and to be "a genuine person."

Joey Adams (author) sought someone "sexy and romantic."

John Mack Carter (editor of *Good Housekeeping* magazine) wanted Miss USA to reflect "American womanhood in a contemporary vein."

Dwight Clark (professional football player) thought Miss USA must be a woman of "sound mind who can handle a year of abuse (traveling thousands of miles and meeting thousands of people)."

Gary Graffman (international concert pianist) was looking for "a certain charisma" (and he thought he had found it the night of the preliminary judging, even before the interviews).

Patrice Munsel (opera singer) said Miss USA must have "the ability to field questions—and then there's that glow that comes through."

Freda Payne (singer) sought "a young lady with self-confidence, class, and dignity, with a strong family and religious foundation."

Be aware that a judge may be looking for a specific trait, one that you cannot predict. Since you cannot prepare for the unknown, do not worry about it. The general attributes that some judges look for are more important and will be shared

THE JUDGING

by several different judges. These traits will help you understand the importance of the composite image and what that image is—the image of a lady. It cannot be stressed enough that a beauty queen (and queen contestants) must at all times behave like a lady.

Who Are the Judges?

Judges are drawn from all walks of life. They usually are not paid for their time but are treated very well. For instance, national judges may spend a week at a lovely resort, enjoying the sun, sand, and luscious food. Judging a national pageant may be considered an expense-free working vacation—with the emphasis on work. Judges give a large chunk of time and personal commitment to the judging process.

You will probably not be able to find out who will be serving on the judging panel for your year prior to the pageant's commencement. Once you get to the pageant, you may receive an advance copy of the program booklet, which will list each judge along with a short biography. Read those biographies very carefully to learn what each judge's background and interests are. If there is time, try to do further research on the person. In a local contest, the judges may be leading citizens from the community. You may already know a great deal about those persons. In a national pageant, the judges may be famous people whose names you know immediately. Other judges may not have a lot of name recognition, but they will be outstanding in their fields. It is not essential, but you may want to ask a friend or family member (you will not have the time or access) to go to the library and check the periodical files for articles on the judge. Learning that a judge likes to grow tomatoes or hang glide may come in handy when talking to that judge.

While you may not know which judges will be serving on your specific panel, it is helpful to know what type of person may be on the judging panel. In local and state contests the judges are often past members of the contest-planning committee, the mayor or the mayor's spouse, an officer of a significant local business, a past queen of your festival or one nearby, the heads of modeling agencies, hairdressers, or a representa-

PAGEANT COMPETITION

tive from a charitable organization. Most national judging panels are composed of a mixture of actors, musicians, modeling agency executives, past titleholders, writers or magazine editors, athletes, and businesspersons. Sometimes the panel will include an astronaut or a government official. The Miss Teenage America Pageant judging panel used to be composed solely of past winners, except for the chairman, who was a representative from an encyclopedia company. America's Junior Miss is now judged solely by past winners. Below are representative judging panels from several pageants.

Miss USA 1980. Anita Gillette, Tony-award-winning actress; Rosemary Rogers, romance writer; Uri Geller, renowned for his powers of telepathy and psychokinesis; Adam West, actor (best known as Batman); Bob Kane, television writer and comic animator; Peter Max, artist; Joan Prather, actress; Gerald Fitzgerald, operatic writer, photographer, and historian; Judi Andersen, Miss USA 1978 from Hawaii; Richard Kline, actor; Roseanne Veal, model and actress; Lloyd Haynes, television producer and actor. There is no bias in choosing Miss USA judges other than to have many areas represented by outstanding personalities.

Miss Universe 1983. Lewis Collins, British actor and former rock star; Irene Saez, Miss Universe 1981 from Venezuela; Rocio Jurado, a Spanish singer; Ruby Keeler, musical/comedy star; Stan Musial, baseball star; Ken Norton, boxer; Patricia Nearby, Director of the Zurich Ballet; Rosemary Rogers, romance writer. In this international competition there is an emphasis on creating an international mix of judges.

Miss American 1987. Dody Goodman, actress; Theodore Bikel, actor; Dr. Bernard J. Dobroski, conductor, author, and educator; Shirley Cothran Barret, Miss America 1975, currently a television hostess; Sam Haskell, a representative of the William Morris Agency; Liliane Montevecchi, a prima ballerina; Bernard A. Maguire, Associate Director of Civil Readiness; and Deedee Wood, choreographer. The Miss America Pageant leans toward judges who are connected with performing talents since the talent competition accounts for 50 percent of the score.

THE JUDGING

Barbara's judging panel for Miss USA 1976 was composed of the following individuals: Ernest Borgnine, actor; Barry Farber, syndicated radio personality; Alice Faye, musical performer on stage and screen; Maggie Daly, journalist and lecturer; Derek Sanderson, professional hockey player; Sue Downey Olson, Miss USA 1965 and second runner-up to Miss Universe; Zoltan Rendessy, owner of the Zoli Modeling Agency; Mr. Blackwell, fashion designer; Claudia McNeil, singer; Richard Adler, producer, composer, and lyricist; and Melanie Kahane, interior and industrial designer.

PART III

Preparing for Pageant Competition

6

Interview and Awareness Preparation

Social Awareness Testing

The titleholder will represent the pageant in the coming year. It is essential that she make a great impression, not just visually, but verbally. She must be able to respond intelligently and articulately to questions about the world, its people, current events and issues, and above all, she must have common sense.

Judging this awareness can be done formally and informally. In all pageant interviews the judges will ask you questions that touch on world or community issues and personalities. This will test both your awareness and your communication skills. In some teen pageants, awareness is also judged as a separate category that is formally judged by means of a written test.

The written awareness test was first introduced by the Miss Teenage America Pageant when it was owned by the Dr. Pepper soft drink company (it is now owned by *'Teen* magazine), and has since been adopted by other pageants. The original Miss Teenage America test, which represented 35 percent of the contestant's final score, was designed each year by the World Book Encyclopedia Company and covered almost every topic imaginable. Pageants that currently use awareness tests draft similar tests. The written tests are not meant to measure intelligence or academic achievement. They seek to measure a contestant's familiarity with international personalities, current happenings in politics, television, literature, sports, teen fads and fashions, health and grooming, and etiquette and also include some school-related material and common sense questions.

It is difficult, but not impossible, to study for this type of test, provided you start preparing for it many months ahead

PREPARING FOR COMPETITION

of the pageant. The following are suggestions on how you can prepare:

1. Read your local newspaper and the *Wall Street Journal* or *New York Times* every day. *USA Today* is also an excellent resource.

2. Read a quality weekly news magazine (i.e., *Newsweek, Time, U.S. News and World Report*) to gain more in-depth knowledge of the world around you.

3. Watch your evening news daily (you can do this while you exercise to get double benefit from your time), and watch a morning news show such as "Today" or "Good Morning America."

4. Read *People, Us,* or *Good Housekeeping* magazines to become familiar with names and personalities, but remember these do not substitute for news magazines.

5. If you have not been an avid reader in the past, read digests of famous literary works and plays so you know characters and plot lines (when you have more time, read the full works for your own enjoyment and growth—digests do not replace the original words of the masters).

6. Read through "Trivial Pursuit" game cards.

7. Discuss issues with others to gain other people's insight and to understand differing viewpoints.

This test preparation will also serve you well in the interview, so follow these suggestions even if you will not be taking a formal written test. While this gunshot approach may seem haphazard, if it helps you answer one or two test questions, or answer an interview question more intelligently, it is worth the hours of effort. The extra points can make the difference between being the winner or first runner-up.

The Interview

From both the contestant's and the judge's point of view, the most important category in any pageant is the interview. It is unavoidable that the interview will carry more than its official weight in the selection of the new queen. If the judges are

INTERVIEW AND AWARENESS

impressed with you when they talk to you, they will want to like you in all the other categories. If the judges are faced with choosing between three talented singers or three pretty women, does it not make sense that what is said in the interview will have a great influence on who is selected to represent the pageant next year? Remember, the interview can create a conscious or subconscious bias in your favor so concentrate on preparing this area.

Susan Perkins was a runner-up to Miss Ohio in 1977. She recognized that the interview would be crucial in her second bid for the title. She worked on her vocabulary and speaking skills and constantly went on job interviews to gain interviewing experience. She approached the pageant interview on a professional level as if it were a job interview. She utilized the seven minutes she had with her judges to convince them that she would make the most of the opportunity and could help the pageant. Her effort in the interview preparation paid off—she became Miss Ohio on her second try and went on to capture the 1978 Miss America title. Do not wait until your second try for your pageant title. Prepare thoroughly for the interview the first time.

The interview is our favorite category. It is fun to be able to sit down and talk to community leaders, successful businesspersons, and celebrities. If your nerves start to jangle, just remember that the judges are not there to scare you or try to trick you with their questions. They just want to get to know you better.

As contestants, we never would have guessed that the judges were as nervous as we were, if not more so. The judges feel pressure to do their job well by picking a winning queen. They realize how important the contest is to the contestants and that the result will change someone's life. We have both judged numerous pageants at national, state, and local levels. We can vouch for the fact that the interview makes the adrenaline flow in the judges as well as in the contestants.

Anticipating Questions

Every question that your interview judges ask you will have been asked in a pageant before in one form or another. If

PREPARING FOR COMPETITION

you are caught off guard by a question, it is because you haven't mentally prepared. Take time to think about what the judges might ask you. Think about the essence of the question, not its particular format.

The judges are instructed that their questions may pertain to anything in good taste. It is usually considered unnecessary to ask personal questions on birth control, sexual habits, personal hygiene, drugs, and other such areas. Some of these areas may be touched on using generalized questions such as, "How do you feel about the issue of drug use?" instead of, "Do you personally abuse drugs?" The judges are likely to ask you many questions that are prompted by the questionnaire you previously filled out so consider your answers carefully, anticipating what questions they may evoke.

Consider the following potential areas of questioning:

BACKGROUND

Education—level and areas of study

Family

Occupation

Community involvement

Special training—languages, arts, etc.

Hobbies

Homemaking skills

Travel

PERSONAL GOALS

What you most want to achieve in life

Personal and career goals

Viewpoint on balancing career and family

PAGEANTS

Do you want to be Miss Somebody? Why?

Meaning of the title to you

INTERVIEW AND AWARENESS

Most important aspect of competition

Message you would share

Describe your preliminary pageant

Conflicting public views on pageants

LIKES AND DISLIKES

Person you most admire (personal and public figures)

Places

Things

Sports and games

Characteristic you least like about yourself

HOME STATE/HOMETOWN

Describe your hometown (or state)

Feelings about hometown (or state)

Most interesting aspect of your town or state—why someone would want to visit there

WORLD AFFAIRS AND ISSUES

Politics

Geography

Current Events

Women's Liberation

Pornography as an issue

Drug taking as an issue

Abortion as an issue

FASHION

Views on current fashion

Views on dressing for success

PREPARING FOR COMPETITION

Feelings on wearing the Miss Somebody sash and crown

How Miss Somebody should dress

Why you decided to wear the outfit you are wearing

FADS
Health foods

Diets

Exercise

Hairstyles

READING MATERIALS
What newspapers or magazines you read

Views on the press

Books—current best sellers, fiction, nonfiction, classics

FAVORITES
Author, artist, television program, movie, singer, actor, food, color, etc.

Sample Questions

Over the last decade, we have collected a list of actual questions that have been asked in pageants. Think about how you would answer these questions, and then think of other possible questions.

1. Why did you enter this pageant?
2. What did you do to prepare for this pageant?
3. Do you really want to be Miss Somebody? Why?
4. What would winning this contest mean to you?
5. What do you consider to be the role of Miss Somebody?
6. What can you contribute to the Miss Somebody Pageant organization?

INTERVIEW AND AWARENESS

7. What do you believe are the most important characteristics a Miss Somebody should possess?

8. Miss Somebody functions as a representative of this community. If you were Miss Somebody, how would you describe your community to other people of the state or world?

9. Describe your best qualities.

10. Tell me about your family.

11. What are your long-range goals and how do you plan to achieve them? How might winning the pageant affect these plans?

12. Who do you think is the greatest person living in the world today? Why?

13. If you could be any person in history who would it be and why?

14. What woman do you most admire and why?

15. Describe your ideal man.

16. What qualities do you look for in a friend?

17. What is your favorite way of relaxing?

18. You noted your career ambition is _____. Why did you choose that field?

19. Who, outside of your family, has most influenced your life so far?

20. Who are your heroes, living or dead?

21. Give us your definition of beauty.

22. How long does it take you to get dressed in the morning?

23. What do you think you will be doing approximately ten years from now?

24. Looking back on your life fifty years from now, what do you hope will be your greatest achievement?

25. What is the first thing you read in the newspaper?

PREPARING FOR COMPETITION

26. What are your impressions of the pageant host city?

27. What is your definition of patriotism?

28. Who is your favorite author and why?

29. What is your favorite sport and why?

30. What is your favorite food and why?

31. What do you think of women's fashions?

32. Do you have an interest in any particular school of art?

33. If your house was on fire, what possession would you grab on your way out?

34. What does a citizen owe to his/her government? What does a government owe to its citizens?

35. What do you think of women serving in the Armed Forces?

36. Should women compete in traditionally male sports? on mixed teams? in contact sports, such as wrestling?

37. What do you think about compulsory retirement at the age of 65?

38. What are your views on abortion?

39. Do you believe a woman's place is in the home?

40. What does "Women's Liberation" mean to you?

41. What qualities do you think our national leaders should possess?

42. If you became president of the United States today, what would be the first thing you would do?

43. What do you consider to be the world's greatest problem today?

44. What era would you most like to live in and why?

45. If you had the choice of living or studying anywhere in the world, where would it be and why?

46. If you could learn any foreign language, which would it be and why?

INTERVIEW AND AWARENESS

47. If you could give one gift to your country, what would it be and why?

48. Who is your favorite actor or actress and why?

49. If you were confined to a hospital bed for three months, who would you want to be in the next bed?

50. What in the last year has given you the most pleasure?

51. What is the most influential experience you have ever had and how did it affect you?

52. What act or achievement would you most want to be remembered for and why?

53. What kind of environment do you prefer to live in—city or country, peaceful or noisy, etc.?

54. What do you consider to be the greatest event that ever happened on earth?

55. If you could be on "Fantasy Island," what would be your fantasy and why?

56. What do you think that you, as an individual, could contribute to world peace?

57. If you were stranded alone on Mars, what would be the first thing you would send for?

58. If you could change anything about your personal appearance, what would it be?

59. If you were given $100,000 and had to spend it on yourself, what would you do with it?

60. What is the biggest mistake you have ever made?

61. What is the best piece of advice you have ever received?

62. Name the U.S. senators who represent your state.

63. Who is the governor of your state?

Your Answers

Occasionally, an interview question will be asked to see if you know the answer, for example, "Who are your senators?" It is

PREPARING FOR COMPETITION

shocking how many contestants cannot answer this particular question. (Barbara once asked a Miss Massachusetts to name one of her state's U.S. senators and was appalled that a woman from a state with a senator as famous as Ted Kennedy could not name him.) A question like this is very basic. It is asked to see if you have a general awareness of your government and your state.

Do not count on bluffing your way through questions that call for a specific answer. Miss America contestant Deborah Mosley, Miss Georgia 1978, was asked what her opinion of Congresswoman Barbara Jordan was. Not knowing who this national figure was, Deborah tried to charm the judges by saying, "I don't know who she is, but just as soon as this interview is over, I'm going to find out." If you do not know someone that you should, this may be the next best answer, but it is a very poor second to being prepared and aware of government leaders. If you do not know the names of your various government representatives or famous national figures, learn them. It is most embarrassing not to know this type of answer.

While you probably will get one or two questions with right answers, most interview questions are more subjective. They will not have a right or wrong answer. For instance, judges will often give you a chance to share what you want to tell them by asking an open-ended question like, "Tell me about yourself." The judges will be asking subjective questions to learn more about you and your communication skills. To develop these speaking skills, get involved in activities such as the debate team, theater, or student government. Charities often need spokespersons for their causes. Volunteer your services to get practice in public speaking.

In your interview it will be more important *how* you answer, than *what* you answer. Remember to:

Listen to what the judges are asking. Too often, contestants start thinking about their answer before the question is through and miss hearing the essence of the question. Nerves can sometimes make the words pass straight through your head without registering if you do not make a special effort to concentrate. You do not want to be in the same position as one Miss Teenage America finalist who, on the national telecast, had to ask for,

INTERVIEW AND AWARENESS

not one, but two questions to be repeated. That slip may have cost her the title.

Answer what the question asks and stay within any limits placed by the question. For instance, if you are asked, "Who, outside of your family, has most influenced your life?", do not answer, "My mother." That option has been eliminated by the wording of the question. Make sure your response answers the question asked and does not just talk in circles. In the interview, if you are asked an ambiguous question, ask for clarification as to what the judges are really asking.

Take time to organize your thoughts before you start to speak. It is better to be silent for a few moments than to start babbling an incoherent or unorganized answer. The judges will appreciate the fact that you are carefully considering their question and your answer to it.

Never repeat the question before you answer it. Contestants often repeat the question as a ploy to gain time to think about their answer. You have time to think. It is easier and faster to think in silence. When you are asked a question in normal conversation, you do not repeat the question, so do not do it during the on-stage or personal interviews. Repetition will only make you appear nervous.

Be truthful. Do not just answer what you think the judges want you to answer. Your answer must first satisfy you. The judges usually do not have a definite answer in mind when they ask the question. Be honest with them, and with yourself, and your answer will sound sincere.

Be yourself. It may be possible to put on an act for the judges during the personal interview and while on stage, but do not do it. If you are selected on the basis of an act, you have not really won the title. The person you have pretended to be will have won the title, and that is who will be expected to wear the crown all year. Acting for a couple of hours is a lot easier than acting twenty-four hours a day for 365 days. Let the judges see who you really are, but make sure it is you at your best.

Be prepared to ask questions. In a one-on-one interview you may be given a chance to ask the judge a question. Have

a couple of questions ready that will show you are interested in the judge and that you are aware of the judge's personal accomplishments. You may also find occasion to ask the judge a follow-up question of your own, but remember not to keep the judge talking throughout the whole interview. The object is for the judge to get to know you.

Do not discuss your interview with other contestants. Many judges use the same standard questions for all contestants. A great deal of the interview's value comes from testing how well contestants can spontaneously answer questions. If you walk out of your interview and tell the contestants behind you what you were asked, they will have the advantage of being able to think about how they will answer the question. Talking about your interview will only hurt your competitive position so wait until everyone has been interviewed before you even consider talking about it.

Body Language

The way you physically handle yourself in the interview can tell the judges a significant amount about you. Make sure that your presence tells the judges you are confident and friendly. The judges start observing and judging you the minute you walk into the room. Approach the judging station with good posture, controlled energy, and a friendly smile.

There are conflicting views on whether or not a contestant should shake the judge's hand. You will never go wrong not extending your hand, and it is better not to shake hands if you are in a panel-judging situation. If any of the judges offers a hand to you, by all means shake it. Look the judge straight in the eye, smile as you introduce yourself, and give a firm, but not vicelike, grip. If you are comfortable shaking hands, it is acceptable for you to initiate the handshake.

When sitting in the interview situation, look alert. Sit on the front half of the chair. Your posture should be erect, or very slightly leaning forward to indicate your interest and involvement in the interview. Never lean back in your chair or forward onto the judge's table. Sit firmly enough on the chair that you do not appear to be perched, ready for flight at the judge's first question.

INTERVIEW AND AWARENESS

Some coaches will tell you not to cross your legs during an interview. It is best to cross your ankles, keeping your knees together, and tuck your feet slightly under you and to one side. If you simply are not comfortable this way, go ahead and cross your legs, but do it properly as described in chapter 13. It is more important that you are at ease in the interview than that you place your legs in a particular way.

Your hands must be controlled. They should rest gently in your lap. If you have a tendency to talk with your hands, concentrate on overcoming this habit. It is fine to gesture occasionally, but hands that flit constantly are distracting. Do not play with your fingernails, rings, or anything else as you talk as this will reveal nervousness.

Eye contact can make or break an interview. No matter what you say or how your voice expresses it, if your eyes are lifeless, that is how you will be perceived. Your eyes must sparkle with interest, enthusiasm, and confidence. Make your eyes speak to the judges. It was her expressive eyes that gave Jineane Ford away as the real Miss USA 1980 to panelist Peggy Cass on "To Tell the Truth." (Three other panelists chose an imposter who later won the 1981 Miss New York-USA title.)

Focus your eyes on the judge as you talk. If your eyes roam all over the room, or if you look down at your lap, the judge will think you are disinterested, nervous, lying, or too shy to fulfill the titleholder's duties. Eye contact will put you in touch with the judge, show your confidence and command of the situation, and will also hold the judge's interest in what you are saying. One word of warning: You do not want to get locked in a stare-down with the judge, so you will want to occasionally break eye contact for a moment. In a one-on-one interview, you should be maintaining eye contact about 90 percent of the time.

If you are being interviewed by a panel of judges, eye contact is especially important. Due to time limits, some of the judges may not be able to ask you a question. Making eye contact is one way you can reach out personally to each judge. Look directly at the judge who is asking the question, then, as you start to answer, shift your eyes to make individual contact with the other judges, including them in your answer. In a panel interview, you should have eye contact with one judge or another 100 percent of the time.

PREPARING FOR COMPETITION

Your Voice

An attractive and interesting voice can do much to enhance how people perceive you. It can create an interest in you as a person and can hold your listeners' attention so they hear your ideas. You want to develop the ability to speak in a way that clearly and concisely expresses your thoughts and convictions in a voice that compels people to listen. This will allow you to project a more confident and attractive you. Listen to a tape recording of your voice in normal conversation. Make an honest appraisal of how you sound—not the words you say, but how you say them.

Your voice will sound more alive and self-assured if it has proper breath support. The first step is proper posture (see chapter 13). To avoid sounding breathy or nasal, learn to control how you exhale when you speak. Place one hand below your rib cage and above your navel, then pretend you are blowing up a balloon. You should feel the muscles under your hand grow tighter. These are the muscles you want to develop for proper breath support and voice projection. One exercise to control breath support is to inhale and then slowly let the air escape in a hissing sound. Try to sustain the hiss for as long as possible on that one breath.

To test your voice projection, try speaking to an imaginary person who is ten feet away, and then to one who is at the back of an auditorium. The pitch should stay the same. If it becomes higher, you are not using your breath support muscles enough. Keep your neck and throat relaxed to avoid shrillness.

How is your pacing? If you speak too fast in normal conversation, you will certainly speak too fast in the interview. Nerves will tend to speed up the pace of your speech. If you talk too fast, it is hard for the listener (the judge) to follow your ideas and to understand your diction. If you are too slow, you may lose the judge's attention. Try reading aloud into a tape recorder at your normal rate using your normal intonation, then count how many words you read per minute. The acceptable range is between 130 and 180 words per minute, with 150 being just right.

Another way to pace your speech is to concentrate on your

INTERVIEW AND AWARENESS

diction. Don't let your lips be lazy. Pronounce your words clearly. Do not mumble. Pronounce every syllable of each word (it is "probably" not "probly" and "want to" not "wanna"), and every word of every sentence. Do not swallow the ends of words or sentences.

Inject variety into your speech. Alter the pitch, speed, and expression that you use. Also, avoid using the same words or expressions too frequently. A small vocabulary will imply you have a narrow range of thoughts or lack creativity. Finally, rid your speech of fillers such as "um," "and," "you know," and the like.

7

The Talent Competition

A five-year study of 120 concert pianists, Olympic swimmers, sculptors, tennis players, mathematicians, and research neurologists concluded that drive and determination, not great natural talent, led to their extraordinary success. Everyone has talent, but it may not be easily shown on stage in two minutes, nor is it necessarily of the entertaining variety. The importance of having a performing talent to be selected as a beauty queen is sometimes overestimated. Once selected, a performing talent is not very important to the main duties of most titleholders. The only "performing talent" that is required to be an effective titleholder is that of extemporaneous public speaking. On occasion, a winner's performing talent may be utilized. For instance, on the 1986 Miss Universe Pageant, Deborah Carthy-Deu, Miss Universe 1985, did not just relinquish her title, she danced and sang a duet in the telecast's production number.

Midge Stevenson, the pageant companion assigned to Suzette Charles, Miss America 1984, stated, "Miss America does not 'perform,' she appears." The talent competition was introduced to the Miss America Pageant in 1938. It is, to some degree, included in the competition to ensure that the pageant program will be entertaining. Until 1986, the weight of the talent category in the Miss America Pageant was reduced after the finalists had been selected, indicating that a performing talent was more important to become a finalist than it was to become Miss America. In fact, very few preliminary talent winners had won the Miss America title (swimsuit preliminary winners fared much better in capturing the crown). In 1986, the talent score was adjusted to account for 50 percent of the final score.

Talent as a judging category is as subjective, if not more so, as the interview category. Susan Perkins, Miss America 1978,

THE TALENT COMPETITION

once pointed out, "Talent? Who's to say that the one who dances well is better than the one who sings well or the one who is an acrobat?" Pageant judges are not experts in all the various arts. A prima ballerina is really no better equipped to compare the talent of a dancer against that of a singer. The comparison comes down to which performance the judge finds more enjoyable, not which performance is more technically sound, or which performer more gifted.

So You Need a Talent—Create One

Do not let a talent requirement scare you off. Everyone has talent. You do not necessarily need to have a well-developed performing talent such as singing or piano playing. You just need to be creative.

You can find a clever way of presenting almost any personal interest or hobby. Cathy Durden, Miss Teenage America 1976, wore a kimono and demonstrated ikebana, the Oriental art of flower arranging, which she learned in Japan as a high school foreign-exchange student. Judi Ford won the 1968 Miss America Pageant after demonstrating her gymnastics skills on a trampoline. Contestants have presented talents in sewing, writing, figure skating, karate, tractor maneuvering, suitcase packing, and horseback riding. In fact, Miss Montana 1949 galloped onto the stage at the Miss America Pageant and caused quite a stir when her horse charged off the stage into the orchestra pit (the use of animals in the live talent presentations is no longer allowed).

Talent competition does not require years of study in one area. It is rumored that Jayne Jayroe, Miss America 1967, gave a speech in her state competition, but was told, "We have got to get you another talent." At the national pageant she brought down the house and won the talent preliminary with a talent created especially for the Miss America competition—she directed the orchestra. Critics of this talent presentation have said, "The Glen Osser Orchestra, having some of the best musicians in the country, could be conducted by a monkey and they wouldn't play incorrectly." If the critics are right, the talent segment is really a competition of creativity.

As a Miss Teenage Minnesota contestant in 1976, Polly wrote

PREPARING FOR COMPETITION

and recited an original piece in which the flag paid tribute to its maker, Betsy Ross. She also presented her sewing and design skills by wearing a Betsy Ross costume that she designed and constructed. This timely and original presentation helped Polly become first runner-up in late 1975.

When Polly decided to re-enter the pageant in late 1976, the same talent was not as timely a choice since the Bicentennial was almost over. Instead of repeating the previous year's talent, Polly won the Miss Teenage Minnesota title by combining her writing and speaking abilities with her nine months' study of the harp. She gave a short speech about the history of the harp and then "demonstrated" the harp by playing "Look to the Rainbow." Polly was not a concert harpist when she, two months later, played before the more than 14 million viewers of the Miss Teenage America Pageant. It was the creativity of her presentation, not the strength of her performing talent, that made her stand out at the national pageant.

Use Your Imagination

The instruction to create a talent is not meant to belittle the talent competition or the strong performing talents possessed by many contestants. Rather, creativity is stressed because even the most talented contestant will not gain a winning point total if she does not display her talent creatively. Creativity is also stressed to make you think about what interests or hobbies you have developed that may be presented as talents.

You do not have to stick to the traditional talents such as singing, piano playing, and dancing. Alecia Rae Masalkoski, Miss Michigan 1986, made national news and caught the judges' attention with a karate kata (martial ballet) number that included stomping through 100 pounds of broken Pepsi and Coca-Cola bottles and putting her foot through four inches of concrete—certainly a less than traditional talent presentation for a Miss America contestant.

If you do happen to have a traditional pageant talent, you need to be extra creative and demonstrate extra ability. Being traditional means you will be compared with many similar talents. If you sing, you may have to outshine twenty-five other singers. You also run the risk that someone else may be singing

THE TALENT COMPETITION

the same song. Polly judged a teen pageant in which the theme from *Ice Castles* was sung by a dozen contestants, some of them back to back. It was also played by two pianists. Hearing the same song repeated fourteen times in one night is a bit taxing on the judges' nerves. It also forces those performers to be the absolute best performer when a different talent would have gained them points for their originality.

The above example demonstrates why it is important for a singer, pianist, or dancer to select their talent music carefully. Avoid common pageant songs. In addition to the theme from *Ice Castles,* avoid selections from *Kismet, Cabaret,* and *Showboat,* and do not use "When Smoke Gets in Your Eyes," "For Once in My Life," or "You Light Up My Life." These songs may be beautiful, but each one is too common. Also, pay attention to the words in your song and consider whether they are appropriate for your pageant. A teen contestant should not use a love song. A talent selection should not contain any suggestive or foul language.

Some talents have been stereotyped as traditional pageant losers. For instance, jazz dancing has come to be associated with those who do not have a "real" talent. It seems that contestants, if in doubt, will make up a jazz dance. A real jazz dancer will stand out in this crowd but still must overcome that bias against jazz dancers. To win, you will have to be a great jazz dancer.

Another stereotyped talent is baton twirling. There is a myth that all pageant contestants are baton twirlers. Actually this talent is somewhat rare. To win as a baton twirler, again you must soar above the anti-twirler bias. Laura Jean Broderick, Miss Indiana 1986, did just that. She won a $3,500 preliminary talent prize for a self-choreographed dance and baton twirling performance. With this same talent she had previously won two bronze medals and a silver medal in the World Free Style Twirling Championships and received the only Big Ten College full scholarship given for baton twirling. In 1986, she performed for the University of Iowa at the Rose Bowl. The talent of this baton twirler was recognized by the judges, but it still did not win the Miss America title for her.

Traditionally, transportable talents have fared better in competition than those that require moving heavy objects. Singing,

PREPARING FOR COMPETITION

dancing, and piano playing (pianos are commonly available) are considered transportable talents. Trampoline and harp talents are not as mobile, but they have been used by national titleholders. Consider how to make your talent as transportable as possible. If your talent requires specific heavy equipment, use it, but your talent will have to be extra special.

Carefully Observe the Pageant's Talent Rules

The talent segment usually has more guidelines than any other pageant category. These rules are needed to give some structure to a portion of the program over which the pageant organization otherwise has little control. The choice and creation of talents is in the hands of the contestants. The rules are also needed for legal reasons to ensure that pageant talents will not infringe copyrights.

The time limit stated will be strictly enforced. Usually points will be subtracted if your presentation runs over the limit. After winning the Miss Teenage Minnesota title, Polly was told that the staff timing her talent had been concerned that her presentation might run over the allotted two minutes. In fact, Polly had planned and practiced the pacing of her presentation to be exactly two minutes—and it was.

Two minutes sounds like too short a time to present anything of substance, but Abraham Lincoln did not need more than two minutes to leave his mark on history with the Gettysburg Address. You can wow the judges in one-and-a-half to two minutes. If your pageant allows more time (Miss America contestants have three minutes) consider it a bonus, and make sure the last minute is as good as the first two.

Practice, Practice, Practice

Adopt the following rules in your hectic preparation schedule:

Perfect your talent. You only need to perform one thing. Do not try to become a concert pianist overnight. Just perfect the song you will be playing for the competition. Marilyn Van Derbur could only play "Tenderly" and "Tea for Two" on the organ, but she learned to play those two pieces well, and they brought her the 1958 Miss America title.

THE TALENT COMPETITION

Schedule specific practice times. Your talent selection has to be so fully prepared that it can withstand any attack of nerves. Missed notes or a shaky voice caused by nerves will stand out clearly. Be dedicated in your practice so that your performance will become second nature to you.

Learn how to sneak in extra minutes of talent rehearsal every day. When Polly was preparing her harp selection, she would head for the harp throughout the day to run through the song, concentrating on nothing else as she practiced. Her practicing continued even after she arrived at the national pageant. Since the harp is difficult to transport, one was rented from a woman in Tulsa, where the pageant was held. The feel of each harp and the tension of its strings is slightly different and takes time to adjust to so Polly kept the rented harp in her hotel room. She would wake extra early every morning (her only free time) to play through her song several times.

Be disciplined. When you practice or perform, concentrate on what you are doing. Pretend that every performance is the performance that counts, even if you are only at home dancing for your dog. The ultimate concentration and dedication was exhibited by Sheri Ryman, Miss Texas 1982, when she won the Miss America talent preliminary by performing a gymnastics routine on a broken foot. With this same handicap, she became fourth runner-up to Miss America. She had prepared for the contest for three years and was not about to let a mere broken foot dash her dreams. (Be dedicated, but sensible. If you are faced with such a decision, consider carefully whether there is any danger that continuing to compete may result in a permanent injury—the pageant title is not worth risking a lifelong limp.)

Take advantage of every opportunity to perform before an audience. Polly played her harp in front of an audience for the first time at the Miss Teenage Minnesota contest and for the second time in front of the 14 million prime-time viewers of the Miss Teenage America Pageant. It will be less stressful for you if you have performed before many audiences. If you sing or play the piano, offer to participate in church services. If you dance, tour hospitals and rest homes.

PREPARING FOR COMPETITION

Ask for observers' comments. If you have a talent coach, listen to his or her comments on your performance. Even people not well acquainted with the technical aspects of your performance can give useful tips. They can tell you whether they find your performance entertaining and what their assessment of your skill is from an untrained point of view (which is what most of the judges will be called on to do). They can also give tips on the subtle aspects of your performance such as how you use your eyes and hands, or hold your head. Also, ask for opinions on the costume you choose. You want to look great during your talent presentation.

8

Getting into Physical Shape

The most obvious area of preparation for a pageant contestant is getting into physical shape. While this may not be the most important area for you to work on, it cannot be overlooked. Pageant winners go into a form of physical training similar to that of an Olympic athlete. Morning, noon, and night, your work and play are inextricably linked to your pageant preparation.

Balancing Your Weight

Like an athlete, every pageant participant, regardless of whether or not she will have to compete in a swimsuit, is and must be concerned about her weight. Weight can become a real problem when you enter college. It is not uncommon for women who could eat anything in high school to find themselves packing on the notorious "freshman fifteen" pounds when they enter college. This is due to several factors.

First, study breaks and social time in college usually center around food. College life may also be more sedentary than high school days as more time is spent sitting at a desk studying. Unless you are disciplined about your exercise program, you may find your only exercise is walking around campus, carrying books and lifting handfuls of M&M's to your mouth. These environmental changes and the fact that your body needs fewer calories as you get older may add more pounds on your frame. Following a sensible eating program is not difficult, but you must be conscious of everything you put into your mouth.

Another factor in weight gain is that college foods, such as potatoes and breads, tend to have an abundance of carbohy-

PREPARING FOR COMPETITION

drates. "Carbohydrates" is not a dirty word. In fact, you need them, so do not eliminate them from your diet, but do guard against excessive intake of such heavy foods. Also, do not overload your carbohydrates with extra items such as gravy and butter.

As you adjust your eating habits to balance your weight, do not sacrifice good nutrition in order to reduce calories. The food you put in your mouth affects more than your dress size. The adage "You are what you eat" has a lot of truth to it. Maintaining a well-balanced diet is essential for clear skin and glowing hair. It is also an important factor in increasing your energy level, and energy is one thing you will definitely need in pageant competition.

Your diet habits must be ones that you can live with, before and after the pageant. You should be diet-conscious for your own sake, not for any panel of judges. Improving your eating habits does not have to be a major ordeal. There are lots of ways to cut corners in your calorie intake. Just take some time to think about what you are eating before it goes in. We are all great about feeling guilty once the food has passed the gums. The guilt is especially strong when the food is "bad" for us.

Calorie-Cutting Tips

- Eat three balanced meals a day and cut out seconds and extra snacks.
- Do not buy or keep tempting food items in your dormitory room or around the house.
- If you have a roommate, friend, or relative who is not nutrition-conscious, do not let her destroy your willpower. (Nondieters love to tempt those who watch what they eat.)
- Learn to study without munching.
- If you have to eat, nibble on low-calorie snacks such as carrots or celery. (Cut up these foods in bite-size pieces and keep them on hand in your refrigerator.) Eat these low-calorie snacks a half hour before meals to help dull your appetite.

GETTING INTO PHYSICAL SHAPE

- Drink lots of clear water. (It will help curb your appetite, and it is great for your skin.)
- Drink diet soft drinks and skim milk.
- Try drinking herbal tea or hot water with a little lemon in it.
- Chew sugarless gum.
- Eat a dill pickle to squelch your appetite.
- Popcorn is a filling snack, and it is low in calories if you do not use lots of oil or butter. (Try air-popping it and eat it without salt. This may take some getting used to, but you will learn to like the great natural corn taste.)
- Beware of beer, the diet destroyer.
- Ignore candy vending machines that beckon to you.
- If you must have sweets, find lower-calorie substitutes (i.e., substitute a baked apple for apple pie, plain angel food cake for fudge cake, and ice milk or sherbert for ice cream. Three vanilla wafers have forty-five calories compared to one Oreo cookie, which has fifty calories.)
- When you take a study or work break, take a walk, jump rope, or try some other form of physical activity. (The activity will do triple duty—keep you from heading for the refrigerator, burn calories, and reduce your appetite.)
- When you go out to lunch with friends, order iced tea and a salad without dressing (or with it on the side so you can control the amount, or try using lemon juice), instead of a hamburger, fries, and a chocolate malt.
- Try a baked potato without butter or sour cream. (If you are really serious about healthful eating, cut out the salt too.)
- Use skim milk on your cereal, and don't add sugar.
- Do not waste your allotted calories on eating anything that is not nutritious.

Chocolate is a good example of a nonnutritious tempter. Consumption of chocolate must be monitored carefully. It not only wreaks havoc with your diet plan, it may also affect your skin. Since chocolate does affect Barbara's skin, she cut it out

PREPARING FOR COMPETITION

of her diet for one year before competing for the Miss USA title. A disciplined contestant will totally eliminate chocolate and other forms of caffeine from her diet.

Your diet plan does not end when you win the title. Pageant winners have to watch their weight continually. Some find they put on weight while on the road when every meal is served banquet style and every host is trying to treat them royally.

Some winners slack off from the discipline they exercised to win. Susan Akins, Miss America 1986, splurged on her favorite foods (apple pie and ice cream) the night she won her national title. The splurge must have continued for more than one night as she put on five pounds in the two weeks after she won the Miss America crown. Do not let this happen to you. Exercise the same discipline that made you a winner throughout your reign.

Don't Go Overboard in Your Weight Loss!

When evaluating your weight reduction needs, be honest and realistic with yourself. Most women think they are overweight. Our society puts such a premium on being thin that we can become compulsive in our quest for the perfect body. Unfortunately, more and more young women are too self-critical and develop anorexia nervosa or bulimia. *These diseases are killers.* They tend to attack women who are high achievers—the same type of women pageants attract. Your health is more important than having a weight level that you feel society has prescribed for you. A healthful diet and exercise plan will maintain your weight at a level that is right for your body. Be sensible. Do not go overboard!

The Problem of Being Underweight

If you have tried to lose weight, you may consider the idea of being underweight a blessing, but it is not. Whether you are a pageant contestant or not, a winning body is one that is healthy and shows it. Being too thin makes one appear sickly. Legs that are too thin do not have a pretty shape. You should

have some flesh on your bones. It is healthier to be a few pounds overweight than a few pounds underweight.

It is not uncommon for state winners to be told to put on weight. Some of these women may have struggled all their lives with the problem of being too thin. Others went overboard preparing for their state competition and became too thin. One Miss Georgia had to put on more than ten pounds before she reached the nationals. It is amazing that she won her state pageant being so thin. Even with the added ten pounds, she was still too thin. Being underweight inevitably hurt her chances of winning the national pageant.

Some winners have the problem of trying to keep their weight up. Barbara discovered that her weight dropped during her reign as Miss USA. She had to struggle to maintain a healthy weight. Her schedule was so fast-paced that she burned off lots of calories. While she was served huge meals, she was so often interrupted with requests for autographs and pictures that she rarely was able to finish a meal. Her chaperone coaxed her to eat foods such as cheesecake and malted milks (not high in nutrition, but definitely high in calories) in order to keep up her weight. Barbara learned to eat a nutritious light salad or sandwich before an appearance. Then if she was unable to finish the meal served to her, she was at least getting energy from some healthful food.

Tips to Put on Weight

If you need to put on weight try the following:

- Add a little extra-high-calorie food to each meal such as a piece of bread or an extra potato.
- Add jam and butter to bread, extra margarine to your vegetables, and rich dressing to your salads.
- Eat nutritious, but high-calorie snacks. Instead of an apple or carrot sticks, eat cheese or peanut butter on crackers, a container of yogurt, or drink a glass of instant breakfast.
- Snack at least two hours before meals so you will not spoil your appetite.

PREPARING FOR COMPETITION

- Exercise enough to tone your muscles, but not to burn off too many calories.
- Eat a large snack before you go to bed.

Exercise for Muscle Tone

A winning body must be more than slender. What the judges look for, consciously or unconsciously, is toned muscles. They will unfailingly notice flabby, unconditioned thighs and subtract points for them. This does not mean you have to be a great athlete. You want firm muscles, but bulging muscles are a detriment. The look you want to achieve is that of vibrant good health.

The judges also look for a well-proportioned body. You do not need measurements that will stun the judges. Judges often comment that they really could not recall whether or not a contestant had a good bustline.

Exercising for the Swimsuit Competition

The pageants that include swimsuit competition use this category to determine how well a woman takes care of herself physically. Physical condition also reflects a woman's mental discipline and how she feels about herself. Physical training cannot start a month before the competition. You must decide early that you want to enter and win. Three to six months is the absolute minimum time required for getting into shape, a year is much better. You must be physically ready when you leave home for the pageant.

This preparation will include a daily exercise routine followed religiously, with no cheating. Each contestant may choose a different method of physical exercise. One Miss Wyoming kept fit helping with cattle drives and mending fences on her family's ranch in Horse Creek, Wyoming. The more common methods include riding stationary bicycles, aerobics, jogging, and weight lifting.

Find a time of day that works for your exercise routine and stick to it. If you have to get up a little earlier or not stay out

GETTING INTO PHYSICAL SHAPE

so late in order to fit your routine into the day, do it! Your appointment with your exercise mat should be a top priority and should never be canceled. It does not have to take long; it just has to be followed consistently. Barbara has found that twenty minutes of exercise a day in her bedroom will do wonders. If you do not like to exercise alone in your bedroom, join a health club or take ballet lessons.

Your exercise routine must be adaptable to travel. Remember, once you win the pageant title, it is just as important to exercise, both to keep in shape and to maintain your energy level. It takes even more discipline after winning your title because it is hard to fit an exercise routine into a winner's travel schedule.

Titleholders can become accomplished at various forms of isometric exercises to keep muscles toned while on the go. Some of these, like tightening buttocks muscles, can be done so unobtrusively, that they can be performed while sitting on an airplane, standing in a receiving line, or riding an elevator. Some titleholders work out by jogging in the different cities they visit. Others swim in hotel swimming pools. Still others choose to do calisthenics in their hotel rooms, using the jump rope that is always packed in their luggage. Shawn Weatherly, Miss Universe 1980, enjoyed weight lifting to keep in shape. Kim Tomes, Miss USA 1977, used the Nautilus system. Barbara found that ballet kept her body both toned and relaxed.

Titleholders know that there is no good excuse for any woman not to get into shape and stay that way. Pageant or no pageant, good health is always in style. Start a disciplined exercise routine now that you can continue all your life. Make it a habit to exercise every day.

Concentrate on Your Leg Muscles

Muscle tone, or lack of it, is most noticeable on legs, hips, and buttocks. Bob Barker says that it is the legs that determine the winner. When designing your exercise routine, concentrate on your legs. Inner thighs that jiggle are point stealers. Heavy, untoned legs are especially noticeable if you are standing next to another contestant who has long, shapely legs.

PREPARING FOR COMPETITION

The importance of good legs is also illustrated by the fact that tall women usually fare better in pageant competition. Long legs call attention to themselves. If they are well toned they are apt to earn more points than equally toned, but shorter legs. Added length in the legs can create the illusion that they are more slender than they might actually be. This illusion can be created somewhat artificially by wearing high heels. Heels place the leg muscles in a different alignment than when you are wearing flat shoes. This alignment creates a more flattering leg shape.

The types of exercises you want to concentrate on most are those that will work the lower half of your body. Riding a stationary bicycle or jogging on a small trampoline are two of the best exercises. They can be done year-round. You can also do double duty with your time by watching the television newscast at the same time. You can exercise the top half of your body at the same time by doing assorted arm exercises using light weights. Using the bicycle has an added advantage in that you can adjust the bicycle tension as your muscles become more fit. If you are jogging, you can achieve the same benefit by adding ankle weights (be careful not to turn an ankle with the added weight).

If you prefer to exercise with someone, find a jogging partner or play racquet sports. Tennis and racquetball are great ways to burn off lots of calories and to tone leg muscles. As the pageant approaches, however, be wary of any form of exercise that may lead to an injury. You should not take up sports such as snow skiing, sky diving, or any potentially rough contact sport at this time. This is not the time to take risks.

Find a form of exercise that has the least chance of injuring you. Calisthenics may not be as fun as other forms of exercise, but they are safer (if performed properly), can be done at any time, and allow you to concentrate the toning effect on trouble areas. For instance, ballet pliés can be done almost anywhere at any time and are very good to tone leg muscles. While the exercises you choose will focus on your leg and hip areas, do not ignore other areas such as the waist and upper arms. Calisthenics give better benefits and more enjoyment if you vary the exercises each day.

GETTING INTO PHYSICAL SHAPE

Seeing Results

One way to reward yourself for your disciplined work is to keep a chart showing your progress. Make a copy of the following graph and tape it to the inside of your bedroom closet door.

	2/1	2/4	2/7	2/10	2/13	2/16	GOAL
WEIGHT							
BUST							
MIDRIFF							
WAIST							
UPPER HIPS							
LOWER HIPS							
PONE							
MID-THIGH							
CALF							
MID-UPPER ARM							

On the left axis write the following: weight, bust, midriff (measured just below the bust), waist, upper hips (seven inches below the waist), lower hips (nine inches below the waist), pone (this is the measurement around the panty line), mid-thigh, calf (at its fullest point), mid-upper arm. Periodically recording the changes in these areas will give you a realistic measurement of your overall progress.

On the opposite side, write down your goal measurement for each of these areas. In setting your goals, remember that your figure does not need to be exactly 36–24–36. The judges want to see proportions that are right for you. Ideally your bust and hip measurements will be equal and your waist will be ten to twelve inches less than those measurements. Setting goal measurements will help you adjust your exercise routine to focus on the areas in which you still need to lose or gain inches.

On the top axis of your chart, mark off dates at three-day intervals. If you weigh or measure yourself more frequently than at three-day intervals you are likely to be discouraged by your slow progress. The beneficial results of an exercise plan

PREPARING FOR COMPETITION

may not show immediately (other than the fact that you may have sore muscles at first). You may also show inconsistent progress. Your weight and measurements may hit a plateau and then start changing again later. If you do not see steady progress, do not be discouraged. The only way in which you will not continue to progress is if you quit.

9

Helping Mother Nature with Cosmetic Surgery

When pageants were first organized, judges selected women who had done the most with what nature had given them. Today there are rumors of surgically created beauties winning the pageants. Debra Sue Maffet, Miss America 1983, caused a stir in the press when it was revealed that she had undergone plastic surgery for a "nose job." Prior to this surgery she had competed in many pageants without the kind of success that she had after the cosmetic changes. Examples like this unfortunately make many women think that they cannot win a pageant without expensive and sometimes painful plastic surgery. This is simply not true. This view just reflects a possible lack of confidence in their own abilities and assets.

Certain types of plastic surgery may indeed be beneficial to certain individuals. This miracle of modern medicine now means doctors can correct some deformities or birthmarks that sap an individual's self-confidence. If the length or shape of your nose has always made you self-conscious, you may decide that you would personally be happier having it surgically "bobbed." If your teeth are crooked, you can straighten them with braces or caps. Surgery can also be used to correct physical problems such as reducing the size of very large breasts or correcting breathing problems caused by a deviated septum.

Since our self-esteem is often linked with the way we look and how we feel others perceive us, plastic surgery may be a personal relief. If you think you would feel better about yourself with the help of some surgical adjustment, then maybe surgery is for you. That decision has to be yours, and yours alone—not a state director's or a coach's.

If you decide to have surgery, be sure you are doing it for yourself and your life as a whole, not for a panel of judges.

PREPARING FOR COMPETITION

Never undergo surgery in order to win a pageant. One contestant who was determined to win her pageant had her nose bobbed and her breasts enlarged with implants. She did win her state title, but even with the cosmetic changes she did not win the Miss America crown. There are no guarantees that surgery will pay off in pageant competition. It is a better bet to develop your God-given attributes through your own efforts, not those of a surgeon.

Breast Size

When a Miss New York-USA was disqualified from the Miss USA Pageant in 1981 for padding her swimsuit, she pointed out the fact that several contestants had undergone surgery to increase their breast size. In effect, some women had "padded" themselves with breast implants. While artificially padding the swimsuit was prohibited, surgical padding of the body was not. The rules have not been updated to cover this area. In fact, it would be hard to regulate this area as some of the women may have had surgery done years earlier for other reasons.

While the Miss USA Pageant does not allow artificial padding, the Miss America Pageant does. Dorothy Benham, Miss America 1977, told a newspaper reporter that most of the contestants her year wore falsies. She chose not to add padding thinking, "If I do happen to win this, will I have to keep putting these in all year?" She decided it would be more comfortable to be herself.

It is not necessary to be well endowed, naturally or cosmetically, to win a beauty pageant. While a contestant who has had breast implants may be selected the winner, such surgery is not a prerequisite to winning. Michael Grade of the British Broadcasting System asked a panel of Miss America representatives on the Phil Donahue Show, "When was the last flat-chested queen?" The fact is that there have been beauty queens in recent years who have had very little in the bust area. Despite being considered more "flat-chested" than well-endowed, Barbara (Miss USA 1976) and Mary Therese Friel (Miss USA 1979) both won a pageant that does not deny the beauty pageant label and that does not allow any swimsuit padding.

COSMETIC SURGERY

Barbara has always joked about the fact that she is not overly endowed. Instead of worrying about what she might lack, she concentrated her efforts on improving her natural assets. She entered the Miss USA Pageant toned and well proportioned. Her natural assets helped her win the title.

Contestants place too much emphasis on the need to have a large bust measurement. Your bust size does not determine who you are or what you can achieve, including winning a beauty pageant. Joan Sewall had a mastectomy, but went on to win the Mrs. Minnesota 1981 title and was second runner-up to Mrs. America. If a woman can win a beauty pageant after having her breast removed, you can certainly win one without adding to yours surgically.

Ann Jillian is a beautiful actress who faced breast cancer just as her career was coming into full-swing. She had to have a double mastectomy, but she did not let that put an end to her dreams. She was quoted in an article in *People* as saying, "If I want to play a sexy role, I'll play a sexy role. You bet, I'd still love to have breasts—but let's face it, I've never seen a pair of breasts tap dance, belt out a song, or play Lady Mac-Beth." It can be added that they have never won a beauty pageant either. It takes more than a good bustline to win any pageant.

The judges are interested in good proportions. Breast implants are usually recognizable, as the resulting shape often looks artificial and, if detected, may detract from a contestant's chances. Judges, consciously or unconsciously, want to pick a woman who has developed her natural assets using her own skills, not those of a surgeon. The "All-American Girl" with a normally proportioned body is always a good bet.

Scars

If you have a noticeable scar and do not want or cannot afford to have plastic surgery, do not let it stop you from pursuing your pageant dream. Suann Hibbs, a lovely woman from Edina, Minnesota, was in a terrible motorcycle accident. Though her life was saved, she was left with a large scar on the outside of her thigh. In a dress, the mark was unnoticeable, but in a swimsuit it was hard to miss. Suann did not let the scar stop her.

PREPARING FOR COMPETITION

She went on to represent her state in the Miss Venus USA competition. Yes, Suann had to appear before the judges in a swimsuit. Her confidence and determination were so strong that the scar simply did not matter. The judges recognized her special inner qualities and looked past the scar. Recently, another woman succeeded in becoming a runner-up in a prominent pageant despite an obvious scar on her face. Barbara won her titles despite a large scar on her knee and a vaccination mark on her ankle. If you believe in yourself enough, you too can enjoy your pageant dream.

Dealing with Acne Scars

If you have had skin problems in the past, you may have scars. If you just have a couple of small pock marks do not be too concerned. Most adults have some minor scarring. You can camouflage these marks by applying a cover stick or lighter foundation, which you should blend carefully with your regular foundation, then lightly powder to set the area.

If the damage is more extensive than can be covered by makeup, you may want to consult a qualified medical specialist about skin "sanding" or "peeling." These medical procedures can eliminate or reduce scar tissue in a few cases, but if not done properly they can increase the scarring. This is a form of plastic surgery. Proceed very cautiously! If you decide to have this treatment, do it for your total well-being, and not just to compete in a pageant.

10

Putting on a Winning Face

Abeauty pageant winner must know how to put her best face forward for all occasions. You must know, not only the basics of makeup application but also some of the tricks used by professionals in the beauty business. Your goal in this area of preparation is to enhance your natural outer beauty while letting your inner beauty shine through.

Know what type of audience you will be facing. Will you be one-on-one, on stage, or on a television screen? You must know what kind of makeup is appropriate for your audience and the physical setting of the particular pageant. You must then determine how to apply the makeup. You will use a different makeup process for the interview than that for stage work and that for television work. Adjust your makeup for your major audience.

Over the years, our pageant and modeling experience has allowed us to work with some of the best makeup artists in the business. Each time someone new applies our makeup, they will do something different. By paying close attention, we have been able to learn new tricks and have the basics reinforced. Not all the looks that the professionals create fit our daily lives. We have learned how to use the techniques with which we personally feel comfortable and to disregard the rest. You can do the same by studying magazine pictures or actresses on television, and then experimenting to find out what works for you. You can also take advantage of the free makeup consultations that some major department stores offer. Call the stores near you to see if they offer such sessions and make an appointment.

PREPARING FOR COMPETITION

Start with Beautiful Skin

When you apply makeup, you are in essence painting the prettiest picture you can. An artist knows that painting on a bad canvas will not create a masterpiece. Your colors will look blotchy. No matter how much makeup you use, or how skillfully you apply it, if your skin is in bad condition it will show. The first step to a winning face is a good skin-care procedure.

Your Skin-Care Routine

It is known that good skin requires a balanced diet, adequate sleep, a balanced emotional life, and thorough cleansing. The five essential steps in your skin-care cleansing routine are as follows:

1. Cleanse the skin with a good cream or soap.

2. Mask periodically (about once a week) to deep clean your pores and to slough off dead skin cells.

3. Apply a toner to remove residue of other skin products and to tighten your pores.

4. Moisturize your skin as needed, especially during the winter months, but do it carefully since too much moisturizer can leave skin looking dull and lifeless.

5. Protect your skin with a sunscreen and a light daytime protector (i.e., good foundation makeup).

All the products you use on your skin should be geared to your skin type—normal, dry, oily, or a combination of dry and oily. Never under any circumstances go to bed without taking off your makeup. It has been said that sleeping with your makeup on will age your skin ten years. This does make one think twice before plopping into bed without going through a thorough cleansing routine.

Experiment with your own skin to find out what works best for you. Different cosmetic companies and dermatologists may tell you to do or not do different things. Your skin, however,

may not fit the normal rules. You may be one of those individuals who should use soap on your skin—something the experts usually say not to do. You should know your skin better than anyone else.

Experiment with cosmetic brands to find out which one you like best. Never try a new product right before or at the pageant—experiment with new products at least two months before the pageant. The pageant is the time when you really do not want to have a reaction to a new product or procedure and have your face break out.

While you have to take good care of your skin every day of your life, it is especially important at pageant time, and it may be especially difficult. Most contestants wear a lot more makeup during a pageant, or while making personal appearances as a titleholder, than they do in their daily life: Cleansing is, thus, even more important. In addition, pageant contestants must be concerned with the skin all over the body, not just on the face. It is quite common to have problems with acne on the chest or back. Treat these areas as you would facial skin, using a moisturizer only if necessary.

If you find yourself under a lot of stage or television lights, you may need added moisturizer. Pay extra attention to your eyes and lips since there are no oil glands in these areas to replace lost moisture. If your skin gets dry, the little lines that form will make you look older and more tired. To help fight dry skin, and to cleanse your skin from within, drink plenty of clear water, at least eight glasses per day.

Problem Skin

If you have problem skin you may want to consult a dermatologist. You may need medication to help solve the problem from the inside. Acne used to be considered an adolescent problem that would be outgrown. Today, many women find that they suffer from this problem into their twenties and beyond. This is caused by changes in the hormonal system (sometimes caused by medications) and also by various chemicals and perfumes in cosmetics and even in skin-care products. Watch your intake of caffeine (including coffee, cola drinks, and chocolate), fats, and greasy foods. Also, try to keep your hands away from your

PREPARING FOR COMPETITION

face as they can grind in dirt and germs that can promote blemishes.

General Makeup Tips

When you have the canvas (your skin) in shape, you are ready to apply your artist's brush to create the prettiest you possible. Some situations will call for special makeup techniques, but your first task is to master the basics of makeup application.

Assemble the Right Equipment

Achieving the right look requires the right materials and tools. Organize a complete cosmetic kit for yourself. First, find a container that will hold all your materials. A fishing tackle box works well if it has lift-out or fold-out shelves so that you can see everything in the box quickly and easily. The container must also have a handle for easy carrying.

The next step is to assemble your makeup supplies. If she could only have three makeup items for daily wear, Barbara would choose a blush, mascara, and lipstick. For pageant competition the list of desired items is slightly longer. A collection of the essential items will include the following:

moisturizer

foundation

concealer foundation (one to two shades lighter than your overall foundation)

contour foundation (about two shades darker than your overall foundation)

translucent powder

blush—powder or cream

eyeshadow—several shades that complement your coloring and that will blend together well

eyeliner

eyebrow pencil

PUTTING ON A WINNING FACE

eyelash/eyebrow brush

mascara

eyelash curler

lipstick—at least two shades

lip gloss and/or petroleum jelly

hand mirror

sponge to blend foundation

cotton balls

cotton swabs

assorted sizes of makeup brushes

tissues (to be used to wipe makeup from your fingers—tissues are too harsh to use on facial skin)

Add your necessary manicure and hair-care items to this list. These items are sufficient to allow you to make up for any type of public appearance. They will enable you to utilize all sorts of makeup techniques.

Only apply makeup to a squeaky-clean face, using clean implements. Covering dirty skin with makeup only seals in the dirt and promotes blemishes. If you apply makeup over old makeup (except for the lightest touch-ups) you will end up with a patched look. Old makeup and new makeup do not blend well.

Keep your fingers out of makeup products as much as possible. Bacteria on your hands can quickly grow in moist cosmetics. Use a small spatula to scoop creams out of jars. Discard cosmetics as they grow old or discolored even if they are not used up. Mascara and liquid eyeliner should only be used for a four-to-five-month period and then be discarded. If the tube runs dry earlier than that, throw it out. Never try to stretch the useful life of these products by adding water or saliva to them.

Whenever you apply your makeup, you must double-check the color intensity and blending in the same level of light in which you will be seen. If you will be seen in a dim light, you can wear more intense colors than if you will be in bright lights.

PREPARING FOR COMPETITION

If you are applying everyday makeup, check the finished product in sunlight, which will reveal your truest colors and skin textures. Do not apply makeup under fluorescent lights as it distorts colors. If you will spend most of the day in an office, do inspect your makeup under fluorescent lighting. Since lighting can vary greatly, a good makeup mirror with adjustable lighting is a wise investment.

Lighting is also important when choosing cosmetic colors. Again remember that fluorescent lighting in stores can distort a product's true colors. Before you buy a product, sample it, then walk out into the sunlight to check its true color. The proper foundation color is especially important to avoid a masklike appearance. Test the color by blending a patch on your jawline. It should be as close to your natural color as possible. If you want to add a little more color, you can choose a color that is one or two shades darker, but blend it with extra care.

When choosing cosmetic colors wear a blouse that is as close to your pageant gown color as possible to see how they will blend with your gown. Keep your eye, cheek, and lip colors in color harmony (i.e., warm or cool tones) with your gown color. White and pastel gowns will reflect more light onto your face, making your makeup look more intense. Testing colors with your gown color will reduce the risk of having your makeup colors overpower you.

Concealing Undereye Circles

If you have dark circles under your eyes, learn how to cover them effectively. Dark circles are especially emphasized by the television camera. Dark circles occur because the blood vessels are too close to the skin surface. This creates a blue cast to the thin skin below the eye. Applying a pure white concealer, which has a blue tinge, will emphasize the problem by putting blue on blue. White can make you look like an owl. Instead of white, you should use a yellow-hued concealer. This shade will neutralize the blue cast. (It is also good to cover up redness caused by blemishes or sunburn.) Then simply cover the concealer with your normal foundation color and blend well. If the yellow color is too strong and bleeds through your founda-

tion, try softening the hue by mixing the concealer with a little white foundation to create a "French vanilla" color.

When working on dark circles, be very gentle. This tissue is delicate and will stretch permanently if rubbed or pulled, creating wrinkles. Use a cream or liquid concealer. Apply it using a small brush or the tip of your ring finger, which, due to the hand's construction, is naturally your weakest, and most gentle, finger. If you use an undereye stick as a concealer, never apply the stick directly to your skin. Pulling the stick across this delicate area is too abrasive. Rub the brush or your ring finger against the stick and then stroke or gently pat it onto your skin as you would a cream concealer. To guard against stretching the skin, start applying the concealer at the outer corner of the eye and circle in to the inner corner. Never apply powder under your eyes as it will dry the area, emphasizing wrinkles.

Highlighting and Contouring

One makeup "trick" is the use of highlighting and contouring to camouflage structural facial "flaws" or imbalances. By using lighter or darker foundations, you can emphasize or reduce a specific trait. Models commonly use this technique to create the kind of facial angles that cameras favor.

If you want to emphasize a feature or make it look bigger, use a color that is about two shades lighter than your foundation, or use white foundation under your normal color. For instance, placing a little white foundation on the highest point of your cheekbones under your overall foundation makes your cheekbones more prominent. A lighter color placed in skin creases around your mouth can make them less noticeable. Placing a dab of lighter foundation on the tip of your nose will make it appear longer. Ann Pohtamo, Miss Universe 1975, placed a line of white highlighter down her nose to camouflage a slightly crooked nose.

If you want to make something look smaller, use a darker base. For instance, you can create the illusion of having hollows under your cheekbones by blending a dark foundation into the area just below your cheekbones. If your forehead is too high, try using a darker base at the top, along your hairline;

if it is too wide, use the darker color on each side above your temples. Your contour color can be as dark as a "chestnut" shade as long as it is blended well.

Models know how to utilize these principles of light and dark. You too can become an expert if you are willing to experiment. If your problem is the opposite of the examples given, reverse the colors—use dark instead of light and light instead of dark. Remember that these tricks must be used in a subtle way. The use of too much contour to create hollows will make you look as if you have been socked in the jaw. These tricks should be used to make slight corrections only.

Painting Your Picture-Perfect Face

When applying your cosmetic "paints," use a light touch. Makeup should only be used to enhance your God-given beauty. The touches you add should reflect your personal style and accent your best features. Decide which feature you consider to be your best and then play it up.

Foundation. After you have used corrective shades in the desired areas, finish off your "canvas" by applying your normal foundation color to your entire face, including your eyelids and lips, and blend it into your hairline with a makeup sponge. Do not apply foundation to your neck. This will result in messy collars as the makeup will inevitably rub off onto your clothes. Since your neck will not be covered with foundation, you must pay close attention to blending around your jawline and ears to avoid a sharp contrasting line of color. Remember, the foundation color you choose is supposed to even out and enhance your natural color, not change it.

You want a matte finish to your makeup. Water-based foundation, good for oily skin, will give you a matte finish. If you have dry skin, you will want to use an oil-based foundation to counteract the dryness. This will give your skin a dewy look. Do not use any makeup product that has a glitter to it or your face will look speckled. To avoid shine and to set your makeup, lightly dust your face with a translucent powder. Use a full brush to powder, first shaking or blowing the excess powder off the brush.

PUTTING ON A WINNING FACE

Cheek color. Blush adds color and warmth to your face while defining your cheekbones. The type of blush you use will depend on your skin type. A powder blush will give you a matte finish. If you have dry skin, cream or gel blushers will again prevent a too dry appearance. For extra staying power, first apply a cream blush and then brush over it with a powder blush.

Blush color belongs on the high part of your cheeks. Smile at yourself to determine exactly where the color should go. The color should not come in close to your nose or below it. If you are using a powder blush, shake or blow the excess powder off the brush before touching it to your face. Apply powder blush starting just below your temples, and run it along your cheekbones to the puffy "apples" of your cheeks. By starting the application on the outer edge of your face, rather than on the "apples" extending outward, you will avoid having too much color at the center of your face. The color intensity should taper off as you move inward. If you use a cream blush, place three dots of it along the top of the cheekbone at the temple, and below the outer edge of the eye and the outer edge of the iris. Blend the cream down onto the cheek's apple and outward toward the hairline.

The secret to a healthy look of color is well-blended blush. Patchy color on your cheeks emphasizes the fact that you have used makeup. A makeup sponge will help you blend the color thoroughly. Check your blush from the front and sides to see if it is evenly applied and blended.

Eyes. Expressive eyes win points; attractive eyes draw attention and seem more expressive. Energetic eyes cannot be created with makeup since the energy must come from within, but they can be enhanced outwardly. Making up your eyes can be the most important, and most difficult, step in your makeup routine. You must become very skilled at applying eye makeup.

Glasses. Your eyes are so important to your appearance that if you are entering a pageant competition you should not wear glasses. If you cannot see the judge sitting across the table or walk across stage without falling into the orchestra pit without

wearing your glasses, wait until you have contact lenses before entering the pageant. (If you have braces on your teeth you should also wait to enter.) Meanwhile, if you do wear glasses, select your frames carefully. Take someone else along when you select the frames. Remember, you are not the one who will be seeing yourself in the glasses—a spectator's view is important. The color and size of your glasses should not overpower your face. Wearing glasses will require a more intense application of eye makeup, otherwise the color will be lost. When applying blush, wear your glasses and run the color just below the bottom rim of your glasses. The blush color should not ride up on your cheeks so as to be seen through your lenses.

Eyebrows. Eyebrows rarely meet the ideal specifications. Your goal is to come as close as possible to the ideal. Eyebrows ideally start right above the inner corner of your eye. To determine how far out your eyebrow should extend, place a pencil next to your nose and swing the upper end outward until it comes to the outer corner of your eye. Look up the pencil until you are in line with your eyebrow. This is how far your eyebrow should ideally extend. The inner and outer ends should be on a horizontal line. The arch of the brow should be above your pupil when you are looking straight ahead.

If your eyebrows do not meet these specifications, tweeze them. Before you tweeze your brows, look carefully at their natural shape. Follow the natural line and remove hairs only from the bottom edge. If you take them from the top, this lowers your brows and makes your eyes look smaller and squinty. Tweezing will be less painful if you do it right after you shower since the steam opens your pores. It is also easier if you pluck the hairs in the same direction in which they grow. This also prevents the hairs from breaking and leaving stubble. Your eyebrows must be neatly shaped with no stray hairs or stubble.

Be careful not to remove too much from your eyebrows. For years the look was to have pencil-thin eyebrows. Now, models like Brooke Shields have made the fuller, more natural eyebrow the new look. If you have overtweezed your eyebrows, it is very rare to have them grow back to their natural, full shape.

PUTTING ON A WINNING FACE

If you have overtweezed in the past, or have natural gaps or thin spots in your brows, learn to use an eyebrow pencil to balance their appearance. Choose a color that matches your eyebrow color not your hair color. Your eyebrows will naturally be slightly darker than the hair on the top of your head. The eyebrow pencil should be applied with thin, feathery strokes. Never draw eyebrows on your face.

To finish off your eyebrows, brush them against their grain. This will remove any residue foundation. Brush the hairs upward, smoothing slightly outward in an attractive arch. If your eyebrows are unruly, spray hairspray on your eyebrow brush and then brush the hairs into place. A clean, old toothbrush works well for brushing eyebrows.

Eye shadow. The color you place on your eyelids is called "eye shadow." It should be just that, a natural shadow, not a bright patch of color. Choose a color that is a variation (not an exact match) of your own eye color or that softly complements your eye color. Also consider your skin shades. If you have a yellowish complexion, for instance, gold- or green-toned shadows may make you look more sallow. The choice of color varies with the individual, even between sisters—Barbara uses green, and Polly uses plums. Pageant contestants should stay away from vivid colors. Blues are especially dangerous choices for most people. Plums, charcoals, and taupes are better for most people. Also avoid dark colors that will overpower your eyes.

Choose your type of shadow carefully. Cream shadows crease easily and may melt under strong lights. Powder and water-based shadows are better. They are less likely to separate and last on your eyelid longer. Water-based shadows will also allow you to vary the intensity of color for different situations. Less water gives a more intense color; more water creates a muted effect. To keep your eyelids from absorbing your shadow, first apply foundation to your eyelids. This will also ensure that your eye shadow does not turn color.

You will achieve the most natural effect if you carefully blend two or three hues of the same color. The lightest shade is placed beneath the eyebrow to open up the eye area. The middle hue adds the color to the lid itself. The darkest hue is used to shape the eye. It belongs on the outer corner of the upper lid

PREPARING FOR COMPETITION

extending up onto the outer edge of the brow bone. Do not blend this color down farther than the outer corner of the eye or it will make your eyes look tired and droopy. This darker color may also be blended into the crease of your eye to add depth if needed. It can be smudged at the inner corner of your eye to help draw in widely spaced eyes. The separate colors should not be distinguishable—blend them.

Eyeliner. Eyelining techniques can open up your eyes or make them look smaller. For instance, some eyes look bigger if they are entirely outlined with eyeliner. Others will look smaller if encircled. A better technique for the latter type of eyes is to use eyeliner on the lower lid and on the outer half of the upper lid. How much of your eye to line must be determined by experimentation and careful observation. Also, experiment with eyeliner or eye pencil colors. Black is often too harsh. A charcoal grey is softer. Midnight blue can make your eyes look whiter.

If you have trouble applying your eyeliner in a thin straight line, simply apply it in a series of small, close dots between the lashes and smudge with a fingertip or cotton swab. Smudging the liner to create a softer effect is the key to accenting the shape of your eyes. (Actually, your eyes have slightly different shapes, one will be smaller than the other, and eyeliner and eye shadow can help balance the sizes.) If you still have problems with your eyelining skill, apply your eyeliner before your eye shadow. The shadow will help mask any slight imperfections.

Mascara. For pageant competition use black, brown, or brownish-black mascara. Black mascara makes eyelashes look longer; brown mascara makes eyelashes look thicker. You can try having "mink lashes" by thickening your lashes with a coating of brown mascara, and then adding length by touching the tips with black. Do not use blue or violet mascara in pageant competition.

Before applying mascara, use an eyelash curler on your lashes. Curl your lashes in at least two spots so they look curled, not bent. Do not curl your lashes if they already have mascara on them as they may be brittle and break.

When applying the mascara to your lashes, wiggle the brush back and forth against both your upper and lower lashes to really coat them. Do not put mascara on the bottom side of your lower lashes or it will smudge. When using your mascara do not pump the handle up and down in the tube to coat the brush. Doing this will just pump air into the tube and dry out your mascara faster. To coat the brush, twirl it inside the tube.

The trick to mascara application is to get the thickest coating possible without clumping. Before applying mascara, separate your lashes using a small eyelash comb. Never separate lashes with a straight pin! It is too easy to slip and injure your eye. Invest in one of the small, dull-edged eyelash combs that can be found in a drugstore. After applying each coat, comb through your lashes again. To add extra thickness to your lashes, dust them with translucent powder before applying mascara and in between coats of mascara. Always let your mascara dry before adding another coat.

Use eye-makeup remover, cold cream, or petroleum jelly to remove your mascara thoroughly, otherwise it will build up and damage your eyelashes. Your eyelashes, like your hair, will benefit from extra conditioning. Once a week lightly coat your lashes with castor oil or petroleum jelly before going to bed. This will add shine and strength to dried lashes.

Lips. Choose a lipstick shade that blends with your cheek and eye colors. Be aware that some colors may make your teeth look dull or yellowish—avoid these. Polly applies her lip color as the final touch to her makeup. Barbara chooses to apply the lip color right after her foundation so that she can apply a balanced amount of color to her cheeks. Whenever you apply your lipstick, be sure your lips are first lightly covered with foundation and translucent powder. This creates an even-toned base and also helps the color last longer.

Lip color is best applied with a lipstick brush. If you use a tube, the color will stay where the tube passes. Your lips are not shaped like a tube of lipstick. A brush allows you to follow the natural curves of your mouth.

Before applying lipstick, you may want to outline your lips with a lipliner pencil in a shade that complements your lipstick

color. Barbara skips this step, but Polly finds it makes a difference and uses this tip for special occasions. Outlining prevents your lipstick from bleeding off your mouth. It also allows you to make subtle changes in the shape of your mouth. If your lips are too narrow, outline just outside your natural lipline; if they are too full, outline just inside that line. Outline your bottom lip from corner to corner. Outline each side of your upper lip starting at the center and working outward. Be sure to smudge the line inward. Use your lip brush to apply color within the outline. If you can see the outline after you have filled it in with lip color, it is too dark. No one should ever be able to discern that you have outlined your lips.

A word of caution when using lip gloss—do not use too much. A heavy gloss on stage or on television can make your lips look greasy. Add a dot of gloss to the center of your lower lip and then touch your lips together. The gloss will highlight the center of your mouth without making the color bleed from your lips. Another alternative is to rub a touch of petroleum jelly over your lipstick. Using a good lip gloss or petroleum jelly also will help keep your lips from drying. To add extra shine to your lips in photos, you can lick your lips, but avoid doing this on the stage or you will appear nervous. Do not make a habit of licking your lips as it will cause them to chap.

Makeup Tips for the Interview

When you are having the personal interview, your makeup should be very understated. Use the basic principles you would use for your daily makeup routine, but use extra care for this important judging event. Remember, tricks, such as highlighting and contouring, must be subtle when you will be meeting someone face to face.

If judges look at you and notice how well you have utilized your makeup skills, then you have applied your makeup wrong. Makeup should not be noticeable. Makeup that is poorly or obviously applied calls attention to itself and away from you.

Judges notice what has not been done right. Make sure your

makeup colors are right for your skin tone and coordinated with your outfit. Also, be sure to blend the colors well so there are no lines showing or patches of excess color. If the judges are distracted by how you blended (or did not blend) your blush, they are not seeing what you want them to see—you.

Makeup Tips for the Stage

The basic principles of makeup must be accentuated for the stage. Your foundation color must be darker because the stage lights will appear to wash color from your face. (Be sure to blend well to avoid a masklike appearance.) Your contour, blush, and eye shadow colors must also be intensified, but do not go overboard.

Using a darker makeup does not mean the same thing as using heavier makeup. Your stage makeup colors must be darker, but your makeup application should not be heavier. When applying your makeup take into consideration how close you will be to the judges. If they are seated close to the stage, you will not want to darken your makeup colors quite as much. You do not want to appear "made up" as you pass by the judges.

Do not use trendy makeup looks. For instance, some performers use glitter in their hair or place it at the corners of their eyes. Do not do this. You are not dressing in a costume. You want elegance, not flashiness.

Mascara may not be enough to enhance your eyelashes on stage. You may want to supplement your own lashes with artificial ones, applying the following guidelines.

1. Eyelashes do not have to be expensive. Many types are available at a discount store. (Barbara bought hers for $1.79.)

2. Spend time experimenting with artificial lashes before you get to the pageant since they may need reshaping to make them look natural.

3. Apply your lashes after you have applied all your eye makeup except for the mascara. Use the mascara to help blend the artificial lashes in with your own.

PREPARING FOR COMPETITION

4. Get used to wearing the lashes so that you look and feel natural and do not blink excessively. Eyes tend to react this way whenever a foreign object is placed near them.

5. Do not use false eyelashes during the interview unless your natural lashes are unusually short or thin and your false eyelashes look very natural.

6. If you feel uncomfortable wearing false eyelashes, do not wear them. Polly has never liked or needed false eyelashes so she never wears them. Whether or not you use false eyelashes is a personal choice.

Makeup Tips for Television

Televised pageants present special problems. Contestants appear before the judges and a live audience on the stage and to the home audience on television. The judges also view them on television monitors. This presents a problem since makeup techniques used for television are very different from those used for the stage.

What should you do? Definitely make up for television. Millions of people will be seeing you through this medium and the judges watching you on the monitors will expect you to look great on television. They are more likely to notice a bad appearance on the television screen than one on the stage.

The television presents you as you would be seen in a live interview situation. Colors have to be only slightly darker because of the strength of the lighting used for the cameras. Eye makeup and cheek color must be applied with extra care because television close-up shots magnify every detail of your appearance. You may not want to wear your false eyelashes at this point. Remember you are always trying to achieve a natural look. Since television lighting can wash you out and camera angles can distort features (i.e., the camera will add ten extra pounds to your appearance), making you look unnatural, you will have to work to regain your natural appearance.

During your months of preparation pay close attention to the colors and techniques used by television actresses who have your coloring. Some colors do not come across well on camera.

Bright blue eye shadow looks especially ghastly on television. Use plums, greens, or light browns instead. Again, do not use any glitter products on your face, body, or hair. Use translucent powder to give your makeup a matte finish and prevent looking shiny under the lights.

Be sure to check your makeup in the bright kind of lighting used for television. The best way to check your television makeup skills is to videotape yourself in very bright light (in a studio if possible) and then study the tape. This session also can be used to practice your interview skills.

On the night of the telecast, there may be professional makeup artists available for your use. Do not use them if you can avoid it. They do not know you and may not be able to provide you with the look with which you are personally most comfortable. Know how to apply your own makeup and do not depend on anyone else. Always apply your own basic makeup, then go to the professional artist, if you want to, for a final check-up.

Your Smile

Smiling is not only the greatest way to enhance the beauty of your face but also is an indication of the true beauty of your spirit. The smile comes not so much from your mouth as it does from your eyes. If your eyes do not sparkle, turning up the corners of your lips will look phony. Perhaps the one thing that most readily turns off a judge is a pasted-on smile.

While you do want to smile on stage, you do not want to smile the same smile for the entire pageant because after a while, it looks insincere. Instead, relax your mouth, and use your eyes to project the warmth of your inner smile. When you do smile with your mouth, keep it relaxed with your lips parted slightly (but be careful not to bare your gums or to draw your lips in when you smile).

Hints to Combat a Wavering Smile

1. Nerves can make your mouth look frozen or make your lips quiver. If you have difficulty maintaining a smile for an

PREPARING FOR COMPETITION

extended period of time try touching the tip of your tongue to the back of your two upper front teeth and push gently. This action will help control your mouth muscles and lift the corners of your mouth.

2. A common problem on stage or in parades is developing a dry mouth or lips. This makes it hard to smile and to speak. Rub a little petroleum jelly over your front teeth to help your lips glide easily over them. This does help. If this suggestion sounds unpleasant, remember the key to this trick is using a small amount. If you use too much petroleum jelly, it will gather between your teeth. Needless to say, this looks awful. It makes your teeth look greasy. Use only a little.

3. The best way to make your smile look natural is to really mean it. Remember that you are living your pageant dream. You should be enjoying every minute of it. If you like what you are doing, your smile will reflect that. If you believe in yourself, your smile will reflect it.

4. If you find that nerves are getting in your way, think of something else that you find pleasant or relaxing. Try reciting the alphabet or a simple poem in your head. Barbara mentally recited "The Lord's Prayer." This mental exercise may distract your nerves enough to keep them from attacking the corners of your mouth with a twitch. A word of warning: Do not, under any circumstances, get so wrapped up in your private thoughts that you mentally drift away. Often a contestant will develop a vacant stare and look as if she is hundreds of miles away. Your eyes and posture, as well as your smile, should reflect your total presence on stage at every moment.

5. The best trick of all is to find someone in the audience to direct your smile at. Find a family member or friend in the audience and smile at him or her. Smile at the judges (but not incessantly). Smile at a stranger or an imaginary person in the audience.

Love Your Audience

Remember that the audience is part of your pageant experience. Love that audience. Keep telling yourself how much you

love them. Tell them how much you love them by your smile. This applies during the pageant, while riding in a parade as a titleholder, or walking down the street as a private citizen. Love people and your smile will sincerely show it. Show people that you love them, and they will love you back.

11

Hair: Your Crowning Glory

A beauty queen's hair is her crowning glory. It can make or break her appearance: It should never look inappropriate. Most of the people who meet a titleholder will only see her once, so a titleholder needs to look her best every day. Looking like a winner requires more than healthy, clean hair; it requires the right style.

Finding a Stylist

The first step to your hairstyle is to find a stylist you can trust. Make sure that the stylist wants to get to know both your hair and you since your hair should reflect your personal style and the image you want to convey. It is always a good idea to schedule a consultation with a prospective stylist before you let him or her work on your hair (some stylists charge for this service). When you do find a stylist you like, stick with him or her.

Do not choose a stylist solely on referrals or reputation. The ideas and temperament of the stylist you choose must mesh with your own for this is a personal relationship that could have a significant impact on your self-image. Polly learned this the hard way. Polly once had a disastrous permanent given to her by someone who did not know her or her hair. She was miserable with the result, but she had to live with it for almost two years before it had grown out. Having learned the hard way, she has now found a stylist she trusts.

Do not try to save pennies by merely choosing the cheapest stylist. Such cost savings become expensive if you are miserable over the resulting hairstyle. Remember, it is worth spending a little extra to be sure you receive the individualized attention and skill you deserve.

HAIR: YOUR CROWNING GLORY

Choosing a Versatile Hairstyle

The magazines may be showing the latest popular style, but it may not be flattering to your face. The "right" style must be the one that is right for you. It should also be a style that does not fight the natural tendencies of your hair. For instance, if your hair is naturally curly, do not try to create a straight hairstyle. Work with your natural curls. Experiment to find the style that is right for your features and your type of hair.

Select your hairstyle well in advance of the pageant. Never make a drastic change in your hairstyle within two months of the pageant. Give yourself time to adjust to any changes and to learn how to get the most out of your new style.

You will want your hairstyle to be versatile so you can change the look for the different activities you enjoy in your personal life. For the pageant, however, you should choose one hairstyle to wear every time you are before the judges. You can vary the style when you are in rehearsal or at community events, but you should never change it during the judging. Your hairstyle is part of the image you are creating. Judges do not get to see you very often and when they do it is for a brief period of time. Do not run the risk of confusing the judges as to your identity. You want them to be able to recognize you quickly.

Sometimes contestants wear their hair down for the swimsuit competition and then put it up for the evening gown segment. While this worked for Kim Tomes, Miss USA 1977, it is generally not recommended. Think very carefully before changing your hairstyle. Remember, you are trying to create an image. Also, the judges may be distracted by the fact that you have changed your hair and overlook some more important point. Be consistent for the judges.

Framing Your Face

Keep in mind that the live audience will be looking at you from one angle, but the home audience will see you from *all* angles. You want to keep your face visible from all vantage points. Stand in front of a mirror and look at yourself from

PREPARING FOR COMPETITION

different angles using a hand-held mirror. You should try different styles to see which flatters you most. Try pulling the hair back from your face at the sides so that your profile can clearly be seen. Debra Sue Maffet, Miss America 1983, softened her look and cleared her profile view by pulling her side hair loosely back with combs. If you are thinking of wearing your hair up on your head, consider whether it fits your personality. Be aware that piling your hair on your head can make you look either matronly and dowdy or sophisticated and elegant.

Length

The length of your hair also creates an impression. Long straight hair may make you look like a high school homecoming queen, not a national pageant winner. Really short hair may be too severe when you want a softer look. Make sure that your style creates the impression you want to portray to the judges. That impression should always be that of a lady.

Color

Titleholders have won with a variety of hairstyles and colors. Contestants, coaches, and the press may try to second-guess the judges' preference for a given year, but it does not always work. For instance, after years of blonde Miss USAs, a bevy of blondes appeared at the 1981 Miss USA Pageant. The press kept predicting that 1981 was the year for a brunette Miss USA. Kim Seelbrede, the winner that year, had a mane of blonde hair. Judi Ford won the Miss America title after she refused to dye her blonde hair brunette, despite the fact that a blonde had not won the Miss America title in years. Phyllis George changed the tide of Miss America hairstyles when she won her crown in 1970 with her hair down instead of piled on her head. Terri Utley, the Miss Arkansas who was selected Miss USA 1982, was a real shock for some Miss USA buffs. Unlike most of her predecessors, Terri's hair was cut up to her ear lobes. Do not try to second-guess the judges. Choose a hairstyle and color that suit you.

HAIR: YOUR CROWNING GLORY

Ready to Wear the Crown

Since you are going into the competition confidently, you should give some thought to how a crown would look with your hairstyle. You may have to adjust your hairstyle after you win to best show off the crown. When you first receive the crown, however, you also want it to look right. If you have combs or flowers in your hair the crown may not sit on your head properly. Barbara wore the front of her hair pulled up with a barrette secured high at the back of her head. The Miss USA crown, which encircles the head, resting low in the back, was able to fit securely without hitting the barrette. If she had been vying for a crown that rests on top of the head, the barrette may have caused a problem. Know what the winner's crown looks like and plan accordingly.

It is common, and unfortunate, that the pictures of the winner at the coronation show the crown askew. The crown has even fallen off the winner's head. This happened to Phyllis George when she was crowned Miss America 1971. She handled the mishap with queenly grace. She stopped, picked up the crown by bending at the knees, and continued her walk to the throne carrying her new crown in her hand. Make sure your hairstyle will not fight against the crown's proper placement on your head.

Maintaining Your Hairstyle

The pageant hairstyle you choose must be natural-looking and easy to maintain. You are the one who has to take care of it when you walk out of the salon. Let the stylist know how much time you can afford to give to caring for your hair. Like most of us, you probably cannot afford to have a personal stylist do your hair every morning. The pageant you pick may also forbid the use of your own stylist during the competition. You have to know what to do with your hair. Watch how the stylist creates the style. Ask questions as it is being done, take notes if you have to, and then go home and practice recreating the look.

You will have little time to care for your hairstyle during

PREPARING FOR COMPETITION

the pageant week or during your reign as a titleholder. Start to finish, your hairstyle should not require more than thirty minutes each day, and it must last from very early in the morning to late at night. Remember also that television and stage lighting can make your hair go limp very quickly. You may also be confronted with weather that is different from that at home. Think ahead. Choose a style that is quick and adaptable. Arm yourself with any necessary tools, such as rollers, driers, mousses, hair sprays, umbrellas, and scarves.

The most crucial step to beautiful hair is to keep it clean. Unless you have really oily hair, wash it every two to four days as needed. The time between shampoos may vary with your age and the length of your hair.

When you shampoo, lather your hair *once* (bottle directions that tell you to lather twice are only designed to make you buy twice as much shampoo), rinse, apply a conditioner or cream rinse, and rinse thoroughly with clear water. Massage your scalp with your fingertips, do not scratch it with your nails. Alternate shampoos and conditioners every few cleanings to avoid building up a dull residue on your hair (shampoo A will strip shampoo B and vice versa).

Deep-condition your hair once a month (more if it is damaged by permanents, coloring, or too much sun). Use a commercial hot oil conditioner or try using natural products. Polly conditions her hair periodically with mayonnaise, a naturally rich beauty aid which tends to be less expensive than commercial hair conditioners. She applies it to her damp hair, covers it with a plastic head wrap, waits for at least twenty minutes (sometimes she sleeps with it on), and then shampoos thoroughly (this time it will take two latherings). To enhance the conditioning benefits, sit in the sun or under a warm hairdryer while the mayonnaise (or other oil conditioning product) is on your hair. The heat will help the products penetrate the hair.

Dry your hair carefully to avoid split ends, which will weaken and dull your hair. Blot dry with a towel. Let it air-dry if your hairstyle allows, or dry with a warm drier held at least six inches from your hair. As the hair dries, reduce the drier temperature. Wet hair will break more easily then dry hair, causing split ends, so never brush wet hair. Use your fingers to loosen snarls,

then comb sections of hair from the ends upward to the scalp using a wide-tooth comb.

Remember to keep your hair tools clean. Soak brushes in a basin of water and ammonia to remove all oils and dirt. Rinse the brushes thoroughly with clear water and let them air dry on a towel. If you use rollers, clean them periodically (if they are electric, do not soak them in water, just clear off excess strands of hair and wipe them clean). These tools are personal items which should not be shared with others except in an emergency.

Never wear curlers during pageant rehearsals. Electric rollers will have to suffice to pick up your style for evening activities and also the judging sessions. Make sure your rollers are dependable. Pack a long extension cord and a timed appliance starter. The latter will give you more precious moments of sleep as you will not have to get out of bed early to plug in your curlers. Barbara found her hairstyle held longer if she set her hair at night and slept in rollers. She only used electric curlers to revitalize the curl in the evenings.

During the actual telecast you must change outfits so quickly that you will be lucky if you have the time to run a comb through your hair. Time constraints are important to remember when selecting your wardrobe. Avoid costumes that require you to wear your hair in a way that is different from the way you will wear it for the rest of the pageant. For instance, be wary of a headdress that would require you to push all your hair into a skullcap. You will not have time to restyle your hair as needed for the next segment of competition. Bring along a scarf with which you can cover your head when you are changing. This will help protect your hairstyle and your makeup.

Wigs and Hairpieces

Wigs are not acceptable in most pageants. You may usually use hairpieces. If you choose to supplement your own hair with a hairpiece, make sure the color matches exactly. Take someone with you when you are shopping to get a second opinion. Check out the color in different lighting (store lighting is very misleading). Take or wear the hairpiece outside in the

PREPARING FOR COMPETITION

natural light. Work with the piece to learn how to place it properly so it is firmly secured and looks natural. Barbara travels with a hairpiece that can be attached in an emergency. For example, she may be scheduled to attend a formal dinner shortly after riding in a parade and it rains during the parade. If the rain or wind straightens her hairstyle, she merely pulls her hair back, adds her artificial curls, and she is ready for dinner.

12

Taking Care of Details

Tanning

Excessive tanning can quicken the aging process of your skin and even cause skin cancer. A healthy glow to the skin is, however, essential in pageant competition. A "healthy glow" means a light golden color. It does not mean you have to make your skin a dark bronze color. In fact, a bronze tan on someone who normally has a light complexion is not as attractive or natural on television as is a light tan. A little color makes you look healthier. A tan is especially important in the swimsuit competition to avoid a washed-out appearance on stage. Remember that television and stage lights tend to neutralize colors, making you look even paler on stage than you do off stage.

Be careful not to develop tan lines. These unsightly marks really detract from your appearance. Here are some hints to help you avoid tan lines:

- If you must provide your own competition swimsuit, it is best to tan in that suit.
- If you are unable to tan in the swimsuit in which you will be competing, choose your tanning suit carefully to minimize strap marks. If your pageant provides the competition swimsuit, remember it may be cut in a style that is very different from yours. Be prepared.
- Try tanning in a variety of suits.
- When you are tanning, readjust your straps and leg edges regularly so that you do not develop sharp, distinct lines. You want to make your tan blend into your normal skin tone in hazy lines.

PREPARING FOR COMPETITION

- ♦ Be wary of any suits with cutouts in the design.
- ♦ Look for suits that will allow you to tan without the straps connected. Avoid straps that crisscross in the back, or shoulder straps that cannot be unhooked. Try using a two-piece suit that will allow you to unhook the back strap or a one-piece with a wide-cut back and high-cut leg line for maximum tan coverage.

Some state titleholders have the luxury of winning trips to the Bahamas or other tropical locations to work on their tans for the national pageant. This, however, is the exception. If you live in the South or if the pageant is in late summer, geography or the seasons may naturally provide you with the chance to get a tan. For those who live in the northern climates and have to compete in a winter or early spring pageant, a tan is still possible. Even in a climate like Minnesota's it is possible to develop a tan by early May. Barbara did. She found an isolated location on her college campus that was directly in the sun. Every day at peak sun time, Barbara would take her books out and study in the sun. This way she finished all her finals early so she could attend the Miss USA Pageant in May, and she had a tan when she got there.

Tanning booths and sunlamps may be another answer to getting a light winter tan. If you use these methods, use them very carefully. These methods are probably the most dangerous to your skin. Make sure you follow the directions. Increase your exposure time gradually. Remember, you are only trying to develop a light tan and you do not want to sacrifice the long-term health of your skin.

The way you treat your skin today may not show its results for twenty years. Heavy exposure to the sun may give you a dark tan today and leave you with wrinkles and dark spots twenty years from now. It will be hard to correct what you caused so many years before. The best steps to take are to use sun screen and avoid heavy exposure to the sun now.

Three Don'ts

1. Do not use body makeup to simulate a tan. Many contestants make this mistake. Body makeup is messy and usually looks unnatural. Get the real thing or go without.

TAKING CARE OF DETAILS

2. Do not use oil or lotion on your legs before going on stage. It is a common mistake to apply baby oil or hand lotion to legs before going out on stage. Do not do this. The oil or lotion will pick up the light in an unnatural way. If you have very dry legs, use moisturizing lotion on them regularly during your months of pageant preparation to correct the problem, but do not apply lotion within an hour of going on stage. Your skin will not have a chance to absorb it and you will look oily.

3. Do not wear nylons during swimsuit competition. Many pageants specifically prohibit nylons during the swimsuit judging. Even if nylons are not strictly prohibited, your legs should be bare during this segment. Nylons are not the way to add color to your skin. They will make your legs look shiny and unnatural. The judges will be able to tell you are wearing hose, no matter how light in color or fine in texture.

Nail Care

In the opinion of Prince Henri d'Orléans, the Count of Paris and a judge for the Miss Universe Pageant in 1976, hands can be one of the biggest clues to how well a woman takes care of herself. Pretty nails do not necessarily have to be long or polished—that is a matter of personal preference—but they do have to be clean and shaped. Most pageant competitors have long, but not clawlike, fingernails. Nails should be shaped into graceful almond shapes. This is true for local and national pageants, for both teenagers and adults. Treat yourself to a professional manicure to help find the appropriate shape and length for your nails. Watch carefully the procedures used so that you will be able to duplicate them.

You want your hands to be smooth and soft so use a hand cream or lotion regularly. If your hands are especially dry, before you go to bed, slather your hands with lots of cream or rub petroleum jelly on your moist hands and cover them with white cotton gloves. Your hands will be deep-conditioned as you sleep.

If your nails refuse to grow, you should first take a look at your habits.

- Do you, heaven forbid, bite them?
- Are you eating foods that provide necessary nutrients such as calcium?
- Do you use your nails as tools to remove staples, open envelopes, dial phones, etc.?
- When doing housework, do you wear rubber gloves or immerse your hands in water and chemicals?

If you have really worked at your nails and they still keep cracking or splitting you may want to try false nails or nail extensions. Have your first set applied at least two months before the pageant so you can adjust to the added length.

Pageant contestants wear fingernail polish. Think carefully about the color you will use. If you are in a teen pageant do not use a bright red or other harsh color. It is better to be understated. This is even true at the adult level.

Your nail color also should be coordinated with what you are wearing. This takes special planning for the pageant program itself. You may have to be introduced in a purple dress, wear a pink swimsuit, and then compete in a red evening gown. Your polish must not clash with any of these outfits. Even during the pageant week you should try to plan your polish to go with as much of your wardrobe as possible for you will not have time to keep redoing your manicure every night.

You cannot go wrong wearing a clear or neutral beige-toned polish. Neutral colors will go with everything in your wardrobe. If you should happen to chip the polish during the day, it will not be as obvious or messy-looking as it will be if your polish is a bright color.

When caring for your nails, do not forget your toenails. In dressy sandals or casually in bare feet, your toenails may show, sometimes when you do not expect them to. Give yourself a proper pedicure. If you choose to use polish on your toenails, it should match your fingernail polish.

Unwanted Hair

While thick hair on the top of your head is an asset, abundant hair on any other part of the body can cause embarrassment.

TAKING CARE OF DETAILS

Unwanted hair often appears on the face, arms, bikini line, or legs. What can you do about it? The most common methods of removing hair on the legs are shaving, waxing, or using a depilatory.

Leg Hair

In a pageant, it is important to remove all traces of hair on your legs both above and below the knee. When you are on stage, any fuzz catches the light and accentuates the presence of the hair or stubble, even if very light in color and texture. Since you are often very close to the judges' table, and your legs may be at their eye level while you are on stage, make sure they will not see any unwanted hair.

Bikini Line

If you have to compete in a swimsuit, pay close attention to the bikini line. Oversight in this area is unsightly and potentially very embarrassing. You may want to consider waxing this area. Since you may be given a competition suit that is cut higher than your own, be sure to remove enough hair so that it will not be seen when wearing any suit.

Facial Hair

Many women are bothered by the presence of a light mustache or other facial hair. If the hair is light, bleaching it may be enough. As with leg hair, however, television light may make this fuzz more noticeable. You may want to remove it completely. The best way is to have it permanently removed by professional electrolysis. This is expensive and time-consuming, but it is permanent. If you have it done, do it well in advance of any important public appearances as the procedure may cause some temporary redness or swelling. Such temporary reactions should clear up within a few days. If you cannot afford electrolysis, consider waxing away the problem. Never shave facial hair!

Perfumes

Do not ignore the sense of smell. For the pageant, choose a scent that reflects your personality and is not overwhelming. The use of perfume should be subtle. You do not want to suffocate those in the rooms you enter.

A pleasant scent puts a nice finishing touch on your grooming. Since the sense of smell is very strong, your scent also adds to the overall image you are trying to create. While some women like to vary their scents with their mood or activity, others advocate always using the same scent so that people will associate that particular scent with them.

Sleep

Do not overlook this beauty aid. Sleep is important not just during the pageant or the week before, it is also crucial throughout the months of preparation. Sleep affects your skin, hair, nails, and also your disposition and discipline. It is harder to stick to your preparation routine when you are tired. You should get at least seven hours of sleep a night. Know your own needs. You may be a person that needs eight or nine hours of sleep. Try to get this sleep during the same time each day.

13

With Queenly Grace

Stand like a Queen

Posture is one point that cannot be overstressed. Your hair and makeup can be just right and your dress may cost hundreds of dollars, but if you slouch the image is ruined. The contestant with rounded shoulders will not win the crown.

Improving your posture can create a whole new image. It may take time to correct years of bad posture, but it is worth it. Concentrate on it for a few weeks and it will become a new habit. With good posture you can make even a bargain basement outfit look like it cost hundreds of dollars. You will also look confident on stage, even when you are nervously awaiting the judges' decision.

Five Steps to Proper Posture

Hold your shoulders back. To find the proper placement for your shoulders, try rolling them forward, up, and back. Now relax. Your shoulders should stay back and not be hunched up. The placement of your shoulders should be natural and comfortable. Your shoulder blades should not be pinched in the back.

Your chest should be held high. An added benefit of good posture is that it will do great things for your bustline. (Remember, your bust should not sag, jiggle, or bounce.)

Pull your stomach in and tuck your derrière under. One pageant coordinator suggested that you pretend you are walking with a silver dollar held between your buttocks. Not a very

genteel suggestion, but effective. The image will cause you to tighten your lower regions, pulling them into their proper positions.

In a three-way mirror, carefully study the way you stand. You do not want any trace of a swayback. This is particularly noticeable, and unattractive, in a swimsuit.

Hold your head up high. You do not want to walk around looking at the ground. Besides looking like a turtle, you will appear less confident. Your ears should be directly over your shoulders. Your eyes should be looking out at eye level. Our mother used to always tell us to imagine we had a string tied to the top of our heads, pulling us upward, or that we were each carrying a glass of water on our heads. Try imagining this—it really works.

Queenly Stance

An attractive alignment starts at your head and continues down to your feet. You may be standing tall, but if your feet are spread apart or pigeon-toed, the queenly image is spoiled. Learn to stand like a model.

The modeling stance is like third position in ballet. Pretend you are standing on a clock face. Place your right foot so that it points to two o'clock. Place your left foot in front pointing to twelve o'clock. Pull its heel into the ball of your right foot, and bend the knee slightly. Do not lock your back knee. If you are on the left side of the stage, this is the stance you should use. If you are on the right side of the stage, reverse your feet so that the left foot is behind, pointing to ten o'clock, and the right foot is in front, pointing to twelve o'clock. With practice, this stance will become comfortable and natural.

On or off the stage, this stance will give a flattering and photogenic three-quarter view of your body. This is especially important in swimsuit competition. It will tilt your hips slightly so they will not give a straight-on view, which makes them look wider. The angles of your legs are also much more graceful with this stance than if you stand with your feet apart or straight

on with your feet locked together. A straight-on view emphasizes any faults in your leg construction (i.e., knocked knees or bowed legs). Locking your knees also will make you sway. The modeling stance will give you more support. If nerves attack you, bend your knees slightly to act as shock absorbers, which will minimize shaking knees.

Arm Position When Standing

To finish off your queenly image, let your arms hang softly at your sides. Never clasp your hands or fold your arms in front of or behind your body. Your shoulders should be slightly angled to follow the same line as your hips. This will cause your arm farthest from the audience to be slightly behind your back hip and your other arm to be slightly in front of your other hip.

Relax your arms from shoulders to fingers. Your hands should hang limply at your sides, not bend outward at the wrists in awkward angles. Do not clench your fingers. If relaxed, your fingers should curl gently. Tuck your thumb slightly behind your index finger. It is very unflattering to clasp your hands in front of you. Stand in front of a long mirror, clasp your hands in front of you with your arms relaxed. Notice where your hands are. Do not stand in this position! Also, do not clasp your hands behind your back, cross them at your chest, place them on your hips, or let them move from position to position. Your hands belong at your sides when you are standing.

Study yourself in the mirror. Adjust your stance to camouflage any figure faults. After careful observation, Polly noticed that her arms caused her to look stiff because they turned out at the elbows. Her arms were in fact quite relaxed. Since Polly's arms are double-jointed, her elbows are naturally twisted outward by the weight of her arms. To create the illusion of having relaxed arms, Polly had to learn to point her thumbs backward, twisting her arms inward, and to hold them that way. What was in reality an unrelaxed stance for her looked relaxed and more flattering on stage. You may have to utilize a similar compensating trick to correct a personal problem.

PREPARING FOR COMPETITION

Walk like a Queen

The proper pageant walk is different from most people's normal walk. Most people learn to walk by placing their heel first and then shifting their weight forward. Onstage, this can make you look and sound awkward and heavy on your feet. Practice walking so that you lead with the balls of your feet. Do not tiptoe across the stage, but strive for a gliding feeling.

The walk you develop will depend on the age level of your pageant and the category in which you are competing. Lynn Reis Scheuneman, a frequent choreographer for teen pageants, tells her teen contestants to "bebop" across stage. This term describes the youthful, enthusiastic step used by teens, but this spirit must not go uncontrolled. "Youthful" does not mean you should not be graceful and even-paced, it just means you should have a light spring in your step. In adult pageants, you will want a subtle version of the bebop step when you compete in your swimsuit. You want to convey a vivacious, cheerful image. Practice walking with your feet and knees acting as tiny springboards, but be careful that you do not overdo it. You want just a subtle spring in your step when you compete in your swimsuit.

In contrast, whether in a teen or an adult pageant, you want to float across stage in your evening gown, looking graceful and regal. The evening gown walk is similar to gliding on ice skates. Practice gliding smoothly so your head does not bob up and down when you walk (think of your knees now as being tiny shock absorbers). Concentrate on keeping your upper body from moving when you walk. Never let your hips swing from side to side when you walk.

Your walk must be properly paced. Never rush across stage—it will make you appear nervous and won't let the judges get a long enough look at you. When onstage, take your time and enjoy it. This is your special moment in the spotlight, and you have worked hard to get there. This does not mean you should crawl at a snail's pace. It is agonizing for the judges to have to watch a contestant who meanders across stage at an unnaturally slow pace. To keep an even gait, Elaine Hall, president

of the Gem Academy of Modeling in Minneapolis and a frequent pageant coordinator, advises her models to mentally recite the poem "Mary Had a Little Lamb" and then pace their walk to its rhythm. This tip really works.

Like a model, learn to walk on a straight line. Imagine you are on a tightrope. Your heels will land on the rope, but your toes will be pointed slightly outward to give you balance. Barbara's right foot had a tendency to swing out too far, giving her what she called her "duck walk." She had to practice pulling her foot into line until the placement became natural for her. She practiced it often when walking across campus to classes or to church.

Place one foot directly in front of the other. If you walk with each foot pointing straight ahead, landing on either side of, instead of on, the imaginary tightrope, there will be an unbecoming distance between your legs. You will look like you are plodding across the stage.

Your hips should lead your whole body forward in one easy motion. If you lead with your shoulders or head, your body will appear tipped forward rather than erect. You do not want to appear as if you are zooming headlong across the stage.

Arm Movements when Walking

If you were walking down the street with your hands at your sides, they would naturally swing. Let them swing on stage. When you step forward with one foot, the opposite arm should swing forward gently from the elbow. Don't exaggerate the movement, but do not stifle it either. Make sure you are not swinging your shoulders as you walk, just your lower arms.

Turning Smoothly

The pageant turn is the same pivot that models use. Imagine you are facing the audience while standing on a clock face in the proper pageant stance, your left foot pointing at twelve o'clock with your right foot behind, pointing at two o'clock. Step forward on your left foot, then bring your right foot around in front so that it points to about ten o'clock. Rise up

PREPARING FOR COMPETITION

slightly on your toes, twist 180 degrees to the left, then lower your heels. If you have done this properly, you should be again in the pageant stance with your left foot at twelve o'clock and your right foot at two o'clock, but you now have your back to the audience. Repeat the pivot and you will again be facing the audience, having turned 360 degrees.

The pivot can be tricky at first. Do not get frustrated, just keep practicing. Once you get the hang of it, you will pivot without even thinking about it. Be sure to learn how to pivot to the left, as just described, and also to reverse the steps to turn to the right. Practice walking directly into a pivot without stopping in the pageant stance—this will make you move more smoothly when you are in fashion shows.

For the evening gown competition, you may not want to use the pivot. In the Miss USA Pageant this segment is staged so that the contestants will not have to turn in place. Instead, the women walk in a small circle. Turning this way makes it easier to handle long, full skirts. Remember, when wearing your evening gown, you should never use your hands to move your skirt except to manage a staircase. Never flair your dress as you walk or turn. Occasionally, a contestant will try to be different by twirling her chiffon skirt as she turns before the judges. Do not do this—it looks too stilted and showy and will call the judges' attention to your dress and away from you.

Handling Stairs

Long dresses can be a challenge when ascending stairs. Definitely lift your skirt with a free hand so that you do not trip. If your skirt is one layer, you may be able to gracefully lift it with the center of the skirt clasped between your forefinger and middle finger. If it is multilayered or more cumbersome, use two hands, if necessary, to clear your step enough so that you will not trip. Practice tackling stairs in your competition gown so that you can do it as gracefully as your particular dress allows. To go up a flight of stairs, place your foot on the upper step and raise your body using your forward leg.

When descending stairs, stand tall and lower your body from

the knees, reaching for the lower step with your toes. Do not simply drop down to the next step. A controlled descent will make you look like you are floating down the stairs. It will also allow you to descend without staring down at your feet. You should look out at the audience as much as possible. If you have to check your step, glance down briefly with your eyes, but do not lower your head. Practice this movement, concentrating on keeping your head from bobbing up and down with each step.

Do not walk down stairs with your body angled sideways, but also do not walk down head-on to the audience. Again, it is more flattering to give the judges a three-quarter view. Angle your body so that you face slightly toward the center of the stage. During your preparation period, attend a professional fashion show and observe how trained models move on the stage, and how they handle tricky stage settings (i.e., stairs, props, escorts, etc.).

Wear the Right Shoes

A graceful walk depends in large part on the shoes you wear. Do not wear flat shoes no matter how tall you are. Never wear wedge or wooden heels; they are sure to appear (and sound) clunky. Choose a neutral pump or an evening sandal with a heel that gives you sure-footed support. Choose a high heel, but not one so high that you look like you are falling forward or walking on your tiptoes. Be sure to break in your shoes before the competition—you do not want to be distracted by pinched toes or blistered heels. Also, wear your competition shoes when you are rehearsing so you get used to the feel of the stage in those shoes.

A Courtly Curtsy

As a contestant you may be asked to curtsy to the judges, audience, or the reigning titleholder. If you are not asked to curtsy, it is better not to. Wait to demonstrate this grace after you have won the title. A curtsy is a regal gesture that may be used during your first official walk as queen or your last.

Learning to curtsy properly must be part of your training, just in case it is needed. Practice the following steps in front of a mirror:

1. Place your right foot behind and slightly to the left of your left foot.

2. Let your arms hang loosely with your right arm slightly forward and your left arm slightly behind you. Do not hold onto your skirt.

3. Bend your knees so that your body lowers gracefully, but keep your upper body erect.

4. Bow your head slightly as you go down.

5. Straighten your knees slowly so you rise up gracefully; at the same time raise your head.

Be sure to practice curtsying in your long dress. You want to make sure you do not find yourself in the same position as BeBe Shopp, Miss America 1948. BeBe wore a hoopskirt when she gave up her crown. When she curtsied, the skirt's hoop formed a suction with the stage, and she was unable to rise without assistance.

Handling Escorts and Flowers

Many pageants use military escorts during the evening gown competition. When your escort offers you his arm, smile at him, then slip your hand through his circled elbow and rest it lightly on his forearm. Never lean on him or grip his arm tightly. If he offers you a rose, look him in the eye and accept it with a smile before turning to face the audience.

If you are presented with a single rose, do not cradle it on your arm like a baby. Simply hold the stem between one thumb and index finger placed one-third of the way from the blossom and the other thumb and index finger placed one-third of the way from the end of the stem. Your other fingers should be held close to your index finger. Hold the flower no higher than your waist with your elbows close to your body. If your pageant uses a ceremonial scepter, this is also how you should

hold it. You may also choose to hold a single flower between the fingers of one hand held low next to your side.

If you are presented with a bouquet of roses, do not make the common mistake of cradling it next to your body as many winners do. This will crush the bouquet and may stain your dress if the moist petals rub against you. Instead, hold the bouquet securely from behind with one hand at the ribbon. The bow should face the audience. Circle your other hand around the bouquet to cradle the stems. If you need to lift your dress to manage stairs or if you have an escort, you can use the second hand freely as the bouquet is really carried by the hand at the back of the ribbon.

The bouquet should be held slightly away from your body, with your arms resting on your hip bones, so neither the flowers nor your dress will be crushed. Remember, you may be photographed later in that same dress without the flowers, so keep it clean. If you are seated and holding the flowers, hold them as previously described, but lower your arms so the flowers appear to be resting in your lap. Do not hold them up against your body.

Handling Props Gracefully

Pageant events may include a fashion show in which you may have to carry a sponsor card. Cards and other such props should be carried gracefully, but as inconspicuously as possible so as not to distract from you or the outfit you are modeling. Hold your hand with the palm facing upward, then place the card in your palm and gently curl your fingers in front and your thumb in back to support it. Drop your arm to your side, carrying the card low, and double-check that the card will be visible to the audience.

If you have to remove a coat, on or off stage, do it with grace. Ease the coat from your shoulders. Reach behind you to hold one sleeve so that you can slip your arm out, then reach across in front to hold both sleeves as you remove your other arm. When putting a coat on, never swing it around your shoulders. Hold it to the side by its collar as you slide one arm into the sleeve, then reach your other arm behind

PREPARING FOR COMPETITION

you to slide into the other sleeve. Lift the coat up and over your shoulders. Be sure your hair is not caught inside the collar.

Sit like a Queen

Posture is also important when you are sitting. Unfortunately, studying can be a posture wrecker. Hours of hunching over your school books can cause rounded shoulders, back pain, and added tension. Make a point of sitting up straight in a chair with a hard seat. Chairs with soft bottoms and soft backs invite you to lounge in positions that are temporarily comfortable but eventually ruin your posture. In the long run, your body will be in better shape if you sit erect.

Never plop your body into a chair. Every time you sit down do it as if you are about to sit on the winner's throne. Approach the chair, turn around and stand so that the back of one leg lightly touches the chair. This will allow you to sit down without having to turn and look at the chair. Simply bend gracefully at the knees until you are sitting on the edge of the chair, then slide back so that you are comfortable on the chair.

Crossing your legs may be a harmful habit. It is bad for your circulation and can cause varicose veins. If you simply are not comfortable sitting without crossing your legs, at least do it properly so that your posture looks attractive. Place your feet slightly to the side of your chair and tilt your knees slightly to the other side so that your crossed leg rests along side of your other leg. This alignment of your legs is more flattering than it is if you let your crossed legs form an inverted V. Your hands should rest together on your lap on the side opposite from your feet. Never cross your legs when sitting on your throne or on stage.

If you can sit comfortably without crossing your legs at the knees, cross them at the ankles and tuck them slightly under you and to one side. Your knees are always together. Even when you think no one can tell how you are sitting because you are wearing a long dress, they can tell when your knees are unfemininely apart or your feet are wrapped around your chair legs. Sit correctly no matter where you are or what you

are wearing. Again, your hands should rest in your lap slightly to the opposite side. Your shoulders should be back and your head held high. Your entire body will be in a graceful and, if properly done, comfortable alignment.

Note: Do not sit down in your evening gown before you go on stage or you may wrinkle the back.

14

Your Wardrobe

The old adage that clothes make the woman is not true. If you wear a three-hundred-dollar outfit and slouch or have not groomed properly, you will not present a winning picture. On the other hand, if you are properly groomed and stand tall, you can look (and feel) like a million dollars in a fifty-dollar gown.

The truth is that the person makes the outfit, not vice versa. This is true in pageant competition as well as in everyday life. It is very important to have an appropriate and carefully selected wardrobe. Your clothes should always enhance you. You do not want to be overshadowed by what you are wearing. Do not let the clothes wear you.

What Clothes Will You Need?

The number and types of outfits required for competition depend on the pageant.

- How long is the competition?
- Will the judges be attending rehearsals?
- How many public functions will you be attending and will the judges be present?
- Do you need a state costume?
- Do you need a talent costume?
- Do you have to provide an outfit for the production number or will the pageant provide these for everyone? (Usually, you will need more stage outfits at the local or state

YOUR WARDROBE

level because these pageants do not have the budgets to outfit all the contestants.)

The basic wardrobe requirements for the Miss USA Pageant judging are:

1. One full-length evening gown for the evening gown competition.

2. One becoming, professional-looking interview outfit.

3. A state costume to be worn in the Best State Costume competition.

These are the only outfits that you must provide in which the judges will see you. The Miss USA Pageant sponsors provide a production number costume, special outfits for the pretaped "fun films," one swimsuit for the pretaped segment, one competition swimsuit (all contestants compete in identical swimsuits, which allows for fairer judging), a street-length dress for the announcement of the semifinalists, and two or three pairs of shoes to be used on the telecast. (Be sure to allow room in your suitcase to bring home these extra outfits.)

Since the basic requirements for the Miss USA Pageant include only three items, it may sound surprising that some contestants arrive at the pageant with ten suitcases. The reason is that the competition covers three event-filled weeks. The judges only see you on a few occasions, but you must look good throughout your stay in the host city. Other outfits you must bring include:

1. Several comfortable rehearsal outfits.

2. Two or three noncompetition formals.

3. At least two or three cocktail dresses to be worn in the evening.

4. Five or six dresses (not formals), as you will be expected to dress for dinner each evening.

5. One swimsuit for the pool. (This is optional as you will probably not have time to take a dip.)

6. Something comfortable to wear in the backstage dressing room.

PREPARING FOR COMPETITION

If you are competing in the Miss America Pageant, you will have to provide more of your own wardrobe. You must supply the outfit for the announcement of the top ten, as well as your talent costume. You also must bring at least one one-piece competition swimsuit. (Contestants are judged in nonuniform swimsuits.) Depending on how often the contestants will appear on the telecast for your year, you may also have to purchase two or three more evening gowns for the telecast.

In assessing your wardrobe needs, remember that it is better to underdress rather than overdress, but be aware that when your pageant schedule says "casual," it may really mean "semiformal." Barbara was not forewarned of this fact when she headed for the Miss USA Pageant. She was astonished when Miss Texas showed up to a "casual" event wearing a billowing chiffon cocktail dress, while Barbara was wearing a Western denim-skirt outfit. Think in pageant terms and consider the specific event. If it is a rehearsal, "casual" means casual (but never jeans). If it is an evening affair or the public will be in attendance, you will want to wear something fancier but not overboard.

If it is unclear what is appropriate, a classic suit is your best bet. A suit can be appropriately worn in the day or evening. It can be dressed up or down depending on the accessories you choose. If the event turns out, in fact, to be casual you can take off the jacket for a simpler skirt and blouse look.

Pageants will often provide special T-shirts for the contestants, so a pair of casual slacks in a neutral shade is essential. Polly had an interesting encounter with a judge over this portion of her wardrobe. The Miss Teenage America contestants were given red-and-white shirts with a profile of the pageant emcee, Bob Hope, which were to be worn for Mr. Hope's arrival. It also happened to be the first day on which the judges were allowed to attend rehearsals. Every contestant wore dark-colored pants, except Polly. The only basic pair of pants she had packed was white. A judge later asked her whether her sister (then reigning as Miss USA) had advised her to wear the white pants. After Polly answered that she wore the white pants simply because they were the only pants she had that went with the unexpected shirt, the other judges demanded

that the questioning judge apologize for the inappropriate question, which she did.

The wardrobe you choose will have to travel well. Try to utilize lightweight separates in a generalized color scheme. Pack lots of accessories. This will maximize your wardrobe while minimizing your luggage. (Chapter 15 gives details on how to pack efficiently.) Choose high-quality fabrics that can be worn in a wide range of weather and which do not wrinkle. (Knits and lightweight gabardine are good choices.) If you are counting on wearing a piece more than once, be sure its label says "wash and wear," in case you have to rinse it out.

The rest of this chapter gives you tips on how to select clothing for rehearsals and for each of the judging categories.

Rehearsal Wear

Rehearsals are hard work and can get very long. You may work up a sweat. You will want to wear very comfortable clothing. The choices of the contestants range from expensive jumpsuits, to sundresses, to exercise wear, to shorts or slacks and sports shirts. Miss New Mexico 1982 chose to wear specially made rehearsal short sets, identical except that she had a different color for each day. Such extravagance is unnecessary and may even cause some friction between contestants.

At most pageants, the judges are not allowed at rehearsals, but this is no excuse to look sloppy. Remember that the press will be there taking pictures. If your picture is taken, you could be seen by the public, and even a judge, in newspapers around the country, including your home state. For this reason, while jeans are not officially banned, you should not wear them at a pageant. Dress comfortably, but neatly, at all times. You should always be prepared to make a public appearance in whatever you choose to wear to rehearsals. You want to project a winning image to the pageant organization, other contestants, and the press and public, as well as to the judges. The winner is a lady and dresses as one.

Be sure to wear comfortable shoes for rehearsals, but also bring your competition shoes to rehearsal. Heights of stairs

PREPARING FOR COMPETITION

can feel very different in high heels than in flats. The stage may feel more slippery in dress shoes than in tennis shoes. Be sure you walk on various portions of the stage in the shoes in which you will be competing. If you are wearing new shoes, first break them in so they will not be uncomfortable. This should be done before coming to the pageant; however, if necessary, wear the shoes around the auditorium or your hotel room and roughen the bottoms by scratching them on cement to prevent slipping on stage.

Take a sweater with you to rehearsals, one that can be easily slipped in and out of quickly. After working up a sweat on stage, you do not want to catch a cold sitting in a cool, drafty auditorium during breaks.

Choosing an Appropriate Interview Outfit

The right interview outfit is critical. You want to look your very best when you face the judges one-on-one. One pageant suggested that the interview outfit should be one you would wear to church. A better description is that you are going to a job interview, so dress for one. Your outfit should be appropriate for a business meeting that someone of your age might attend. A classic suit is always safe. A tailored dress is also a good choice.

At some national pageants, a few contestants have worn evening gowns, sequins, or clinging cocktail dresses. These are most inappropriate. The contestant (or perhaps her coach) has forgotten that this category is an interview. Go in understated. The judges want to meet you. Your clothes, like your makeup, should not be flamboyant or distracting.

Everything you wear for the interview must be carefully planned. Check to make sure your lingerie does not show through an open neckline or a slit in your skirt when you walk or sit. Lingerie should not be visible through the material of your clothing.

Your jewelry should be simple and enhance your outfit, and, in turn, enhance you. If your outfit and personality require a bold statement, wear large gold earrings and a matching necklace that draw attention up to your face. Do not try to make

YOUR WARDROBE

a statement by wearing an accessory on every part of your body. Wearing a ring on every finger looks clunky and may hurt the judge if you shake hands. Also, never wear noisy jewelry, such as a charm bracelet or an armful of bangle bracelets, which may distract or annoy the judge.

Your outfit does not have to be expensive or even new. Barbara wore a yellow wrap dress that she bought on sale. She traveled to the pageant in this same outfit, with the addition of a wide-brimmed yellow hat. Polly wore a yellow knit dress with a blouson jacket that she purchased at a factory outlet store.

Rather than worrying about cost, you should be more interested in whether the outfit reflects your good taste and personal style. Choose a color and style that is flattering to you and makes you feel terrific. You want the color to project a warm and lively impression. Stay away from drab colors. Vivid shades of the primary colors—red, yellow, and blue—are good. White also works well. Do not wear a too-bold print that may distract the judges. Do not try to get by in a polyester knit that looks cheap. Also do not wear an outfit that screams, "I'm homemade!" It is great to wear something you made, but you do not want it to look "homemade." Take an honest look at the outfit you are considering and ask whether it looks like something a Miss Somebody would wear. You want the judges to see you as the next Miss Somebody.

Selecting a Flattering Swimsuit

The swimsuits worn in pageants have varied over the years. In the 1950s, the swimsuits were extremely heavy one-piece Lastex suits with heavily formed brassiere cups, built-up shoulder straps, and modesty panels. In the 1960s, the maillot was introduced. This was still a heavily constructed one-piece suit, but the modesty panel was removed and the cut of the legs was higher. In the late 1970s, the Miss USA Pageant introduced a swimsuit that was to promote "the natural look." This "second skin" swimsuit was made of Antron nylon and Lycra spandex, and for the first time there were no built-in cups.

The Miss USA Pageant has long stood behind its policy of

PREPARING FOR COMPETITION

forbidding any kind of padding or temporary means of changing body measurements. This rule is strictly enforced. In fact, in 1981 Miss New York was disqualified from the competition for having padded her swimsuit.

In contrast, the Miss America Pageant encourages padding. Morrie Greenblatt has fitted Miss America contestants for more than forty-five years. His swimsuit alterations often include adding what he calls "normalizers" (falsies), which push small breasts up and outward, making them look bigger and giving added cleavage. "Taping" is another common trick at the Miss America Pageant. By bending over and taping breasts as high as possible by criss-crossing strips of surgical tape, contestants can maximize cleavage. One also can minimize a waist by cinching it in with tape. These tricks are strictly prohibited at the Miss USA Pageant.

Even if your swimsuit will be provided for you at the national pageant level, you will have to provide your own for the local and state competitions. The right swimsuit can make a vast difference in your chances for the crown, so choose carefully.

To demonstrate how much the right swimsuit can affect the outcome of the pageant, one can look to the "supersuits" created by Ada Duckett, a Texas dressmaker. These first were created in 1979 and there were originally only two "supersuits" (sizes 8 and 10). In 1985, five suits were made available, and all five wearers made it into the top ten. Again, the supersuits (including one pale-pink suit) were predominant in the top ten in 1987. One was worn by the winner, Kellye Cash, Miss America 1987. Ms. Duckett has lent her special suits each year to the first Miss America Pageant contenders who contact her. The only stipulations are that the wearers must (1) have good bodies and (2) agree to hire her to design at least one pageant gown (at a price tag of approximately $1,000). Ms. Duckett customizes the swimsuits to the wearers and gives two hours of instruction on how to put on the swimsuits. Contestants who have worn these special suits have consistently won the swimsuit category. The same original suit was worn by two Miss Americas, Cheryl Prewitt (1980) and Debra Maffet (1983).

The cut of your swimsuit can help mask figure faults. The spacing of the shoulder straps can widen or narrow the look of your shoulders. Wider shoulder straps can hide large back

YOUR WARDROBE

wings (shoulder blades). A high swimsuit back will divert attention from a large derrière, and low backs will divert attention from flat ones. Adjusting the neck and armholes can prevent too much cleavage from showing. Raising or lowering the cut around the leg openings can make legs appear longer or shorter, wider or thinner.

Do not wear a swimsuit with a high French-cut leg, the kind that comes up to your waist. Swimsuits that have armholes cut too far down on the side will reveal too much bust. You never want to be able to see the outer part of your bust. This area usually appears to be sagging in a swimsuit and is both unattractive and too immodest for pageant competition. Avoid rounded necklines or bandeaux, which cut you straight across. These necklines will flatten small busts and emphasize busts that are too large. A V neck is best. If the neck is too low, close it in slightly by stitching up the front V a little. You may also want to close any peepholes and remove any bows (as Ada Duckett did when creating her special swimsuits).

The color of your swimsuit is very important. It should be a bright, *solid* color (no prints or stripes). Never wear black, brown, navy blue, or pastels. Find a vivid color that complements your skin tone. Try cerise, royal blue, red, or turquoise. Again, white is always good for stage, provided you do have a tan.

The great fear of contestants is that they may have "fanny overhang." This dreaded condition is caused by the back edge of the swimsuit creeping high up on the buttocks. The best ways to counter unsightly "fanny overhang" are to tone the buttocks and hips with exercise, and select a swimsuit that fits well. Try moving in the suit before you buy it—walk, sit, bend over from the waist, and crouch down by bending your knees—the suit should continue to cover your derrière. You can also fight against having your suit crawl up by pulling forward on the material at the crotch, which in turn tightens the material around your buttocks. Susan Akins, Miss America 1986, used the same sticky spray that baseball players use on their gloves to help them catch, but she applied it to her buttocks to keep her swimsuit from riding up. You may find this type of adhesive spray in your sporting goods store (before using such a spray, read the can labels and patch test it to avoid any possible allergic reactions).

PREPARING FOR COMPETITION

The year Polly competed in the Miss USA Pageant, the swimsuits were cut so wide on top that the contestants were concerned about getting too much "exposure" on national television. Some chose to use double stick tape along the bust edge to keep the swimsuit in place. Another popular trick is to tape your nipples down with the adhesive parts of Band-Aids to keep them from showing through your swimsuit. These tricks, which merely keep you in your swimsuit, are distinguished from those used to alter its shape and are allowed in both the Miss America and Miss USA pageants.

In swimsuit competition, do not wear pantyhose. No matter how sheer, they will shine in the light, and won't fool the judges. You should also not wear a watch or any jewelry, except small simple earrings. Finally, if you should have your period, you must use a tampon, *never* a sanitary napkin.

Choosing a swimsuit also requires you to choose good competition shoes. Polly chose to wear taupe high-heeled sandals. The color and airiness of the shoes made them unnoticeable. Wearing heavy, or brightly dyed shoes will draw attention to your feet and, necessarily, away from your face. Wearing a skin-toned shoe will make your legs appear longer as it will not cut the visual leg line at your feet. The shoe should be easy to walk in—wobbly ankles will be noticed when you are in a swimsuit. You cannot go wrong with a classic pump. Never wear wedgies, platform heels, or loose shoes that will flap against your heels as you walk.

Tasteful Talent Togs

The outfit you wear must be suitable for your talent. The possibilities are so vast that it is difficult to give advice on what to choose. Just remember that you want to look as beautiful during your talent competition as you do for the other categories. Again, choose a lively color, unless it absolutely does not fit into your talent (i.e., you are presenting a dramatic monolog from a tragedy).

Go through your presentation step by step, and consider the predominant angle from which you will be seen. If you will be playing the piano, the judges will watch you from the

side. Make sure your outfit is flattering from a side view when you are seated. Since your arms will draw attention by their movement, the sleeves should be flattering. Sequins may fit with your talent presentation better than with your evening gown since talent presentations usually lend themselves to a flashier look.

Polly played the harp for her talent in the Miss Teenage America competition. Since the harp is usually associated with elegance, Polly chose a soft silk evening gown that flowed around her harp stool as she sat and gently draped her arms as they moved. To allow easy arm movement, her dress had elasticized insets running from the neck down across the shoulders. She chose a bright red color since red looks great on stage.

Choosing a State Costume

The state costume is required by the Miss USA, Miss Universe, and Miss Teen USA pageants. Each contestant must bring a costume that is indicative of her particular state. It is the first outfit in which the judges will see you; thus, it is a very important part of your overall presentation. You will wear it in the Opening Ceremonies, the Preliminary Judging Show, and the final telecast. A prize is given for the best state costume.

Your costume must be colorful and original. You will not win a prize by wearing the same costume that has been worn by every other representative of your state. Your costume cannot bear any official trademarks or brand names, and professional sports team uniforms are strictly prohibited. Ideally, one should be able to identify your state merely by looking at your costume.

Think carefully about what feature belongs uniquely to your state and how you can portray that attractively in costume. Some past examples include:

Miss Washington as Mount St. Helens

Miss Colorado as an aspen tree

Miss Nevada as a slot machine

PREPARING FOR COMPETITION

Miss Minnesota as an ice skater (complete with ice skates)

Miss South Dakota as a pheasant

Miss Kentucky as a jockey

Miss Pennsylvania as a firecracker

Miss Texas as a rhinestone-studded cowgirl

Barbara's costume depicted Minnesota as a "Winter Wonderland." She wore a long, furry, white skirt, a jeweled top, and a fur headpiece. Her costume was particularly appropriate for Minnesota as the top was borrowed from the costume department of the Ice Follies, which originated in Minneapolis.

Polly's costume was designed in a special contest held at the Minneapolis College of Art and Design. The final result, "Minnesota: The Land of Ice and Snow," was a silvery-blue sequined dress (portraying an icicle) and a midnight blue velvet cape edged in white marabou and studded with large glittery snowflakes. Her headpiece was made of similar snowflakes that dangled above her head on thin wires.

You will have to dance in your costume. Be wary of any costume that may cause movement problems, not only for you, but also for those around you. One contestant came as a butterfly with a six-foot wingspan. Polly had to hold the train of her cape in a modified manner to allow her to dance in the opening number. She also had to be careful backstage to guard against having her snowflake headdress tangle with Miss Colorado's aspen branches.

Polly's long cape came in handy for another contestant who had a difficult costume. Miss Massachusetts, who won the 1981 costume award, wore a skirt, midriff top, and shell-shaped headdress made out of forty-seven pounds of lacquered, glittering seashells. The shell skirt was structured in two panels that were completely open on the sides, so only a G-string could be worn underneath. The problem came when the contestants had to go to the beach to tape the opening number. Miss Massachusetts could not sit in her shell skirt. She had to dress at the beach, where crowds had turned out to watch the taping. The dressing room problem was solved by having a group of contestants gather on one side of Miss Massachusetts with Polly shielding

YOUR WARDROBE

the other side with her cape. If you have a difficult costume, there is no guarantee that someone will have a long cape. Try to make your costume as easy to move in as possible. It should also be packable, and transportable.

You must also be able to get in and out of your costume very quickly with no assistance. On the telecast, you will have to change from your costume to the sponsor's dress in the space of a few commercials. You will not have time to re-do your hair. The original design for Polly's costume required a skull-cap headdress. This type of headpiece would have destroyed any hairstyle, and had to be redesigned. Choose your costume with quick changes in mind. Practice your costume changes before you get to the pageant.

Choosing a State Gift

Along with a state costume, a Miss USA contestant must choose a state gift that represents her state. For instance, Barbara presented a peace pipe carved on a Minnesota Indian Reservation. The gift represented Minnesota and was symbolic of the Miss USA role as an ambassador of goodwill. As part of the Opening Ceremonies, the gifts are presented to a host state official (usually the mayor of the host city). The gifts are put on display and then sold in a silent auction that raises money for a charity.

Many of the gifts are frivolous. For example, Miss Alabama 1981 brought a football autographed by famed coach, Bear Bryant, and Miss Alaska brought a piece of the Alaskan pipeline. Miss Wisconsin 1981 brought her weight in Wisconsin cheese (which could not be auctioned off due to health regulations). Novelty gifts may cause more attention at the presentation, but practical gifts, which also represent your state, better serve their fund-raising purpose. Polly presented a painting of Minnesota's Lake Itasca, the source of the Mississippi River, which was painted by a Minnesota artist. Help the charitable cause by trying to bring an item that is practical or decorative.

Before you choose a gift, brainstorm with your state director, family, and friends as to what represents your state. (Also do this to choose a costume.) When you have an idea of what gift you want to give, think of who can help you obtain it. Is there a store that specializes in memorabilia from your state?

PREPARING FOR COMPETITION

If you know a local artisan, ask for a contribution. Call your Department of Tourism, or the office of your governor, and ask for their help in obtaining a suitable gift.

The Ultimate Evening Gown

The most important outfit you will wear in front of the judges is your evening gown. This elegant segment can do much to impress the judges and also to make you feel like a queen. When you glide across the stage, you will be the center of attention. You want a gown that will make you feel enchanting. It does not have to cost you a fortune, as long as it makes you look like a million bucks.

When selecting a competition dress, plan for disaster. Always bring at least one extra gown to the auditorium. Barbara was rewarded for her insurance preparation when she competed in the Miss Universe Pageant. She intended to wear a vivid blue silk gown; however, when she put it on backstage, the zipper fell out of the back. Barbara simply wore the white chiffon dress she had brought with her as insurance.

Polly also had to switch to her Plan B dress. She was supposed to wear an evening gown designed and made by a design contest winner. The gown did not arrive at her home until three o'clock in the morning she was to leave for the national pageant. The delivered dress was too short and looked too homemade for a national pageant. Polly would have been left without a competition gown if she had not planned ahead. Always carry a spare.

Color

The best color for an evening gown has always been white. (All contestants in America's Junior Miss Pageant wear white gowns.) It is classic elegance. This is the color Barbara chose. If you do not wear white, wear a bright color. Red is excellent. A vivid blue (periwinkle or royal) or turquoise is good. Emerald green, maize yellow, or cerise will also help you draw attention. Pastels will wash out on stage to look faded or "yellowed." Avoid obvious patterns. Prints tend to be less elegant than solid colors. A final don't—don't wear a black or brown evening gown. Black

YOUR WARDROBE

may work for a cocktail party, but it is not a good choice for the stage or screen as it makes objects (you) recede into the background (fade out of the judges' view).

Sequins, Rhinestones, and Beads

When you think of pageants, you may think of glittery evening gowns. On national telecasts, contestants often wear sequins, rhinestones, or dangling bugle beads. They are also worn at state and local pageants. These dresses are similar to those worn by entertainers. The jewels catch the stage lights and add flash—sometimes too much flash. Be careful that your dress does not "wear you." Jewels that dazzle too much may blind the judges to what you want them to see—you.

If you are choosing an evening gown for an offstage event, remember that sequins, rhinestones, and beads will not have the same effect when they are not under bright stage lights. Off stage, or on, you cannot go wrong with a simple chiffon gown in a beautiful color. If you really want some sparkle, add an accenting touch—a jeweled waistband, rhinestones scattered across your bodice or the edge of your skirt, or rhinestone spaghetti straps.

Style

There are two basic pageant evening gown styles. The most traditional look is a fitted bodice, with an empire or natural waistline, and a soft, full skirt. The second is the body-hugging gown which usually has sequins, rhinestones, or beading. Most of the competition gowns are variations of these two styles. Miss USA 1986 won in a slightly different style. She wore a pink tunic gown with a drop waist that was designed for her by her state directors, who design under the Guyrex label. The hoopskirted gown is gaining some popularity (if you wear one, practice walking and sitting in it as hoops can be very tricky to maneuver).

The style should always be regal. You should not choose a gown that may shock the judges. Avoid very low necklines or extremely high slits in your skirts.

Before you decide on a style, try on several different cuts.

PREPARING FOR COMPETITION

Take along a trusted friend, and leave your preconceived notions of what is "you" at home. You may just find that a neckline you have never worn before does wonders for your neck and bustline. As you try on different styles and materials, study yourself carefully from all angles. You must be physically comfortable in your gown. You also want to be mentally comfortable with the look, but listen carefully to your friend's observations. Remember, it is crucial how you look to others, namely the judges.

The style you choose should make you feel pretty. It should also reflect your personal taste and enhance your figure type. The right style can hide weak points.

- If you want to look taller and slimmer, stay away from knit materials, which show every ounce of weight. Instead, wear chiffon, which will camouflage weight and make you appear to glide across stage.
- If you are too thin, choose a waistline that fits around your natural waist, and a bouffant skirt. Avoid necklines that will reveal protruding collarbones. Soft, billowing sleeves will disguise too thin arms.
- Height is an asset in pageant competition, but if you are a little too tall, a tiered skirt will make you appear shorter.
- If you are too short, avoid designs that will divide your body line (i.e., don't wear tiered skirts, which will cut your lower body line into sections). A short contestant should never wear a bodice that is a different color from her skirt.

The Fit

An ill-fitting evening gown, regardless of how much you pay for it, will not enhance your figure. Make sure it has a professional finish and fit.

- The dress should drape your figure gracefully without any pulling or sagging from the shoulder to waist.
- The bustline should mold to your bosom with the darts falling in line with the fullest part of your bust. Adding

YOUR WARDROBE

boning will help define your shape in lightweight fabrics (it also holds up strapless dresses).

- The shoulder seams should be exactly on the top of your shoulders (approximately an inch behind your earlobes). They should not be visible from the front.
- Check the fit across your shoulder blades to be sure it is not too snug. If you cannot hug someone in the dress, it is too tight.
- The armholes should not be cut so high that they are uncomfortable (also, if they are too snug under your arms on the tense night, perspiration may show through).
- Long sleeves should be measured to the wrist bone with your elbows bent. Make sure that fitted sleeves are not too fitted.
- Side seams should fall from the armhole to the floor in a straight line.
- The waistline should fit snugly without wrinkling. If it is a fitted waist, make sure it hits at your natural waistline.
- The fabric should fall easily over your hips and derrière without wrinkling.
- The hem should be slightly (about one to two inches) off the floor when you are wearing your competition shoes. This will give you some clearance to avoid tripping on the hem.
- The dress should be comfortable. You should be able to walk, sit, and handle stairs easily.

Undergarments

Achieving the proper fit will be aided by choosing the proper undergarments. Wear these garments when you have your gown fitted. They should be of a neutral color that will not show through your dress. You should never see brassiere straps. If in doubt, wear a strapless bra. It is also a good idea to sew dress shields into your dress if possible to protect your expensive gown and to prevent perspiration from showing.

The most important undergarment is your slip. The bright stage lights may make the skirt of your evening gown see-

through, so wear a long slip. If your dress has a slit, the skirt must be lined. The lining should be heavy enough to block out stage lights so that a separate slip will not be necessary. Otherwise, the slip must be color-coordinated and custom-made to prevent the slip from peeking through the slit.

Accessories

Your competition shoes should either match the color of your skirt or be a basic silver or gold evening slipper with a high heel. Be sure they are broken in before the pageant. Wear these shoes at least once when working on stage (especially if you will have to move on stairs) to get the feel of the stage.

When selecting jewelry, remember that it is better to under-accessorize rather than to overdo it. If you are wearing sequins, rhinestones, or beads, stick to sparkling jewelry rather than pearls. Pearls mix well with soft materials, but rhinestones look better with sparkling dresses and with the crown you hope to capture. If your evening gown has a lot of sparkle to it, you will need very little jewelry. Dramatic earrings may be enough—try dangling rhinestones. Avoid heavy rhinestone necklaces that scream "costume jewelry!" If your arms are bare, add a dainty bracelet that matches the other jewelry you are wearing. The key is to coordinate your jewelry pieces to each other and to your evening gown while keeping the overall look uncluttered.

One of the perennial pageant questions is whether or not one should wear white gloves. The overwhelming answer is that gloves are passé. But if you do choose to wear gloves, be sure the length goes with the style of your gown. If you are in a teen pageant and are wearing a youthful dress, wear wrist-length gloves. If you are projecting a more elegant image, wear full-length (above the elbow) gloves. Never wear three-quarter-length gloves, which reach just below your elbow. Also, never wear any jewelry over gloves.

Wardrobe Expenses

Miss America contestants receive $1,000 to defray their wardrobe expenses. In 1978, it was estimated that $150,000 was

spent in excess of the pageant's total allotted wardrobe allowance. That figure is undoubtedly more today. The prize money awarded to state winners is often used to acquire the additional national pageant wardrobe needed or to pay debts incurred in competing at the state level.

The amount of money spent on a wardrobe varies drastically depending on the pageant, the state, and the individual. For instance, Miss Texas 1983 chose forty outfits for the Miss America Pageant, at a total cost of $25,000. Miss Michigan, in the same year, chose a $5,000 wardrobe consisting of seven evening gowns, two suits, and many dresses and swimsuits. Neither of these contestants won.

One Miss Ohio was asked how she could justify the expense of competing in a pageant. She responded that she had bought her competition gown at the Goodwill for $7.00 and had hired two people to sew on the beads. It is possible to look great at the national pageant without spending a fortune, but you need to plan carefully and know your budget. Barbara found this to be a creative challenge.

When Barbara arrived at the pageant, she was amazed at the number of dollars being spent. She was a student at St. Olaf College and did not have much money to spend on clothes. The Minnesota pageant organization did not have the kind of clothes sponsors that some of the other states had. For example, the Miss Texas-USA state directors are dress designers who create the very popular and gorgeous Guyrex gowns worn by many contestants and titleholders. Miss Texas-USA naturally wins an extensive wardrobe of beautiful gowns created especially for her by her talented state directors. For example, in the 1986 Miss Universe pageant, Christy Fichtner, Miss USA 1986, wore a lace and silk, bugle-beaded gown which would have retailed for $10,000. This exclusive gown was created for her by her former Miss Texas-USA state directors. Barbara had to use her own limited resources. She planned ahead and shopped carefully to maximize the impact of her dollars. Barbara won the Miss USA title wearing a gown that she had purchased on sale and that she had worn on many other occasions.

You do not need to spend a fortune to win. The judges are usually instructed to disregard the expense of an outfit and to

PREPARING FOR COMPETITION

only consider whether the outfit is in good taste and flattering. The judges also do not know or care where you got your clothes. Elizabeth Ward, Miss America 1982, won in a dress made out of a tablecloth. Some Miss Louisiana-USAs have worn rented gowns. Polly competed in most of her pageants wearing borrowed evening gowns. Your pageant sponsors should provide you with an appropriate competition gown and funds to purchase whatever else you need. If they don't, do not spend vast amounts of your own money. Borrow a few outfits from friends. Better still, approach local merchants about supplying your pageant wardrobe in exchange for a little informal modeling in their stores. Above all, remember it is what is inside you that will win the pageant, not what you are wearing.

15

Traveling Tips

National pageant winners may virtually live on the road. Miss USA is only guaranteed one day off during her reign—Christmas. For almost a year she will live out of suitcases. It requires organization to coordinate a wardrobe so as to get a maximum number of outfits into a limited number of suitcases and to be sure all supplies are on hand. Barbara's constant travels, both as Miss USA and now as a businesswoman, have made her an expert on efficient packing.

What to Pack

Packing for a trip can leave you with that uncomfortable feeling that you are forgetting something very important. To ease this feeling, start a list as early as possible of things you will need, and add items as you think of them (these are examples of what Barbara calls "thoughts while brushing your teeth"). On a personal trip, the advice is "if in doubt, leave it out," but for a pageant or appearance trip, you do not want to skimp on your wardrobe—"if in doubt, put it in." As you review your list, eliminate only those items you positively do not need. As you pack, you can refer to your list and check off each item as it goes into your suitcase. To help you start your personal needs list, here is a list of suggested items for traveling titleholders (suggested number of outfits for a three-week pageant are in parentheses).

COMPETITION CLOTHING
 evening gown (and alternate gown which you can also use for dress rehearsal)

PREPARING FOR COMPETITION

interview outfit

swimsuit (if needed)

talent costume (if needed)

state costume and gift (if needed)

GENERAL CLOTHING
travel outfits (suit or tailored dress) (two)

casual rehearsal outfits
slacks (three), white, black, and another color or pattern
skirts (two)
assorted blouses and tops to mix with slacks and skirts
jumpsuits (two)
sundresses (for summer pageants) or other casual dresses (three)

daytime appearance outfits
suits (two)
tailored dresses (three to four)

"cocktail" dresses (four to six)

evening gowns (four to six)

noncompetition swimsuit and cover-up (one)

LINGERIE
brassieres
white (two to three)
beige (one)
black (if needed)
strapless (one to two)

panties (eight to ten)

dress shields (two to three)

slips
white, short (one)
beige, short (one)
long slip (one to two)
black (if needed)

TRAVELING TIPS

nylons (eight to ten assorted shades)

nightgowns (two)

robe

SHOES AND PURSES (INCLUDING COMPETITION SHOES)
daytime heels (three to four)

evening sandals (one to two)

casual flats

tennis shoes (clean ones)

boots (if needed)

slippers (Barbara liked to take ballet slippers for comfort in her room)

daytime purses (two to three)

evening clutches (two)

tote bag

OUTERWEAR
rainwear and/or coat

evening shawl

cardigan sweater

ACCESSORIES (BRING LOTS OF THESE)
jewelry (avoid traveling with very expensive jewelry)

belts

scarves

gloves

hats

hair decorations (barrettes, clips, flowers, etc.)

MEDICAL AND EMERGENCY NEEDS
Band-Aids

safety and straight pins

sewing kit

PREPARING FOR COMPETITION

aspirin

antacids

eye drops

prescription medication

vitamins

analgesic pain relief rub

petroleum jelly

rubbing alcohol/witch hazel

thermometer

insect repellent

moistened towelettes

BEAUTY AND GROOMING

eyeglasses/contact lens supplies (if needed)

brush and comb

shampoo and conditioner

styling mousse or gel

hair dryer

curlers (electric or sponge)

hairpieces

shower cap

cosmetics and makeup tools

hand or makeup mirror

skin-care items

soap

cotton balls/tissues

hand and body lotions

dental items

mouthwash/mints

TRAVELING TIPS

deodorant

manicure items

perfume

razor and blades, or depilatory

sunscreen and tanning lotions

tampons

MISCELLANEOUS

address book/stationery/stamps

your journal

writing (autograph) pens

alarm clock

travel iron

magazines or books

sunglasses

umbrella

camera/film/flashbulbs/batteries

good-luck charms (if you have any)

extra washcloth (avoid white or you may lose it when the maid collects the hotel's towels)

laundry hanger or clothespins

small bag of laundry detergent

hangers or hanger arm (to be hooked over a door)

adapter plugs (if traveling internationally)

travelers' checks/spending money/credit cards

airline ticket

Plan Ahead

You can save needless worries, purchases, and packing if you carefully consider what you will need before you leave for the

PREPARING FOR COMPETITION

pageant. About three weeks before most pageants, you will receive a schedule of events. Sit down with that schedule and consider what you will wear for each event (pay close attention to the times when you will need to change extra quickly). Write an identifying description of the planned outfit in the margin by each event. This forethought will help you to determine how many outfits you will need and will avoid the predicament that the perfect outfit for some event will be the outfit you just wore to the last event. When you plan ahead, be sure to plan for changes in the schedule. Remain flexible so that a change will not throw you into a tailspin. Always pack a few extra outfits in case there is a change in the schedule, or the weather. Basic separates, such as a pair of white pants and a couple of blouses, will add several extra outfits to your supply, and layered separates will work through any weather changes.

Polly made up notecards on which she listed each outfit and everything that went with it—lingerie, jewelry, shoes, and purse. For example:

RED/WHITE/BLACK STRIPED DRESS:
red full slip, black nylons
black tie, red belt, black/gold bangle bracelet, black chunky earrings
black open-toed heels, black clutch bag

and

BLUE COMPETITION GOWN:
white strapless bra, long white half-slip
dangle rhinestone earrings, rhinestone necklace, rhinestone bracelet
silver evening sandals

Using these cards, she could easily coordinate her wardrobe by determining which separates and accessories would combine to make additional outfits. This saved space when packing. The cards also ensured that she would not forget to pack a needed

TRAVELING TIPS

accessory. Most important, the preplanning saved time when dressing at the pageant. No time was wasted trying to decide what to wear or how to accessorize the outfit. Polly had already noted on each card to which event she would wear that particular ensemble.

How to Pack

Everyone who travels frequently develops a personal system of packing. Here are some tips to help you develop a system that will work for you.

1. After making your list of needed items, start collecting those items into one place—your bedroom. For a major trip, start assembling your items several days ahead of time. This will allow you to review your supplies, and to find or purchase any missing items. Double-check your wardrobe to be sure it is in perfect condition. Be sure you have enough suitcase space to hold your needed items.

2. First pack the items you will carry onto the plane with you. This will prevent packing those necessary items in your general luggage. The crucial items you should personally carry include your:

airline ticket

passport (if necessary)

money, travelers' checks, credit cards

prescription drugs

expensive jewelry

cosmetics (at least enough to get you by should your luggage be lost)

reading or writing materials, or knitting

suitcase keys (if needed)

Try to minimize the items you carry on the plane, as you do not want to exit the plane looking like a packhorse as you greet your hosts and the press photographers. When packing

PREPARING FOR COMPETITION

your carry-on items, be sure to set aside everything—from underwear to accessories—that you will be wearing on the plane. You do not want to reach for a needed pair of shoes only to discover they are at the bottom of your suitcase.

3. Remember that when you lift your suitcase, heavy items will slide to the bottom. To prevent these shifting items from wrinkling your carefully packed clothes, place all heavy items (i.e., shoes, hair dryers, electric curlers, etc.) along the hinged side of your suitcase so they will rest on the bottom of the suitcase when it is carried.

4. Minimize the space your items take. Pack smaller items inside larger ones. For instance, stuff the toes of your shoes with your stockings, then place them toe-to-heel. Use the space around the heels to hold loose items such as your travel alarm clock. Pack your jewelry with extra care or you may arrive at the pageant with only one of your interview earrings. Place all jewelry in a jewelry carrying case that you can roll up and tie together, or use small plastic bags or boxes. Wrap delicate necklaces in tissue paper and fold in thirds to prevent the chains from becoming tangled.

5. After packing your heavy items around the base of the suitcase, fill in the rest of the space with soft clothes, such as lingerie. Slips, panties, and swimsuits can be rolled up and tightly packed to prevent the heavy items from shifting. This will also give you a flat base on which to pack your clothes.

6. Before placing clothes in your suitcase, close all buttons, zippers, and snaps. This will cause the clothes to lie in their natural shape and will minimize wrinkling.

One packing system you may use is to interfold all clothes. Fold clothes lengthwise along their natural crease lines. Place each item across the suitcase—the first flush to the right side, the second flush to the left side, and then repeat. The excess fabric of each item should hang out over the opposite edge. Place all blouses face down with the collar toward the hinged side and the sleeves stretched straight out across the other clothes. Smooth wrinkles out as you add each piece. Place sweaters, shawls, and scarves on top of the separates. These will cushion the fold areas to prevent fold marks. Fold the draped

TRAVELING TIPS

edge of each piece back into the suitcase, alternating from side to side.

Barbara has chosen to use a modified system that speeds up packing and unpacking. She layers her wardrobe, but keeps each piece on its hanger. Loose items are packed as described above. To unpack, she simply picks each piece up by its hanger and places it in her closet. (If clothes get slightly wrinkled, she places them in the bathroom while she showers and lets the steam ease out the wrinkles.) After years of travel, Barbara finds this packing method to be the most efficient. Her packing routine is further speeded by having her cosmetics suitcase packed at all times.

Use the smallest suitcase necessary to hold your travel wardrobe, but be sure to allow a little extra room to transport the gifts you will inevitably receive on your travels. Any empty space will allow the suitcase contents to shift and wrinkle, so fill in any extra space with accessories or tissue paper. Tie the suitcase ribbons and lock your suitcase.

Make the Most of Your Time

Titleholders spend many precious hours traveling by plane or car. Learn to utilize this time constructively. Perhaps the most beneficial use of travel time is to catch up on much-needed sleep. As Miss USA, Barbara trained herself to sleep during airplane flights. (To this day, she has to fight the impulse to fall asleep on takeoff.) If you find you cannot sleep while traveling, use your time to write speeches or thank-you notes. If you really need to relax, but cannot fall asleep, read a news magazine or knit. Barbara knitted many afghans during her year as Miss USA. The afghans made terrific presents for some special people during her reign, including her chaperone.

16

Poise: Handling Disaster with Grace

*P*ageant judging categories always include a factor called "poise." The problem with this criterion is that it is an elusive concept. There is no consistent definition for poise. *Webster's New World Dictionary* defines it as "1. balance; stability. 2. ease and dignity of manner. 3. carriage, as of the body." It is an attribute that cannot be quantified. It has a certain you-know-it-when-you-see-it quality. Poise is essentially a summation of how well a contestant handles herself in front of other people and in new situations. Does she look at ease? Does she make others feel at ease as they watch her? Poise is confidence and composure. Poise is something one cannot fake. If you can fake it, you have it.

The true test of one's poise comes when one is faced with disaster. How do you handle situations that do not go as you have anticipated? You have prepared fully for your pageant competition. One step in that preparation is to realize that unexpected things can and will happen. What would you do if any of the following happened:

- You lose a false eyelash or fingernail on stage.
- Your pheasant costume starts to molt on stage.
- During the telecast you cannot find your underwear between changes.
- You are called out of order or by the wrong name.
- The contestant next to you is wearing the exact same evening gown.
- You are asked a question about something about which you know nothing.
- You lose your luggage on the way to the pageant.

HANDLING DISASTER WITH GRACE

- You get sick, or have allergies that act up during pageant week.
- You are a vegetarian faced with meaty meals.
- You and your roommate or chaperone do not get along.
- You arrive on stage late.

All of these things have happened to pageant contestants. You must have the confidence and composure—the poise—to handle every disaster. Let's consider how your poise and planning can carry you through a few specific mishaps.

Situation 1: You trip or fall coming down the steps in your evening gown. Pow! You think you have just blown away any points for poise, but that is not necessarily true. Handling this potential disaster with confidence and composure can gain extra points. If you trip, regain your balance and keep going. If you fall, stand up, quickly straighten your gown if needed, and continue as if nothing had happened. You will lose points if you burst into tears; you will not lose points if you look the judges directly in the eyes and smile. This worked for Jineane Ford, Miss Arizona-USA 1980. She absolutely fell down the stairs during the preliminary competition, but she handled it with the poise described above. Jineane went on to become first runner-up to Shawn Weatherly. When Shawn became Miss Universe 1980, the woman who handled a fall down the stairs with true poise became Miss USA 1980.

Situation 2: It is ten minutes to showtime and the zipper has just fallen out of your competition gown. Handling this problem requires a combination of planning and poise. First, you have planned ahead by bringing that extra evening gown. Now you change quickly into your backup dress. Next, your poise comes into play as you step onto stage with the same assurance as if you had planned to wear that dress all along. The fact that you must wear your second-choice dress is not going to lessen your confidence one iota.

Situation 3: You are speaking on stage and the microphone fails. Keep talking as if the microphone is working. Do not look flustered. Do not try to test the microphone or tap on it. The stage crew will be scrambling to restore the sound. It is

PREPARING FOR COMPETITION

their problem not yours. If the lack of sound is going to continue, or if the judges have not heard your answer from the stage, a pageant official may ask you to stop and repeat what you have said when the sound returns. Until someone intervenes, however, follow Bob Barker's example. Keep talking with the same zest you would have if it were being amplified.

Situation 4: The show's emcee skips over you during the finalist questions. It is hard to imagine this happening, but it happened to Polly during the Miss Teenage America Pageant. The four finalists were each asked to answer the same four questions. The chance to be the first to answer one question rotated with each question. Polly was the first finalist. The second question started with the second finalist. The emcee, Bob Hope, forgot to call on Polly as the last finalist to answer that question. Polly subtly tried to whisper a reminder to Mr. Hope but did not make a scene out of the omission. She simply waited for pageant officials to correct the error. They did. As the questioning continued, a note was handed up to Mr. Hope reminding him to go back and give Polly a chance to answer.

Situation 5: Shortly before you leave for the pageant or during the pageant you have an accident. Do not let a little accident stop you from reaching for your goal with gusto. Miss Georgia-USA 1981 dropped a garbage can on her ankle shortly before heading to the Miss USA Pageant. She was first seen by the judges with stitches and a large white bandage around her ankle, but they still selected her as a semifinalist. Remember that Sheri Ryman, Miss Texas 1982, competed in the Miss America Pageant with a broken foot. Her gymnastics routine won her a preliminary talent award and the fourth runner-up's slot, both of which gained her scholarship dollars.

The key to handling any of these potential disasters is to remain composed. Do not let the unexpected shake your confidence. The judges know that accidents can happen. They will not subtract points for something that is not your fault, if you handle the situation well. Never try to stage such a mishap simply so you can impress the judges with your poise—it is sure to backfire. Just do your best through the planned and the unplanned.

PART IV

Tips for the Titleholder

17

The Queen's Guidebook

Women who have worn pageant crowns understand that the moment they really deserve to wear the crown is the moment they have passed it on to their successors. Only then have the duties and responsibilities of the titleholder been fulfilled. Winning the crown is only the first step. The crown may make you and those who know you proud, but the real test is whether you can make the crown proud. You must be prepared to wear the crown for one year, and carry out its ideals for the rest of your life. If you are not prepared to meet this challenge, you will only possess the crown, you will not deserve it. Furthermore, you will never realize the true rewards that accompany the crown.

Being selected by the judges can suddenly thrust you into the limelight, making you a public person. You will be watched carefully as you are presented with new situations. How do you handle yourself? The following sections give some helpful hints to help you handle new challenges and questions with confidence.

Your Formal Regalia

Wearing Your Crown

One of the most awkward moments in your reign may be when the crown is first placed on your head. The outgoing queen seldom manages to secure the crown in its proper position.

TIPS FOR THE TITLEHOLDER

The crown may dangle precipitously over one ear. Thus starts the problem of how to wear your crown.

Crowns come in many styles:

Tiara. Most local winners will receive a tiara style that only has rhinestones along the front and is open in the back. This type of crown should be worn right on top of your head with the front section even with the front of your ears. It should not be too far forward, nor should it be placed back on the "crown" of your head. There are usually combs on either side that are slid into your hair to hold the tiara securely in place. The Minneapolis Aquatennial's crown does not have combs. Instead, the metal ends are bent slightly inward to grip the wearer's head. Barbara has permanent dents in her skull from wearing that crown.

Adjustable Crown. Miss USA wears almost a full circle of rhinestones. There is a gap in the back, which is connected by an adjustable sliding bar at the bottom to ensure the crown's fit. The state titleholders receive a similar crown, but their rhinestones are slightly lower in height. Some titleholders make the mistake of wearing this crown flat on their heads so that the front and back edges are at the same height. This crown should be placed like a tiara with the front parallel to the front of your ears. This type of crown encircles the crown of your head, with the back edge dipping down in the back. Gravity and proper positioning will hold this crown in place without combs or hairpins. The adjustable bar should not be visible. Pull a section of hair up in the back, pull it through the center of the crown, and smooth it in back so that it hides the bar.

Coronet. Miss America and the state winners, wear small, fully-enclosed coronets which rest squarely on top of the head. These crowns cannot be adjusted to fit varying head sizes, and are the most difficult crowns to wear. A metal bar runs along the diameter of the crown, touching the top of your head. Use hairpins that match the color of your hair to pin the bar securely to your hair. Do this as neatly as possible, using as few pins as possible to make it feel secure. Crisscrossing the pins will help strengthen their hold.

Remember to select a hairstyle that will complement your crown. Do not wear noticeable combs, barrettes, or other hair

THE QUEEN'S GUIDEBOOK

ornaments. If your style requires hairpins, be sure they match your hair color, and are placed unobtrusively.

Note: Real royalty (i.e., Queen Elizabeth) do not wear their royal trappings for all public appearances. You shouldn't either. Consider how you have been invited to appear and whether the crown is appropriate.

Caring for the Crown

Crowns are fragile and do break. Treat them with loving care. Do not let them drop on the ground or get bent out of shape. When traveling, carry the crown in a protective container. The Miss America crown is carried in an engraved, velvet-lined box. The Aquatennial Queen used to carry her crown in a leather box.

You do not need a fancy container—just one that works. Barbara traveled all over the world carrying her Miss USA crown in a round, metal cookie can that was just the size of her crown. Find a metal can that is the size of your crown. Be sure the crown is held snugly in place so that it will not bounce around and be damaged in its container. If you want to be fancy, line the inside with a scarf or felt and cover the outside with pretty contact paper. If the can is big enough, your banner may be rolled up to fit snugly within the circle of your crown. If there is any extra room, add a small cosmetic bag filled with a small comb and mirror and extra hairpins—you will have an appearance tool box.

Note: When traveling, never pack your crown in your luggage. Carry it with you on the plane or in the car. This will protect it from potentially rough handling, and will guard against it being lost in transit. Summer Bartholomew, Miss USA 1975, packed her crown in her luggage while traveling in South America. When the bellman delivered her luggage to her room, the crown was missing. Always hand-carry your crown.

Wearing the Banner

The purpose of the banner is obviously to tell people who you are. If you are going to a formal banquet which will be attended by many queens, you should wear your banner (and crown) to distinguish who you are. If you are in a situation where there is no doubt that you are Miss Somebody, you do

TIPS FOR THE TITLEHOLDER

not need the banner—wearing the crown may be enough. If the banquet is connected with the festival over which you reign, the banner is unnecessary as presumably everyone will know you are their reigning queen. Miss USA normally does not wear her banner at formal functions. People will know she is Miss USA. She wears a beautiful formal (from which the banner would detract) and her crown.

The banner is reserved for daytime appearances. Miss USA may wear her official red, white, and blue, satin-and-rhinestone banner with a suit or tailored dress. She may or may not also wear her crown. The banner is also appropriate when she is appearing in a group photo.

In parades, the banner is also unnecessary as the people on the street will probably not be able to read it anyway. There are usually signs on the sides of the float or car that tell the observers who you are. A banner will only detract from your attire. If not securely fastened, you also run the risk of wrestling with a slipping banner throughout the parade. If, however, there are no signs on your vehicle that identify you by title, you should wear the banner.

When the banner is worn, it should rest on the right shoulder and drape across the body to rest against the left hip. The banner should be secured to the right shoulder using a hidden pin. If the banner ends are not secured by invisible snaps, pin them together from the underside, or use a decorative crown pin. Better yet, sew the banner ends together so they will not flutter open at the wrong moment.

The banner must be kept in impeccable condition–cleaned, pressed, and without visible pinholes. Never attach festival pins to your banner. If you visit a festival and are given a button that you feel compelled to wear, wear it on your left shoulder. Another option is to use that pin, instead of a crown pin, to secure the loose banner ends at your hip. For the next festival replace the pin with the crown pin or the current festival's pin—never accumulate pins on your banner!

Wearing a Cape

Few festivals still present a cape to their winner. If you have an official cape, wear it only for the most formal occasions

(i.e., when being crowned, and when crowning your successor). The cape may also be used in parades. If you are riding on the back of a car, spread the cape out on the trunk (outside facing up, collar folded down the back seat), and then sit on it. On very cold days, the cape may be worn in parades for warmth, but it would be ridiculous to wear a heavy velvet cape in 80-degree temperatures. If you are told that you should wear the cape, wear it over your shoulders, but still drape the end over the trunk. You should not sit on the cape if you are wearing it in a parade. Whenever you do sit directly on the cape, pull it up slightly before you sit down so that it billows slightly around you.

Wearing Gloves

For years, queens wore white gloves, but like pageant capes, white gloves are passé. You generally should not wear gloves, even in parades. If you do decide to wear gloves, be sure they are the right length for what you are wearing. Sophisticated sleeveless formals require long (above the elbow) gloves. With younger styles, or styles with sleeves, wear short (wrist-length) gloves. Never wear three-quarter (just below the elbow) gloves—long gloves are more flattering. If your gown has long sleeves that completely cover your arms, do not wear gloves.

Note: White-glove etiquette requires that you remove your gloves when you are meeting heads of church, heads of state, or when you are eating. In addition, you should never wear jewelry (rings and bracelets) over gloves. All buttons must be closed. Finally, your gloves must be clean! Be careful not to touch your white gloves to your face or you may get makeup on them.

Dressing for Public Appearances

Your appearance wardrobe is part of your formal regalia. Your attire should reflect a queenly image. It should be appropriate in style and very neat. Clothes must be clean and pressed, hems straight, shoes and purses polished and coordinated with your ensemble. Boots are never appropriate for inside wear.

An appropriate wardrobe is one that is right for your age,

TIPS FOR THE TITLEHOLDER

the time of day, and the function you are attending. For example, a tailored suit or dress is perfect when Miss USA or Miss Small Town attends a luncheon, cuts a ribbon, or goes to an autograph session. A cocktail dress is appropriate for semiformal functions. As a titleholder, you may want to wear formal attire to an otherwise semiformal event (i.e., a dinner not designated as black-tie). People expect to see titleholders dressed a little more formally.

You will also be expected to look great when traveling. Always travel in a suit or dress. You may not know what the schedule will be when you arrive. Be prepared to attend a luncheon or press conference the minute you step off the plane. Always arrive at an appearance ready to go. Arrange your crown before you emerge from the car. Princess Diana does not step out of her car and make a beeline for the ladies' room so as to adjust her appearance before facing her subjects. Similarly, you should be ready to face the public the moment you arrive.

Slacks are rarely appropriate for appearances, but there are exceptions. For instance, when Barbara was called on to ride an elephant in a circus parade, a slack suit was the only appropriate attire (but a titleholder would not wear jeans even for this type of appearance). Slacks may also be called for by the weather. For instance, in Minnesota, the St. Paul Winter Carnival Parade takes place in January's sub-zero weather. No one in her right mind would ride in that parade without wearing slacks—and thermal underwear!

Note: If you are wearing outer wear (i.e., a coat), always remove it upon entering a building.

You do not need a vast wardrobe. When you are on the road meeting different people, you can wear the same outfit frequently. You may know that you wear that suit every other day, but the people you meet will only see it once. Follow these tips to stretch your wardrobe and lighten your luggage load:

- ♦ Choose classic lines that can be mixed and matched.
- ♦ Stick to materials that will wear well. You must look as fresh eight hours later as you do when you first leave your hotel room. Choose fabric blends that will resist wrinkling and from which wrinkles can be hung out after being packed. (Ultrasuedes are terrific for traveling. Pure

silks and fine linens are luxurious but will quickly look rumpled.)
- Invest in loads of accessories that can be combined for different looks.

Public Appearances

Press Interviews

When Barbara was selected Miss USA, the telecast credits had not finished rolling when a pageant official was at her side saying, "I'm Bob Parkinson. Congratulations. Remember, whatever you say tonight will be tomorrow's headlines." Then she found herself in a crush of media people. Bob was right. The words Barbara uttered throughout the evening were quoted the next day in newspapers around the country. Your first words set the tone for the rest of your reign. Avoid the "dumb beauty queen" stereotype by saying something that will reflect intelligence, awareness, and perhaps a sense of humor.

Your reign will be filled with press conferences and interviews. That is part of being a titleholder, and something most winners have not experienced prior to their reign. In giving interviews, you must select your thoughts and words carefully. A reporter can, by design or by accident, twist your words when writing an article. Phrase your answers as clearly as possible to limit the potential for misunderstanding or distortion. Remember that whatever you say and do in the presence of a reporter or photographer is fair game for publishing. While most reporters honor their word when they say, "This is off the record," it is possible that an unethical reporter may not. The reporter's job is to get you to talk; your job is to make the reporter hear and see only what you want the article to say. Do not say anything, on or off the record, that you would not want to see in print.

After giving countless interviews, Barbara and Polly have learned that there are actually very few new questions for the press to ask. The same questions keep coming up with different wordings. Go through this list of questions, and think about

TIPS FOR THE TITLEHOLDER

what answers you would give to them. When you get into an interview, listen to the wording of the question to determine which of these questions you are really being asked, then give your answer.

1. Why did you enter the Miss _____ Pageant?

2. What is involved in a pageant?

3. What are your responsibilities as Miss _____?

4. Would you do it again? Why?

5. What were your feelings during pageant week? the moment you won? the day after you won?

6. What was the first thing you did after you won?

7. What is the best thing about being Miss _____?

8. What would you change about your experience?

9. How has your winning affected your family?

10. Do you have a boyfriend?

11. How would you address the charges that pageants sexually exploit women?

In addition to the above questions, the press may try to present you with controversial questions about issues such as abortion, nuclear arms, or national foreign policy. Miss Americas have learned that controversial responses may cost them thousands of dollars in personal appearance fees. For instance, Tawny Godin, Miss America 1976, became a controversial queen when she spoke out in favor of abortion rights and on marijuana issues. In dealing with these questions, it is all right to assert a well-considered opinion. Remember that you will have to live with the opinion you give—your answer may come back to haunt you in future interviews. Do not give a controversial answer lightly. Your position as titleholder carries many responsibilities. You can be a positive role model for many people, so you must keep informed and consider issues, but remember that your title should not be turned into a weapon to further your own political or ideological crusade. Remember,

if the reporter asks questions that you consider too personal, "I have no comment," or "I consider that to be a private matter," are always sufficient answers.

Public Speaking

If you are considering entering a pageant, practice your public speaking. If your knees shake, voice quivers, eyes cast downward or flit around the room, hands move uncontrollably, or mouth goes dry, you need more public speaking practice. Take a speech course. Accept opportunities to stand in front of groups and open your mouth. Even reading the Scripture lesson in church on Sundays will help you develop verbal skills in front of large groups. As a titleholder, you must be able to prepare your own speeches and give them without notes or hesitation. You must be able to compose your ideas spontaneously. Without warning, you may be asked to "say a few words." Pick a topic off the top of your head, stand in front of a mirror, and wow your reflection with the smoothest, most sincere speech you have ever given. Also practice speaking into a tape recorder to improve your pitch, tone variation, and speed.

Note: Unless you are the keynote speaker, keep your remarks brief. Avoid gushing phrases such as "You guys are wonderful." Do not thank your hosts repeatedly. Thank them once with true sincerity, and sit down.

Parades

Parade observers are usually unaware of the unwritten conduct and hints adopted by titleholders. Here's a list:

♦ Sit forward on your seat with your knees together and your feet spread slightly apart so that you can brace yourself against any sudden or jerky movements of your vehicle. Flair the skirt of your formal around you so that it looks soft and hides your feet.

♦ If the car you are assigned to is not a convertible, you will probably have to ride on the hood of the car. If you have a cape, spread it over the hood and sit on it. Adjust your position so that you are comfortable and secure on the car. The safest

TIPS FOR THE TITLEHOLDER

way to ride is with your legs stretched in front supporting you against any jerky car movements. Try to make this unflattering position as graceful as possible. Cross your ankles, and flair your long skirt (never ride like this in anything but a long formal) so that it covers your legs completely.

♦ Wave across your body (i.e., wave to the right side using your left hand, and to the left with your right) so you do not cover your face.

♦ Keep your wrist straight, so that your fingers do not fall forward or back, and wave in a figure-eight motion as if you were polishing a window. This is the standard parade wave about which people joke, but it is also the most attractive wave.

♦ Do not wave nonstop. If your vehicle stops in one place, do not keep waving to the same people. When you are not waving, your hands should rest in your lap. Occasionally turn your head, glancing from side to side, to make contact with the spectators.

♦ Make eye contact with the people on both sides of the street. Also scan upper windows and balconies to wave at observers perched at higher levels.

♦ If the parade is televised, locate the camera, look directly into the lens, and wave as you pass by—there is a large group of spectators in that lens.

♦ If you are given flowers to carry in the parade, rest them across your lap so that both hands remain free. If the flowers are damp, place a piece of plastic under them so that you do not ruin your dress.

♦ Always bring a clear piece of plastic (i.e., a dry cleaning bag) that you can sit on if the float is wet (wet tissue paper can bleed onto your formal). If rain is threatened, bring a pretty folding umbrella or parasol that can be tucked out of sight at your feet. Pull it out only if it starts to rain hard. If it rains, take off your banner (if you are wearing one) so that it will not be ruined.

♦ If it is an extremely hot day, a handkerchief may come in handy to *discreetly* blot your face.

THE QUEEN'S GUIDEBOOK

♦ Never wear sunglasses, chew gum, carry a beverage, etc., in a parade.

♦ Do not yell to people along the parade route. If your friends call out to you, simply smile and wave back to them.

♦ Remember that if you are watching a parade, you should stand for the first American flag that passes by you. You need not stand for subsequent flags in the parade.

Autograph Sessions

Autograph sessions are possibly the most difficult of all appearances. They require you to sit for four to six hours meeting person after person and signing autographs. These sessions are often held in connection with store openings or product promotions. These appearances are the ones that allow the most people to actually meet a titleholder. Little girls are especially excited to meet you. Make their encounter with you special. You may be tired at the end of your day and have a severe case of writer's cramp, but you will have created a special moment for many people. They will undoubtedly tell others that they met Miss Somebody. Just as going to a concert can make the audience feel a special bond to a performer, these brief meetings can make the pageant seem more personal to hundreds of people. These meetings also encourage sponsors to continue their association with the pageant.

Note: Signing hundreds of autographs can quickly destroy your penmanship. Try to keep each autograph neat—it is the only one that person will have. A felt-tip pen is often easier to use. If there is a picture, never sign across the face—regardless of whether it is yours or someone else's. We suggest always signing in the lower corner of a page so that nothing can be added later to your message and potentially be misconstrued.

Photograph Sessions

Pageant winners are among the most photographed celebrities. The press and public will constantly take candid or posed shots of you, so act appropriately at all times. Never hold a glass in your hand while posing for a picture (such photographs are

TIPS FOR THE TITLEHOLDER

strictly forbidden by the Miss America rules). Avoid having photographs taken with anyone's arm around you (it could be misconstrued as a public display of affection). Finally, never be photographed kissing anyone, even on the cheek. When making presentations of any kind, do not kiss the recipient—shake his or her hand instead.

Mind Your Manners

Following simple rules of etiquette is essential to becoming a titleholder and to fulfilling the duties of the title. The first rule of etiquette is always be on time. The second rule is that thank-you notes must be promptly written to all hosts and hostesses. The two areas of etiquette that cause panic in people are introductions and dining. The rules for these areas are summarized below.

Introductions

1. When introducing adults, always present the man to the woman first (hint: say the woman's name first)—"Mrs. Bowles, I'd like you to meet Mr. Burwell."

2. A younger person is usually introduced to the older person—"Mrs. Anderson, I'd like you to meet my friend Kristi Smith."

3. Members of your own family are presented to the other person—"Paul, I'd like you to meet my sister Ann." Notice that the man is not presented to the woman in this case. There is an exception to this family rule. If you are introducing your parents and a younger friend, follow rule 2.

4. If someone of high honor is being introduced to another person, present the other person to the honored guest—"Mr. President, I'd like to present to you my traveling companion, Jewel Baxter."

5. When introducing people at social functions, always say something about each person that will help the people strike up a conversation—"Kristi, I want you to meet Stewart. He

owns two golden retrievers. Kristi raises cocker spaniels." Now the two are on common ground and can dive right into a conversation on dogs, eventually moving on to other subjects.

6. When you start talking with a friend and an unknown person, if you are not introduced immediately, offer your own name as an introduction. This can save much embarassment if the mutual friend has happened to forget either of your names.

7. When you are being introduced, listen carefully for the other person's name, and use it later in the conversation. If you do not catch the name at first simply say, "Excuse me. I didn't catch your name."

8. When you are being introduced from your seat in the audience, let the emcee finish the introduction before you stand to acknowledge the audience. Then simply stand in place, smile, and nod your head to various parts of the audience. If you are in a large auditorium, you may wave (using the parade wave) so that people can locate you. If you are being introduced on stage, do not wave.

Note: Whenever you enter a room, you should pause briefly at the door to survey the situation. It will help you feel more comfortable as you step in to meet the people. Later, when you say you are going to leave, do it. Do not hang around over long good-byes.

Dining Rules

1. Wait for your hostess to sit before you sit. Your hostess is your guide to the meal. If in doubt as to what to do, take your cue from her.

2. Immediately after you sit, unfold your napkin halfway and lay it in your lap. Your napkin remains in your lap until the meal is over. Then it is laid in loose folds (not refolded) to the left of your plate.

3. You should wait until everyone at your table has been served and your hostess seated before you start eating. If you

TIPS FOR THE TITLEHOLDER

are at a large dinner, or there is no hostess, wait until five or six people around you are served before you start eating.

4. To choose the right piece of silverware, start with the appropriate piece farthest from the plate. For instance, the soup spoon will usually be the spoon farthest from the plate because the soup course is the first course which will require use of a spoon. If the table is set wrong, use your own judgment on what piece is appropriate for each course.

5. If the soup bowl has one or two handles, you may pick it up and sip the soup. Never slurp soup. If using a spoon, tip the bowl away from you to get the last spoonfuls (this will avoid having any spill in your lap).

6. If you start to use the wrong utensil, keep using it. If you are being served by a waiter and you drop a utensil, you need not pick it up. Simply ask the waiter to bring you another one.

7. Dinner forks are larger than salad forks. If you have two identically sized forks, use one for dinner and one for the salad. Try to cut large salad pieces with the side of your fork rather than using a knife.

8. The small plate to your upper left is your bread plate (it may have its own small butter knife). Never cut rolls with a knife. Use your fingers to break them into two or three easy-to-handle pieces. Butter each piece only as you eat it, replacing your butter knife on your bread plate after each use.

9. The utensil placed above your plate is for dessert. If there is no such utensil, you may use either a fork or spoon, whichever you think more appropriate for the dessert being served.

10. When you have finished your meal, place your knife and fork beside each other diagonally on the plate to signal that you are done.

11. Food dishes are usually served from the left and removed from the right. Beverages are served and removed from the right.

12. Be careful to eat only the appropriate "finger foods" with your fingers.

13. No foods should be eaten while wearing gloves.

14. A titleholder never reapplies lipstick or combs her hair at the table. These are private tasks that should be done after retreating briefly to the powder room.

15. Be aware of how long the program will be, and pace yourself in the amount of liquid you consume. It is difficult to excuse yourself from the head table unobtrusively. Go to the ladies' room prior to your meal and, if necessary, after the completion of the program—never during an awards ceremony or speech.

Relationships

The hallmarks of a true lady are how she handles herself and how she treats other people. As a titleholder, you will meet numerous people to whom you will be expected to be kind and gracious. Not all of these people will be kind and gracious in return, but most will be. Some of these people will be famous personalities. Others may be small-town farmers. Usually, they are excited about meeting you and have gone out of their way to make your visit special. Each one should be treated with equal dignity and enthusiasm.

Many of the people you meet you will not see again, but that is no excuse to pass them off as being inconsequential. The one person you tell yourself it won't matter how you act toward is the person that you can be sure will cross paths with you. Always assume the person you are meeting is someone who will be a part of your life in the future—or at least treat them as if you hope they will be a continuing part. Furthermore, you may be the only titleholder that person meets. It is your responsibility to leave those you meet with a good impression, not only of you as a person, but of pageant titleholders in general. You are upholding the reputations of your predecessors, and paving the way for your successors.

Pageant People

You will have to work closely with the pageant staff. Often this group of people becomes a family for you. Barbara main-

TIPS FOR THE TITLEHOLDER

tains very close ties with the Aquatennial and Miss USA officials with whom she reigned. Treat the pageant staff with respect. Listen to their advice, but don't be afraid to exert your own ideas and values.

Your traveling companion is a crucial figure in your year. The two of you will spend countless hours in each other's company. From the beginning, try to establish a good rapport. Perhaps you won't end up being friends for life, but you absolutely have to be able to get along. Include your companion in on the fun parts of your reign. Polly was delighted when she was able to appear on stage with Bob Hope for the second time (the first time as Miss Teenage Minnesota, the second as Miss Minnesota). When she was called back to meet with Mr. Hope and his wife in his dressing room, Polly happily included her companion, Ruth Anderson, in on the fun. The two of them spent a memorable time talking with the Hopes and taking pictures. Do not leave your companion sitting in the wings all the time.

Family

Winning a pageant title is a wonderful, but demanding experience, not only for the winner, but also for her family. When a woman wins a title, so does her family. The family's schedule may often be dictated by what pageant appearances are to be made in any given week. Parents may be called on to act as chaperones. Parents and siblings may act as chauffeurs and wardrobe consultants, help answer mail, and answer telephones. They may also see more parades in one year than most people see in a lifetime.

We learned early how important the family is for pageant contestants and titleholders. Their moral support, encouragement, and assistance are important before the pageant competition, but they are even more important throughout the winner's reign. Among our family movies is a clip showing Barbara's coronation as the Minneapolis Aquatennial Queen of the Lakes. Watching that clip makes the viewer dizzy since the cameraman (brother Mark) was trying to film the event while simultaneously jumping up and down in excitement. That clip aptly symbolizes our family's involvement in and feelings toward the pageants.

THE QUEEN'S GUIDEBOOK

It is a dizzy whirl of activity that is filled with excitement, joy, and family support. Be grateful for that family support, and return it to other family members as they pursue their dreams.

Friends

The relationships that may require the most tender loving care on the part of a titleholder are the friendships she had before she won the crown. The demands on your time will tend to pull you away from time with them. Remember, these friends are people who have supported you in your preparation, and they are the ones who will welcome you with open arms when you relinquish your crown. Show your appreciation and love. Make time for them.

Winning a title may suddenly triple the number of friends you have. Acquaintances at school and work will suddenly be telling their friends that you are one of their best friends. Some people who you considered friends may turn away from you, perhaps out of jealousy. To your true friends, your victory will not make a difference, except in the joy and excitement they feel for you. Share your experiences with them, but also be sure to ask them about their lives and to appreciate their accomplishments.

Boyfriends

Boyfriends are a touchy subject for titleholders. They are also the nightmare of pageant staff members. Some boyfriends hate the idea of their girlfriend winning a pageant. In other cases, the title may become more important for the boyfriend than it is for the titleholder. It may become a matter of great pride to him that he is dating Miss Somebody. The fact that he may hardly see her anymore is of little consequence to the latter type of boyfriend.

Many titleholders break up with the boyfriends they were seeing prior to their reign. Others may get engaged shortly after competing in, but not winning, a pageant. At the Miss USA Pageant, there is a celebration ball following the telecast. Every year at this ball, engagement rings appear on the fingers of some contestants—some have become engaged immediately

TIPS FOR THE TITLEHOLDER

after the telecast; a few may have been engaged during the competition, but have kept it secret fearing it might hurt their chances of winning.

Winning a pageant does not necessarily mean you cannot maintain a solid relationship with a beau. Kim Tomes, Miss USA 1977, continued to date, and later married, her prior boyfriend, Cody Dutton. During her reign, they had to catch brief moments at the airport as she passed between cities, but they both wanted the relationship enough to make it work. Sue Downey, Miss USA 1965, later married a man she met during the Miss USA Pageant. Ann Pohatomo, Miss Universe 1975, dated a new man throughout her reign but then returned to her native Finland to marry the boyfriend she had when she first competed.

Keep Your Perspective

It will be easier to maintain your relationships if you keep your title in perspective. The reign will broaden your horizons, but underneath you are still the same person you were before you won. You are simply enjoying and growing from a special year. That year will only last 365 days. Enjoy each one, but know that it will end.

Lee Meriwether, Miss America 1955, once said that the best advice she received as Miss America came from her predecessor, Evelyn Ay, who told her, "The night you crown the next one, you're going to be as popular as yesterday's newspaper. Just be prepared." The night that Lee crowned Sharon Kay Ritchie, Miss America 1956, a cameraman pushed her aside saying, "Honey, do you mind moving out of the way? I want a picture of Miss America." The crown will pass on as quickly as it came to you.

A few months after relinquishing her Miss Teenage Minnesota title, Polly was standing in a reception line waiting to greet the president of her university. There were two fellows standing in front of her. Suddenly one of them turned to Polly and said, "Didn't you used to be somebody?" Polly responded that she liked to think she was still somebody. The young man pointed to his companion and said, "He said you used to be

198

somebody." His red-faced companion later became a friend of Polly's. He probably considers that initial meeting as one of his more embarrassing moments. The encounter drove home for Polly just how fleeting fame can be.

Barbara learned this lesson the morning after she relinquished her crown. She was standing with her successor, Kim Tomes. A little girl walked by and said, "Look Mommy. There are two Miss USAs. There's the new one. And there's the old one." Less than twenty-four hours had passed since the crown left her head, and Barbara was already "the *old* Miss USA." (One piece of advice, if you meet a past titleholder, never refer to her as "the old queen." The preferred term is "the former queen.")

At times your reign may be a little overwhelming. The schedule is hectic and demanding. You have to be organized and energetic. There may be times when you wonder why you are racing around between appearances. Is it all worth the effort? At these moments, think about your first runner-up. She came so close to being in your position. She (and all your sister contestants) would probably love to trade places with you right now. They dreamed of having your schedule, but were not given the chance. You were. You were picked because you said you wanted it, and the judges believed you could handle it. Don't prove them wrong.

A Year Worth Remembering

The busy schedule will come to an end, but the memories will last forever. It is a special year, one that should be cherished and shared with friends. Someday you may be telling your children about your experiences, such as the time you met the president of the United States, or were on the "Tonight Show." Do not let the details of these experiences fade. Keep a journal. Log in the big items such as where you were and who you met, but also add the details which give the experience extra flavor, perhaps what you wore, what the conversation was about at dinner, what mementos you were presented with, etc. Collect newspaper clippings, letters, and other assorted memorabilia to put in a scrapbook. This task may be time-

consuming, but it will be more valuable with each passing year. Also be sure to give your camera to your companion to help complete your photograph album. You do not want to forget one moment. You may also want to start a special souvenir collection. For instance, Barbara collected Christmas tree ornaments and Sue Ann Downey, Miss USA 1965, collected dolls from each of the countries they visited. Your souvenirs can be decorative additions to your future home and cherished mementos.

Relinquishing the Crown

Everyone who wins a pageant title has to relinquish it after a year. Some women find this a bittersweet task. They have enjoyed their year and are sad to see it end but are ready to move on to other challenges and to share the pageant experience with another winner. Some winners, however, find it very difficult to pass the crown on to their successor. These are the women who have not fully utilized their pageant opportunities and who have not been considering their future throughout their reign. Here are some tips on how you should pass on your title.

1. Realize from the beginning that your reign will end in approximately 365 days. Throughout your reign consider what new goals you will reach for after your reign. Prepare yourself for a new role.

2. End your reign with appreciation toward those who have made it so special. Write thank-you notes to appropriate people. Give gifts to those extra-special individuals. These tokens of appreciation do not have to be expensive. The gifts should be presented in private, not on stage, with a personal word of thanks.

3. Give careful thought to your farewell speech. Keep it short, but make it carry a message. Be selective in the people (if any) whom you thank in the speech. Everyone knows that many people have helped you reach your goal and have contributed to your experience. Selective thank-yous are more mean-

ingful than thank-yous that include everyone you have met since first grade. Your gifts will adequately convey your thanks to those not included in your speech.

4. When you crown the new winner, take care in placing the crown. Be sure the crown is securely and attractively placed. Practice placing the crown on someone else's head so that you can accomplish this last duty quickly. Do not try to attempt this task while wearing white gloves—remove them. Do not kiss the new winner. You do not want to leave her with lipstick on her cheek. It is also thoughtful to write your successor a note of congratulations and offer to answer any of her questions about her upcoming reign. It is fun to get together to share advice, similar experiences, and pictures. You may also want to present the new winner with a small gift. A charm engraved with her title and the date of her coronation is perfect. Many titleholders become close friends with their successors. Kim Tomes, who succeeded Barbara, was later a bridesmaid in Barbara's wedding. This close relationship started upon the passing of the crown.

PART V

Living the Dream

18

Behind the Scenes at the Miss USA Pageant

A contestant works hard to prepare for her local and state pageants. After a three- or four-day weekend of rehearsals, interviews, and parties, she may be crowned at a shopping center, high school, or hotel ballroom. As a state titleholder she will be absorbed in making public appearances and preparing for the national pageant. A wardrobe must be fitted, a state costume created, and her previous diet and exercise plan must be continued. Most women would be excited to be in her place, having the chance to compete in a nationally televised pageant such as Miss USA, Miss America, or America's Junior Miss. Only a handful of women get this chance each year.

What is it like? While the telecast is billed as the spectacle, the pageant week is the growing experience. It would test the heartiest and most self-assured person. For up to three weeks prior to the telecast (yes, the Miss USA Pageant is three weeks long!), contestants are bombarded with questions and photographs by the press, rules by pageant officials, directions from the television crew, advice from parents and state directors, and surveillance from the chaperones. Contestants joke that the pageant is a marathon and the woman who remains standing at the end of the telecast will be the winner. (Since a national titleholder's reign is hectic and demanding, such a test for stamina is actually quite important.)

No two pageants are identical, but there are some experiences common to all. To give you an idea of what to expect at a national pageant, let's take a look at what it is like to be a contestant in the Miss USA Pageant. This overview is based on Polly's experiences at the Miss USA Pageant. Since the preparations and activities of pageant week are substantially similar from year to year, Polly's experiences are still representative

of today's pageant. A contestant's national pageant experience may go somewhat like this:

Pageant Week Kick-off

The time has finally arrived. All the contestants fly into the host city on the same day, except Miss Alaska and Miss Hawaii. They arrive a day earlier than the rest of the contestants so that they can adjust to the greater time difference between their homes and the host city. The contestants have started a three-week adventure. The time ahead will be filled with excitement, new friends, laughter, and challenges. It may also be a time of self-doubt, some tears, fatigue, and blisters. When it is over, however, it will have been worth every minute.

The contestants' arrival at the host city airport is just a taste of what is to come. Contestants descend from the plane to be greeted by a red carpet and the music of a brass band. They are welcomed by several city officials and presented with the key to the city. This is just the first of many mementos that each contestant will receive. Many contestants present small gifts which represent their home states. These range from small items of jewelry to volcanic ash from Mount St. Helens. After this brief welcoming ceremony the contestants are whisked away to the pageant auditorium to be formally checked in as pageant contestants.

The executive staff of Miss Universe, Inc., which puts on the Miss USA Pageant, greets each contestant and presents her with $100 to cover incidental expenses at the pageant. (There will probably not be any additional expenses as everything is provided for the contestants.) The regulations that the contestants must follow are clearly explained. They include the following:

1. No dating during the pageant period.

2. Consumption of alcoholic beverages, other than light wine and champagne, in moderation, is prohibited.

3. Please smoke in private.

4. No padding is permitted.

BEHIND THE SCENES

5. No girdles are permitted.

6. No full wigs, but hairpieces are allowed. Contestants may not bring their own hairdresser to the pageant.

7. Chaperones are to be present at all times with contestants.

8. No members of your family, your friends, or your state director are allowed backstage or in dressing rooms during any of the stage functions. Nor are they allowed at any time in your hotel room.

9. Any misconduct, nonobservance of rules, or disrespect by a contestant are grounds for immediate dismissal by pageant officials. All rulings are final.

Each contestant must sign a contract agreeing to follow the pageant rules. The contract also binds the woman to serve as Miss USA if she is selected as the winner. All of the regulations are strictly enforced. There has even been a case in which one contestant was disqualified for breaking the fourth rule by padding her swimsuit.

Next, Bob Barker's assistant interviews each contestant. She asks questions based on the biographical information sheets the contestants have sent to pageant headquarters. She then writes the questions that Mr. Barker will ask the semifinalists in their onstage interviews. If a contestant pays close attention to what the interviewer seems interested in, she may be able to guess what she will be interviewed about on stage. For example, the interviewer may ask about a contestant's trip to Sweden and whether she speaks the language. If she does speak Swedish, this would be an unusual ability. Therefore, there is a high probability she will be asked about her trip and asked to demonstrate her language ability (Barbara was).

A contestant can help determine the questions she will be asked on the telecast by subtly steering the interview to a subject or incident that is especially interesting, amusing, or unique. If you raise chinchillas as pets and enjoy talking about this topic, include this on your information sheet and mention it to the interviewer if you can, telling her something amusing about this hobby. The interviewer wants to find this kind of information and may ask a very open-ended question like, "Is

there anything else you want to talk about?" That is your chance to subtly tell the interviewer what you want to talk about on stage. Mention your chinchillas now and you will probably be asked about them on the telecast.

The next order of business is to get each of the contestants fitted with the wardrobe that is provided by pageant sponsors. Every contestant is supplied with outfits for the "fun films," a production number costume, two swimsuits (one for competition and one for the pretelecast swimsuit taping), and a swimsuit cover-up. Shoes for each of these outfits are also provided.

Each contestant is presented with two long white sashes with the name of her state sewn on in blue felt letters. (Some other pageants use large buttons instead of sashes.) A special pageant banner is used instead of the more elegant official state banner, which is satin and rhinestone-studded. The competition sash has to be worn at all times until the contestant departs from the host city. Since the sash gets a lot of wear and tear during the busy three weeks, the duplicate is provided for use during preliminary judging events. (Unbeknownst to the contestants, there is a third banner which is saved to be used only on the telecast.) There are also shorter versions of the sash to be used with the swimsuit. Instead of draping around the body like the longer banners, these banners are tucked by their edges into the right armhole and left leg openings of the swimsuit.

Pageant Chaperones

The people who get the contestants through the first harried hours and the rest of pageant week are the chaperones. A contestant's chaperone is one of the most important figures in her pageant experience. She is a mother, security guard, chauffeur, confidante, and friend. Each chaperone is in charge of two contestants (the two contestants will be roommates). It is the chaperone's job to arbitrate any dispute that may arise, keep the voluminous wardrobes of each of her charges separate (this task should not be underestimated—remember that some contestants arrive with ten suitcases worth of wardrobe), keep her two contestants on schedule, and mend broken fingernails and torn costumes. She can also be instrumental in bolstering sagging self-confidence and nursing bruised hopes. She accom-

plishes these feats armed with a set of rules, a sense of humor, great affection, and a bottomless "ditty bag." The ditty bag goes wherever the chaperone and "her girls" go. It contains everything from pins, eyedrops, and hair spray to super glue, pliers, and bug spray. It also carries the essential cameras and autograph pens.

The most important function of the chaperone is just to be there in case she is needed by one of her charges. She is not a servant and should never be treated as one. She is a friend and helpmate. These women, usually between the ages of 30 and 70, volunteer their services. Although they are busy homemakers, secretaries, nurses, etc., they move into the hotel for the entire pageant time. Many do it because they want to experience the excitement of a national pageant, and a major television show. They end up developing close ties with and great pride in "their girls." Many contestants continue to correspond with their "pageant Mom" years later.

Pageant Security

The chaperone is not alone in watching out for the security of the contestants. Each contestant's whereabouts are closely monitored, not because she is distrusted, but rather because there is so much public interest in these women. Security is provided to guard the contestants from the ever-present and potentially overzealous fans. The women live together on one hotel floor. Anyone entering that floor will be met by a twenty-four-hour armed guard. This protects the women and their possessions, which often include mink coats and expensive jewelry, which they have won in their state pageants.

Contestants are not allowed to use stairwells or leave the group unless accompanied by a chaperone. Visitors to the hotel, including family, may be met only for brief periods in the lobby while a chaperone waits patiently a discreet distance away. While some contestants find the constraints a little tiresome, most understand the reasons for the ever-present security and welcome it. This same level of security will surround the winner throughout her reign.

While security is also extremely tight at the auditorium, family and friends whose names the contestant has registered with

security are allowed to watch rehearsals. Once in the auditorium, the contestants may move around more freely. When not needed on the stage, a contestant may sit with her family. One evening may also be set aside for contestants to go out to dinner with family members who are in town for the pageant. This is the only break in the tight supervision and may not be allowed at all pageants.

Pretaped Segments

The Miss USA Pageant, a major television extravaganza, must be pulled together in three short weeks. There is no time to waste. While the competition portion of the telecast is televised live, some portions are prerecorded. Tapes will be produced showcasing the prize package and special highlights of the host city. Barbara, who has been invited back to the Miss USA Pageant more often than any other past winner, has narrated several of these segments. The contestants' pretaped segment efforts go mostly into the "fun film," which shows clips of the contestants in various locations around the host city.

Unlike the Miss America Pageant, which is located in Atlantic City, New Jersey, every year, the Miss USA Pageant travels to a variety of major American cities. Hosting the pageant generates much revenue for the host city. The advertising time offered to the city during the telecast is worth a small fortune and can increase the city's tourism. The fun film serves the dual purpose of showing what the contestants have done during the pageant and showing the public what sights the city has to offer.

The fun film *is* fun to film, but it is not exactly what the public thinks it is. The film gives the impression that the fifty-one contestants go from one fun activity to another with a film crew traipsing behind them to catch the spontaneous interaction. In reality, the film segments are, by necessity, very staged. The women are divided into groups. Group A may ride in the bumper cars at the amusement park, Group B attends the Crayfish Festival, Group C goes roller skating, and Group D spends time on the banana boat.

Polly's fun film experience is an example of how the film is

BEHIND THE SCENES

made. Polly visited the banana boat. This large ship transported fresh fruit such as bananas, pineapples, and coconuts. The filming started after a delicious lunch, which included plenty of fresh fruit. Miss Wyoming-USA was selected to throw a large rope from the deck of the ship down to Miss Ohio-USA, who was waiting on the pier to tie up the ship. The heavy rope kept landing on Miss Ohio. The director decided that it would not look good to show one contestant dropping something on top of another contestant (that would go against the spirit of friendly competition) so the routine had to be repeated many times.

After several attempts, the first scene was completed. Polly and two other contestants were then picked to load boxes of bananas onto a conveyor belt. They climbed down a narrow ladder into the dank and dirty hole of the ship (of course, security was following right behind). Two very large crew members demonstrated how to toss the crates with one hand. It looked easy enough. Polly reached for the nearest box. It would not move. It took all three contestants to lift one box. They managed to heave a couple of boxes onto the belt, then learned that was only a rehearsal! They had to lift the boxes again for the camera—not once, not twice, but three more times.

After the fun film is taped, Bob Barker's narration is dubbed onto the tape. Meanwhile, the contestants scurry back to the hotel to change for a charity bowling tournament. They barely have time to change their clothes and brush their hair before they are off again.

For the bowling tournament, the contestants are each paired with an Air Force cadet who was originally from their state. After a lovely dinner, capped off with a cake the size of a pool table and shaped like the United States, the bowling begins. One contestant is pulled out of the game to film a promotional commercial to be used in her home state. There she is, still grimy from loading banana boxes, with no time to repair her appearance. Ah, the glamorous life of a beauty queen. She quickly memorizes the script, smiles, and faces the camera. Fifteen minutes later she is back in the game.

Each group goes to a different location to tape a swimsuit segment for the telecast, which will spotlight each contestant. Later on, the fifty-one contestants sail out to an island fortress

to tape the last shot of the swimsuit segment. Most of the women take advantage of the sun's rays to deepen their tans (this was not the case in Niagara Falls in 1976 when it was only 10 degrees during the swimsuit taping, and the women huddled around heaters). Those who tend to get seasick try to sleep off the cruise so they will not look green in the upcoming taping. The contestants reach the island, line up, and wave at the camera as it pans the group. Of course, today is windy. It is always windy when this segment is taped. It will be difficult for friends and family to recognize each woman as, inevitably, her hair blows across her face just as the camera passes her by. Luckily, the banners identify each contestant.

Rehearsals

The bulk of time at the national pageant is spent in rehearsals. The Miss USA telecast gives a significant amount of air time to all the contestants. While there may be guest stars, it really is the contestants' show, so there is a lot to rehearse. Besides preparing a two-hour television extravaganza, contestants also must rehearse the untelevised Opening Ceremonies and Preliminary Judging Show. In contrast, the Miss America Pageant uses a professional dance group; thus, non-semifinalist contestants, who are rarely seen by the television audience, have little to rehearse. That is why the Miss America Pageant involves less than one week compared to the Miss USA Pageant's three-week schedule. Most televised teenage pageants run from about nine to fourteen days, but the Miss Teen USA Pageant follows a three-week schedule similar to that of the Miss USA Pageant.

Acting the Part of a Professional

The demanding rehearsal schedule calls for some "rules." This list contains some suggestions that we would like to share with you:

1. Be on time for everything!
2. Do not criticize or complain.
3. Get lots of rest.

4. Never wear blue jeans to rehearsals—remember the press will be there, and the judges may see a picture of you at rehearsals, so dress in nice sportswear or casual dresses.

5. No hair curlers at rehearsal.

6. Be prepared to run late—plan to dress quickly for your next function.

7. Wear comfortable shoes.

8. Treat each run-through as the real performance.

9. Be yourself with everyone. People will be aware of you at all times. Do not "turn on and off" for certain people or the press—be "on" at all times.

10. Enjoy yourself and the experience of rehearsing for a major television production.

The Production Numbers

The initial rehearsals are spent learning the opening number and the Parade of States. The telecast opening usually involves hundreds of people. It requires extra creativity due to the fact that the contestants are wearing elaborate state costumes. One woman may be almost eight feet tall with her headdress on, another may be six feet wide when her butterfly wings are outstretched, and yet another may be five feet long when her velvet cape is trailing behind her. At the Miss Universe Pageant, the choreographer has an even larger challenge since many of the contestants do not speak English. It is not unusual to have thirty-five different languages or dialects spoken by the Miss Universe contestants. As if all these factors were not enough, a shorter version of the opening number must also be learned for the Opening Ceremonies and the Preliminary Judging Show.

The next routine to learn is the production number. The year Barbara won, contestants did a 1920s Charleston number. For Polly's year, it was a fast-paced, high-stepping cowboy dance that left the contestants wringing wet by the end of it. Whatever the routine, the contestants will reach a point when they want

LIVING THE DREAM

to strangle that voice that comes over the loudspeaker saying, "Do it again. One more time." He said that the last time.

Pulling Together a Television Show

That booming voice belongs to the director. He does his work from a trailer at the edge of the auditorium. From his seat he can watch every stage angle on monitors that display the images transmitted by the six television cameras located around the auditorium. If a contestant steps off her assigned mark, the director can flip to a different camera in seconds.

The director heads up a crew of some of the finest professionals in television. It is fascinating to watch them pull together a major television extravaganza. "Three, make those transitions any time. Six, put your bug in. Two, when the Hump comes on, I want a super waist shot, star lenses, the whole bit. Yeah, Rupert, kill that monitor, put one of those potted plants on the desk. Five, zoom in . . . and . . . yeah, zoom." The language of their craft may sound like Greek to the contestants, but the crew responds instantaneously. Out of chaos, the patient director and his crew manage to create a professional show using fifty-one amateurs.

The rest of the rehearsal schedule is devoted to learning the moves of the semifinalists and finalists. Each contestant walks through all the positions. Bob Barker interviews each contestant during the rehearsals using fake questions. This segment is fun as Bob is a real professional and also a delightful person. The following statement reflects his terrific attitude about the show: "The girls are the stars of the show, but it's something they've never done before. It's my job to make them come off as well as possible. I make a point of talking to them before the show and when they find themselves on camera, they know they are with a friend, someone they can trust." He does his job well—the contestants really do feel as if they are chatting with a friend on stage.

Growing Friendships

When not practicing on the stage, contestants rest in the auditorium. Some contestants use this time to catch a few needed

winks of sleep, others talk with family members who are watching the production progress, and some go into counseling sessions with their state directors or do a little needlepoint while chatting with other contestants. This time gives the contestants a chance to get to know one another.

There are stories of contestants in some pageants who purposely sabotage other contestants—rip dresses, flush false eyelashes down the toilet, and so on. This is really very rare. You are more likely to find that friendships grow quickly during this intense—both physically and emotionally—demanding experience. You will find that although you are all competing with each other for the same goal, contestants tend to be supportive of one another.

In fact, there may be a greater sense of competition coming from the contestants' families and some state directors than there is among the contestants. Some of these spectators may try to play mind games with you, talking about when their girl wins the crown, or you may find them staring at you during rehearsals. Do not let it get to you. Recognize it for what it is—psychological warfare. It is also a compliment as it says the directors and spectators think you are competition worth intimidating.

The contestants actually become quite close friends. They spend three intense weeks together. They know the pageant will soon be over so they make a great effort to get to know one another quickly. In the end, one special contestant will be chosen as Miss Amity, an honor the contestants cherish as it means their sister contestants have found them to be beautiful inside, where it really counts. The Miss USA Pageant organization considers this award to be so important that it gives the winner an all-expense paid trip to the Miss Universe Pageant where she is treated as a special guest. In contrast, the Miss America Pageant discontinued the Miss Congeniality award (their equivalent to Miss USA's Miss Amity award) after the 1974 pageant when forty-seven contestants voted for themselves in order to win the award's $2,500 cash prize. Vonda Kay Van Dyke, Miss America 1965 (and the only Miss America who was also Miss Congeniality), has urged that the Miss Congeniality award and scholarship be reinstated as a way of inspiring the Miss America contestants to "mind their manners."

Press Coverage

The press follows the contestants everywhere. Interviews are conducted during rehearsal breaks. A contestant never knows when her picture will be taken or where that picture will appear around the country. The host city's paper usually carries a large story each day. A contestant's home state newspaper may print daily pageant updates, perhaps sending along a reporter to give special reports rather than using the Associated Press or UPI clips.

A portion of one morning will be devoted to a pool-side press conference. Contestants wear the swimsuits that the sponsors have provided for the swimsuit fashion show that is taped for the telecast. This gathering gives the reporters and photographers a chance to see all the contestants together. Based on this press conference, the members of the press will vote for Miss Photogenic (a Miss USA Pageant honor that has no effect on the selection of Miss USA). The winner is announced onstage the night of preliminary judging.

Reporters try to pick the ultimate winner early in the competition. Some contestants are repeatedly photographed and interviewed. Remember, the press does not pick the winner—the judges do. If you are never approached by the press, just remind yourself of Barbara's experience. She was never sought out by the press. When she was crowned Miss USA, the media all asked, "Miss Minnesota? Who is she?" She got her chance to be in the media when it meant something!

The Public

The hospitality of the host city can be overwhelming. Polly competed in the Miss USA Pageant when it was held on the Mississippi Gulf Coast. She met local residents at several special pageant events. These events included a sumptuous Hawaiian luau buffet honoring the civic leaders who were instrumental in bringing the pageant to the host city; sampling catfish and turnip greens at Catfish Charlie's; a night of dancing on a show-

boat; and a packed party featuring Fats Domino at the piano. Also, while the contestants are busy filming portions of the show around the city, the public is watching and picking their favorites.

The public especially enjoys the filming of the telecast's opening segment. Polly's year happened to be the Miss USA Pageant's thirtieth anniversary so a triple-decker birthday cake was built out of sand on the beach. Television viewers first saw the contestants singing and dancing in their state costumes on the various cake layers. What the television audience did not see were the hundreds of onlookers encircling the cake.

The Discipline Continues

Food is not scarce during the pageant weeks. Breakfast, lunch, and dinner are huge meals every day. A typical breakfast includes fresh fruit, eggs, ham, sausage, grits or hash browns, French toast, and assorted muffins and pastries. At the auditorium contestants have constant access to a free snack bar. When they return to the hotel each night there is a midnight "snack," usually a meal in itself.

The goodies are a sore temptation to fifty-one women who have been carefully watching their weight for months. Those who have been under the ever-watchful eye of strict coaches may find it especially hard to resist temptation now that they are on their own. As the days pass, willpower may wane. But don't give up or slacken your desire for one moment during pageant week. You have worked too hard to get where you are. Avoid going to bed on a stomach filled with morsels of that midnight snack. Do at least some portion of your regular exercise routine each day. This is hard to fit in at the national pageant, but three weeks is a long time to go without exercising. You may even join several contestants in a nightly jog around the hotel halls under the watchful eye of the chaperones and security guards. Remember, you still have to compete in that swimsuit.

LIVING THE DREAM

Judging Week

Two weeks have already passed. The telecast is only one week away. Viewers around the country are unaware of what the contestants have been going through so far and what is ahead during the coming week. Everyone is tired, and the judging has not even started yet. As the contestants apply their stage makeup and adjust their state costumes, they catch that second wind that will take them sailing through this final, all-important week of judging. With bright smiles, they take their places for the Opening Ceremonies of the Miss USA Pageant. This show, besides serving as the kick-off for the judging week, will give them a chance to feel what it is like to work on the stage in front of an audience. It is also the first time they will appear before a panel of judges.

The judges at the Opening Ceremonies are not the judges who pick the new Miss USA. This first panel of judges is composed of civic leaders from the host state. Their sole function is to pick the winner (and two runners-up) of the Best State Costume Award. Since the state director usually selects the state costume, this award is usually more important to the state directors than it is to the contestants. Winning the award is only a slight advantage in that the winner will be introduced at the preliminary judging, giving her an additional chance to be pointed out to the judging panel that selects Miss USA. Thus, it is nice to win the costume award, but it is not important enough to make you nervous. Relax and enjoy the Opening Ceremonies.

The most significant aspect of the Opening Ceremonies is that each contestant is introduced and personally presents her state gift, usually to the mayor of the host city. Presentation speeches are not long. They may be serious or may show a contestant's sense of humor. They give each woman a chance to reveal her personality and stage presence. State directors and the press use this ceremony to gauge who the outstanding contestants are. The public uses it to pick out their personal favorites. Winning the support of the local community can bolster a favorite's confidence. Furthermore, while the judges are

instructed not to pay attention to the reactions of the audience, it is impossible for judges to completely ignore the fact that the audience especially likes a particular contestant.

The Opening Ceremonies are on a Wednesday. The judges arrive in the host city two to three days later. They are met at the airport and whisked away by limousine to a luxury hotel away from where the contestants are living and rehearsing, ensuring that the judges will not see the contestants other than at judging sessions. While the judges may read press coverage about the contestants, the first time that they will see them in person is on the stage (usually on Sunday) during the preliminary swimsuit and evening gown judging. The contestants are judged in swimsuits that are identical in style, but that vary in color, and in evening gowns they have chosen. In 1981, Polly and Barbara made pageant history by being the only sister team to ever appear on stage simultaneously during this segment of judging—Polly was a contestant, and Barbara was emceeing the show, as she has done many times.

With the official judging now under way, there is a different atmosphere in the auditorium. The contestants really start to feel the pressure. Top contenders may come to light. The feeling of competition starts to grow. The change, however, is slight. Most contestants manage to keep their perspective. They have spent more than two weeks getting to know and, in most cases, to like each other. The prevailing attitude is, "I'm not going to let the outcome of this week affect my memories of this experience. Win or lose, I'll be glad I came."

On Tuesday and Wednesday, personal interviews are held. Then the competition is suspended. The semifinalists will have already been determined by the judges' ballots. The contestants must wait until the telecast to learn whether they will be able to progress to the next level of competition.

Dress Rehearsal

The production number is taped the morning of the telecast. During the telecast, the non-semifinalist contestants perform the same number, leaving gaps where the semifinalists would have stood. The auditorium audience sees this somewhat bro-

ken-up version of the number. The television audience sees the taped, whole version. The director may cut into the taped number to insert close-up clips of the contestants performing live onstage.

That afternoon, a full dress rehearsal is conducted that is as much as possible like the live show. There is even an audience that pays to come to the rehearsal. What that audience sees, however, may look more like a three-ring circus than a beauty pageant. This is the first chance to run through the entire, full-length opening number with all its participants.

The Miss USA Pageant telecast opens with a major production number, using lots of people. Besides the fifty-one contestants and the guest stars, there may be a military chorale, marching bands, flag bearers, cheerleaders, Boy Scouts, and Legionnaires on camera. There are also dozens of production assistants, cameramen, cue-card holders, stand-ins, etc., scurrying around the auditorium. Someone who was trying to organize this mob once observed that the Miss USA opening number had all the makings of a "Cecil B. De Mille movie with a cast of thousands." Somehow, each year these assorted groups are organized into a well-choreographed opening.

The dress rehearsal may take all afternoon. After the opening number, ten "pretend" semifinalists are named. They are interviewed with "pretend" questions and walk through all the steps of competition. This last rehearsal lets the contestants have a final review of what they must do if named as a semifinalist that evening. It also lets the television crew double-check lighting and camera angles.

Being chosen as one of the dress rehearsal finalists is a mixed blessing. First of all, it should not be taken as any indication of your chances to be selected as a finalist that evening. The two are unrelated. Many of the contestants do not want to be called on for dress rehearsal. Racing through the quick changes can be tiring. No one wants to waste their energy when they hoped to need it that evening. Being called on at rehearsal can be helpful though as it gives you a final chance to walk through all the steps. The key is to try to enjoy the experience. You may not be called on for the real show. The rehearsal gives you the next closest feeling of what it is really like to compete in the Miss USA Pageant telecast.

BEHIND THE SCENES

At the end of the rehearsal, Bob Barker stands onstage with two contestants who are "pretend" finalists. He gives that famous speech about how important the first runner-up is. As he names the first runner-up, the choreographer steps into the remaining contestant's place. The Miss USA crown is never placed on a contestant's head until the final telecast announcement. Year after year, the choreographer is crowned Miss USA at the dress rehearsal. This is contrary to the Miss America procedure.

The emcee at the Miss America dress rehearsal calls out a contestant's name to play the role of the new Miss America. In 1980, the emcee, Ron Ely, offhandedly used the name of Susan Powell. Later that night, Susan Powell became Miss America 1981. The next year, the emcee called out the name of Sheri Ryman, the Miss Texas who had earlier won the talent preliminary and had been chosen by a computer as the most likely winner. The use of her name underscored the fact that people thought Sheri would win. But she did not. After all the build-up over her chances to win, the end result was probably extra-hard for Sheri to bear. To avoid building up anyone's hopes or adding to the pressure, the Miss USA Pageant chooses to crown someone who is not competing for the title.

After the rehearsal, there is not much time to prepare for the final event. Never count on having the time allotted on the schedule because the dress rehearsal is bound to run overtime. (Barbara had only forty-five minutes between her dress rehearsal and the telecast.) Contestants rush back to the hotel, grab a box dinner (which are probably eaten by few), and then go to their rooms to do preliminary preparations for the telecast. Final grooming preparations take place backstage at the auditorium.

Contestants are each assigned a space in one of three large dressing rooms. Each contestant has a large paper bag in which she places everything she will need during the telecast if she is named a semifinalist—shoes, underwear, jewelry, touch-up makeup, hairbrush, etc. This bag is looped over the hanger of her evening gown. The proper banner is then hung over the dress to identify it. After the names of the semifinalists are announced on stage, their chaperones will grab the appropriate hangers and take them to a separate dressing room closer

to the stage where all the semifinalists will change. If the contestant forgets to put something in her bag, she will not have it for the telecast. Be prepared and organized.

The Miss USA Pageant Telecast

The contestants, dressed in their state costumes, take their places in the wings. The music starts. Frank Sweeney announces, "Live from Host City, it's the Miss USA Pageant." The moment these fifty-one women have dreamed of and prepared for is at hand. They step onto the stage to go through the opening number for, as the director would say, "one more time." After the opening, they are introduced in the Parade of States. While the contestants quickly change from their costumes to the dresses given by the sponsor for the announcement of the semifinalists, the tape of the swimsuit fashion show is shown. This gives families and friends another chance to see their contestant on television.

The announcement of the twelve semifinalists is next. Before this announcement, only the auditors know the names of the semifinalists. After the announcement, the writers of the show scramble to pull the appropriate contestants' interview cards, put them in order, and hand them to Bob Barker.

The lucky twelve semifinalists race through the rest of the program. First they chat with Bob Barker. These interviews are unrehearsed. This is one factor that distinguishes the Miss USA Pageant from the Miss America Pageant during which the contestants are not interviewed onstage. Instead, they recite rehearsed statements. Next, the semifinalists walk through the swimsuit segment (their swimsuits are identical in color and style), and then the evening gown competition. The latter segment may include the pageant little sisters, local youngsters who are paired with the contestants for special events throughout the three weeks. During Polly's year, military escorts were used. The semifinalists floated down the stairs of a Southern mansion to the strains of "The Battle Hymn of the Republic" and received a rose from their escorts. They then passed through an arch of uplifted swords to meet the judges, the audience, and millions of television viewers on the other side.

BEHIND THE SCENES

The contestants' feelings during these final hours of competition were aptly described by Kelly Hu, Miss Teen USA 1984, when she said, "It feels like taking a final exam in front of fifty million people."

While the new scores are being verified, the nonsemifinalist contestants return to the stage to perform the production number. These contestants had disappeared from the stage after the semifinalists were announced. They all went back to the dressing rooms to change to their production number costumes, and to anxiously watch the telecast on backstage monitors. Many of these contestants have already shed some tears, others will probably cry later. The tears may be from disappointment, but just as often they are tears of fatigue and of release from the intense pressure. Many are happy to have reached the end of their quest able to say they did their best. Most are now curious to see which of the women they have come to know will reach that final goal. The contestants decide to enjoy the rest of the experience. They run through their production number with more spirit than ever before—that attitude reflects the fact that each of the contestants came to the pageant as a winner and she will go home a winner.

Meanwhile, for the twelve semifinalists the pressure mounts. Bob Barker reads off the names of the five finalists. They must now answer one last question. For Barbara's year, each finalist had a different question. The pageant has since adopted the practice of using the same question for each finalist. Each finalist waits her turn in a soundproof booth. One by one, they stand by Bob Barker, listen to the question, think for a moment, and then answer confidently. Backstage, their sister contestants cheer. It may not be until this point that the realization hits each of these five remaining contestants that she may, in fact, become the next Miss USA.

The judges' scores are no longer counted by the computer. While the accountants tally the result, the guest star serenades the finalists. The competition is over. The reigning queen gives her farewell speech and takes her final walk.

All night long, each contestant has hoped to hear Bob Barker announce her name. Now as he names the runners-up, each finalist prays *not* to hear her name. Making it to the pageant as one of the fifty-one contestants is quite an accomplishment.

LIVING THE DREAM

As one of fifty-one contestants, thinking about making it to fourth runner-up is exciting, but to the five finalists, fourth runner-up is suddenly last place. There is a natural let-down in being named a runner-up when you are so close to being the winner.

The names are called off. Fourth runner-up. Third runner-up. Second runner-up. Now it is just one other contestant and you standing alone, squeezing each other's hands, and hoping. The odds have gone from being a long-shot to an even fifty-fifty. Bob Barker says, "If for any reason the winner cannot fulfill her duties as Miss USA, then the first runner-up will become the new Miss USA. And the first runner-up is. . . ." You do not hear your name. Bob Barker has called the name of the woman next to you. In a split second the realization hits you. You are the new Miss USA.

Your mouth opens and your hands go to your face—the usual reaction of pageant winners. Many winners cry. Some react differently. When Kim Tomes won, she laughed. Instead of hugging the first runner-up as many do, Kim threw her arms around Bob Barker and gave him a big kiss and then yelled. When Amber Kvanli was selected as America's Junior Miss in 1984, she shed no tears and appeared very reserved. She later said, "I'm a very calm person. I don't get upset very easily. If you get upset you can't enjoy what's happening." Your reaction upon winning is next to impossible to plan or rehearse. The surprise and thrill are so overwhelming that the reaction, or lack thereof, is spontaneous.

The crown and banner are quickly bestowed upon the winner and the traditional walk is taken. Flashbulbs pop from hundreds of cameras (tiny flashbulbs are also hung as part of the stage lighting). No matter what the pageant, at the end of the show the other contestants will flock to congratulate the winner. In the background, there may be a few contestants who hold back, having no desire to congratulate that particular winner. (At the 1986 Miss Thailand World Pageant, there was such general discontent over the winner that the contestants, on live television, snatched the crown from the winner's head and placed it on the first runner-up's head.) For some, the rush to reach the winner is merely a part of friendly competition, like the sports teams lining up to shake hands at the end of a close

contest. For most of the women, there is a genuine desire to congratulate the winner.

The contestants have shared an experience that many women would like to go through, but cannot. These fifty-one women, win or lose, are bound together in a special sisterhood. While they may not be able to wear the Miss USA crown, they will personally know the new Miss USA. That is exciting. It is the next best thing to winning the crown yourself. Each contestant will follow the winner's year closely, knowing that they have been a part of it. This new friend has reached a goal and most of her sister contestants are genuinely pleased. As they surge forward to show their support, Bob Barker marks the end of another pageant by simply saying, "Good night everybody," and the credits roll.

19

View from the Throne: A Look at the Winner's Reign

Miss USA's Reign

After the credits roll at the end of a pageant telecast, the millions of viewers head off to bed. But not the winner. For the new titleholder, the work and the fun have only just begun. This chapter will take a look at what it is like to reign as Miss USA. Barbara's experience is representative of what it may be like for anyone who wins a national title.

The Posttelecast Celebration

After Bob Barker says, "Good night everybody," the stage breaks into pandemonium. There is a rush of contestants and the press. The first person to reach the winner is a pageant official. She or he will say something like, "First of all, congratulations. Just remember the first words you speak could be tomorrow's headlines." Those words of warning are right on target. The press will be quoting what the winner says that night and throughout her reign.

After the initial rush of press pictures, the winner will be escorted backstage. She may have five or ten minutes to run a comb through her hair and to catch her breath before she, accompanied by her family, is taken to a small room for a private champagne toast with the pageant officials. This meeting doubles as a celebration and a quick briefing on what will be happening in the immediate future. From this celebration, everyone moves to the Celebration Ball, which is held for all the contestants, their families, and the pageant officials and

VIEW FROM THE THRONE

volunteers. As tradition dictates, the previous year's winner will announce the new queen's arrival. The winner will be extended an official invitation to the Miss Universe Pageant. (In Barbara's year, the Miss Universe Pageant was held in Hong Kong.)

Around 4:30 A.M., the winner may finally find herself alone in her hotel room. Barbara recalls standing in front of the mirror looking at the crown on her head, and not believing it. She then knelt down to offer a prayer of thanks.

Press Conferences

The winner's year will be filled with press conferences in a vast array of settings. Traditionally, Miss USA's first press conference is held the morning after her coronation, while she has breakfast in bed. The new winner will awaken from her "nap" at 6:00 A.M. so she can apply her makeup and fix her hair for the day, put on her robe, and then crawl back into bed to nibble at her breakfast as she fields a variety of questions. Her next meeting with the press may take place on top of the World Trade Center in New York City or in a television studio in Los Angeles.

The press will not just quote the winner, they will quote people who know the winner. Her family will be interviewed. Her neighbors, teachers, and childhood playmates may even be interviewed.

The First Appearance

Miss USA's first appearance, after the Celebration Ball and press conference, is at an awards brunch, which is held for the contestants the day after the telecast. This gathering gives the winner a chance to address her sister contestants. Barbara was also addressed by her sister contestants through a representative selected by them. It is at this brunch that the scholarships, trophies, and plaques are awarded. It is the formal conclusion of the pageant. Contestants check out after the brunch, say their farewells, and depart for their home states. They leave the host city with even more luggage than they brought (they have collected many mementos) and countless memories.

LIVING THE DREAM

The Public's Reaction

A new Miss USA's first days are extremely hectic. She will be taken directly to her new, rent-free apartment in Los Angeles. She will not be in her hometown to experience her community's reaction. She will not be able to spend a lot of time visiting with family and friends. The public's reaction may not catch up with her until several weeks after her coronation when she starts hearing stories about how the press and people have responded. And there will be stories.

When Barbara's family returned to Minnesota a few days after the pageant, they found their mailbox filled with letters from all over the country. One letter had arrived at the proper address after the sender had simply taped a newspaper picture of Barbara to the envelope. Since Barbara would not be allowed to return to Minnesota for several weeks, Polly served as her secretary. She sorted the hundreds of letters—those she could answer for Barbara, those Barbara would have to answer for herself, and those that did not call for an answer. There were letters from all ages. There were several from people who regularly wrote to new titleholders. There were some from people in Barbara's past with whom she had lost touch. Some of the letters were a little strange. She actually received marriage proposals from men whom she had never met. Most of the letters were very touching. For example, Barbara received a letter from a young girl in Atlanta who had heard she liked hot fudge sundaes. She sent Barbara 89 cents and said, "Have a sundae on me."

Barbara's homecoming in Minnesota was a special event. She was met at the airport by her high school's marching band and several hundred well-wishers, including the Mayor of Minneapolis, President of St. Olaf College, her high school principal, representatives of the Minneapolis Aquatennial and the St. Paul Winter Carnival festivals, family, friends, and, of course, the press. The city held a special presentation for her in the center of downtown Minneapolis. Her neighborhood held its own homecoming party. Several restaurants opened their doors for celebration lunches and dinners. The press covered all these events. A national magazine even sent a photogra-

VIEW FROM THE THRONE

pher to get an exclusive story. The delay in celebrating certainly does not dampen the enthusiasm of the winner's state.

The winner's visit home is not just one of celebration. It is a time to take care of necessary business. She will be moving away from home for one year. She will have to pack enough belongings to get her through the year. She must make arrangements with her school and any employers for her one-year absence. Since it was an election year, Barbara also arranged to receive an absentee ballot.

A Typical Week in a Winner's Reign

There is no typical week, or even day, in the reign of a Miss USA. The most that can be said is that all her weeks will typically be hectic. She may average three appearances per day. The only day she is guaranteed off is Christmas Day. She will travel extensively throughout the United States. The only states Barbara missed in her travels were Tennessee and Oregon. On one particularly hectic day, Barbara landed in seventeen different airports. In addition to her domestic travel and a trip to Hong Kong for the Miss Universe Pageant, Barbara's year took her on a trip around the world. She spent much time in the Orient, Mexico, and the Caribbean.

A sample of Barbara's travel schedule, taken from her journal for a portion of June 1976, may give you an idea of what she did for an entire year:

- Fly from Minneapolis to New York for the dentist appointment which was required by the pageant office.
- Wardrobe fittings, gown selection, receiving fur coat on New York's Fashion Avenue.
- Attend Durham North Carolina Golf Classic—other guests included Jim McKay, Buddy Hackett, Perry Como, Lorne Green, Chet Atkins, and Mickey Rooney.
- Two days in Chicago for a CBS promotion.
- Lunch in St. Louis and dinner in New Orleans for CBS promotional tour.
- Back to New York to be fitted for Miss Universe competition gown.

LIVING THE DREAM

- New York for filming of documentary for the American Lung Association.
- Cincinnati for Procter & Gamble.
- Fly to Washington, D.C., for lunch at the White House, fly back to New York, fly to Oklahoma City to rehearse for the "Stars and Stripes Show."
- Appear on the "Stars and Stripes" television special with Ed McMahon, Kate Smith, Tennessee Ernie Ford, Chita Rivera, Anita Bryant, Les Brown Band of Renown, Frank Goshin, The Fifth Dimension, Dionne Warwick, Mike Douglas, Miss America, Miss Teenage America, America's Junior Miss, Miss Indian America, Miss Rodeo America, and Miss Black America.
- Fly to Los Angeles, then to San Francisco, and then depart for Hong Kong for the Miss Universe Pageant.

Experiences to Last a Lifetime

National winners are presented with so many thrilling opportunities during their reigns, it would be difficult for most of them to choose any single experience as being a favorite. Barbara visited countless cities, and some of her most special memories come from times spent at small-town festivals. She also treasures her visits to children's hospitals. The child in her was tickled to see the behind-the-scenes of Disneyland. Her list of memories also would have to include the friendships she made with the staff at the New York hotel in which she had her apartment. They worked hard to ensure that she would feel at home. They even let her bake cookies in the hotel kitchen. Barbara remembers sampling many new delicacies during her travels. These ranged from pumpkin burgers to shark fin soup to monkey brains.

The following appearances were special highlights of Barbara's reign:

- Meeting two presidents at the White House. Shortly after winning the Miss USA title, Barbara flew to the White House to meet President Ford. What was scheduled to be a five-minute introduction to the President evolved into a forty-five-minute visit. After the 1976 election, she had the chance to return to

the Carter White House. Then Senator Hubert H. Humphrey made her arrival at 6000 Pennsylvania Avenue especially memorable by lending his limousine and chauffeur to Barbara and her chaperone for the afternoon.

♦ The election year also provided Barbara with another unique experience. She was invited to open the National Republican Convention in Kansas City with a salute to liberty and to lead the delegates in the Pledge of Allegiance.

♦ Reigning during the Bicentennial afforded Barbara many additional opportunities as a titleholder. In addition to the previously mentioned "Stars and Stripes" television special, a list of favorite appearances would have to include her participation in the inauguration of the Amtrak Freedom Train in New York.

♦ As Miss USA, Barbara had the special honor of serving as the National Christmas Seal Ambassador for the American Lung Association. She continues her involvement in this worthwhile effort by serving on the Board of Directors of the American Lung Association.

♦ Miss USA's foreign travels allow her to experience many different cultures. Barbara especially enjoyed her travels through the Far East, including Japan, Hong Kong, the Philippines, and Taiwan. The Miss Universe Pageant was held in Hong Kong and created many special memories.

♦ While appearing on Stanley Segal's television talk show, Barbara was surprised by a mystery guest that appeared live via the telephone wires. The guest was Muffy, our family's aging beagle. The television staff had heard that our dog "sang," so they called our parents' home to see if Muffy would sing to Barbara on the show. Muffy cooperated with enthusiasm.

♦ During the negotiations to bring the Miss USA Pageant to Charleston, South Carolina, Barbara was asked to address a joint legislative session at the capitol in Columbia, South Carolina. Her personal interest in government and the political process made this a treasured appearance. Since she has a great respect for our government officials, their standing ovation had extra meaning for her.

LIVING THE DREAM

- A special part of any winner's reign is the opportunity to meet individuals from all walks of life. Barbara especially enjoyed meeting world leaders and certain celebrities, such as Bob Hope, Billy Graham, King Karl XVI Gustaf of Sweden, Prime Minister Pierre Trudeau of Canada, Omar Shariff, Diane Von Furstenburg, Ernest Borgnine, Alice Faye, John Mack Carter, astronauts Deke Slayton and Gene Cernin, Connie Towers, General Omar Bradley, members of the Osmond family, Senator Strom Thurmond, and Bob Barker.

The Less Glamorous Side of Being a National Titleholder

Being Miss USA or Miss America is not all excitement and glamor. There are some necessary parts to the reign that most winners could do without, such as the following:

- Catching 4:00 A.M. planes
- Spending hours riding in planes (Barbara advises all titleholders to have a special project to work on during this time—she knitted several afghans during her plane trips)
- Doing one's laundry in the bathtub or trying to find a one-hour dry cleaner in a strange town
- Packing suitcases
- Unpacking suitcases
- Catching taxicabs
- Returning to hotel rooms late at night and having to wash and set one's hair for an early morning appearance
- Having to live by a strict schedule
- Changing clothes in an airplane lavatory

Note: A trick to getting through these less glamorous duties is to remember your first runner-up. She would gladly trade places with you at that moment in exchange for the experiences the year is offering to you.

A Pageant Can Change the Winner's Life

The financial awards that accompany winning a major pageant title give the winner some financial security. Her travels and

experiences will broaden her horizons immensely. They will bring her into contact with world leaders and international personalities. The new situations in which she finds herself will help her to cultivate new skills. She will gain greater confidence and awareness.

Even many years after she has relinquished the crown, the former titleholder can continue to reap the intangible rewards of having reigned as a titleholder. Although the crown is passed on, the title remains with a woman all her life. The title, when coupled with a college degree, is a powerful career tool. The title seems to open doors and make people take notice. Although the title alone would not get her much farther than in the door, a college degree and the experiences gained while reigning as the titleholder will served her well in proving her abilities, thereby advancing her chosen career.

The title also creates lasting responsibilities for the winner. Her community has given her many opportunities. "To whom much is given, much is expected." A titleholder must be willing to give her time and talents back to her community, not just as a titleholder, but as an individual, not just during her reign, but also after she relinquishes the crown. Get involved in worthwhile causes and activities. Volunteering is a way of thanking your community and returning its support.

Relinquishing the Crown

Reigning as a national titleholder was a wonderful experience for Barbara. The 365 days in which she served seemed more like 365 minutes. At the same time, the reign lasted just the right length of time. The pace is so hectic that after one year, Barbara thinks the titleholder needs to be "recycled." During her year, she received many exciting offers, sorted through them, and selected new pursuits for the following year. When the night of the 1977 Miss USA Pageant arrived, Barbara was ready to share her pageant privilege and opportunities with another lucky lady.

At the end of the 1977 telecast, Barbara walked off the stage as a "former Miss USA." Her chaperone, Jewel Baxter, delivered to her a small gold crown charm that had first been given to Alice Faye, a friend of Jewel's, when she appeared in the

Broadway play, *Good News*. Alice Faye had been one of the judges who had selected Barbara as the winner the year before. She had asked Jewel to pass the crown on to Barbara on her behalf. It is a treasured memento.

The day after the coronation, Barbara once again attended the contestants' awards luncheon. This time she was there to salute another woman who had been crowned Miss USA. Over the next couple of days, she spent some time talking with her successor, Kim Tomes, sharing advice and answering questions. Those visits were to be the start of a special friendship.

Within a couple of days, Barbara left Charleston for New York, where she had to pack up and move from her apartment. She returned to Minneapolis. Less than one week after relinquishing her crown, she found herself back in a classroom completing the last year of her college degree. She also signed a three-year contract to serve as a spokesperson and public relations representative for part of the Ford Motor Company.

The State and Local Titleholders' Reign

The reign for local and state winners varies greatly from title to title and state to state. A state titleholder may do very little except attend the national pageant and crown her successor. Her prize package may also be very small. On the other end of the spectrum, she may reign like a Miss Texas-USA who devotes herself fulltime to her title, traveling throughout the United States and to foreign countries. State titleholders may or may not be paid appearance fees, which increase the initial financial rewards of the pageant. The 1983 Miss Texas who competed in the Miss America Pageant earned $20,000 in appearances fees.

Even reigning at a local level can bring you the fun and many of the rewards of reigning at a national level. Local and state titleholders may do many of the same things a national titleholder does, but on a smaller scale and with fewer appearances scheduled. For instance, they may speak at luncheons, cut ribbons at grand openings, ride in parades, visit hospitals, appear at charity events, model in fashion shows, and give interviews on television or radio, or to the press. Some titleholders

may not travel more than fifty miles from their hometown; others will travel across the continent. They all, however, are expected to assume the responsibilities of a pageant winner, i.e., maintaining their personal appearance, coordinating an appropriate wardrobe, and serving as a public relations emissary for the town, festival, or organization they represent.

State and local titles also provide the titleholder with many opportunities and rewards. The scholarships allow these women to continue their education without incurring (or at least minimizing) any debts. You may work promoting special causes, such as fire safety, the March of Dimes, the United Way, the American Lung Association, or the Cystic Fibrosis Foundation. Pageants also introduce the titleholder to some wonderful people—government officials, celebrities, children, and small-town farmers. The education engendered in fulfilling the duties of a pageant title is a unique and valuable one that complements the education gained through books and classroom study.

20

There Are No Losers in Pageant Competition

You may have heard it said that there are no losers in a pageant. You may have also thought that was merely pageant rhetoric—easy for the pageant staff and titleholders to assert. The fact is, it is true. Polly learned this through personal experience. Polly won several pageant competitions, but she also lost some. She knows what it is like to not reach a pageant goal. In fact, her pageant disappointments may have been made more difficult as she followed in the wake of a sister who consistently won pageants. Looking back, however, Polly can honestly say that while she had more fun winning, she learned more from the pageants that she did not win.

If you enter a pageant, you are taking a gamble—you are chancing disappointment. For every winner there are many "also rans." You may be one of those. But if you don't enter, you do not even have a chance of being the pageant winner. By accepting the challenge, you will never have to look back and wonder whether or not you could have won, if only you had tried. You will have peace of mind. You will also have many fun memories. Best of all, you can apply the experiences gained and skills developed through your pageant participation to help you achieve in other areas.

The pageants can have a profound impact on the lives of those who participate in them. It is not just the winner who benefits from participating in a pageant. The next chapter highlights some of the pageant participants who have gone on to success in other areas. Read this list carefully. Many of these women did not win the crowns they sought, "losing" at some level of pageant competition, but they did not let that stop them from reaching for new goals. Many of these women have become more famous than the women who finished higher in

THERE ARE NO LOSERS

their pageant competitions. It is not always the titleholder who comes out farthest ahead in the end. Not winning a sought-after pageant title can be disappointing, but it is not defeating.

Do not let your self-esteem be determined by a pageant judging panel. The judges are merely choosing one woman to fulfill a particular role. Their choice is a difficult and subjective one, reached by a panel of individuals. If you do not win the crown, do not confront a judge by asking why. A single judge is not responsible for the panel's choice. Your question will just make the judge feel awkward and will probably not result in an answer that will satisfy you anyway. Just remember that in selecting a winner, the judges are not designating you and the other contestants as "losers."

Remember that the judging panel cannot give to you, or take away from you, the most important things in life. This includes the love of your family. After every pageant, there will be one family who thinks the judges made an inspired choice. The rest of the families will think the judges were totally incompetent as they did not select the most obvious winner. The love and loyalty of your family and friends will be unaffected by the pageant outcome. That love is a terrific crown. Best of all, you never have to relinquish it. Cherish it always.

If time were turned back, and she had to choose whether to compete in the pageants again or not, Polly would do it in a minute. Even if she knew what the outcome of each pageant would be, she would enter the pageants again. The positive aspects of pageant competition, and the intangible benefits that accrue to all participants, not just the winners, far outweigh any possible disappointments. Polly's advice to any young woman would be "Go for your dreams."

21

Pageant Epilogue: There Is Life after Pageants

*J*ustice C. Donald Peterson, our father, was quoted in *People* magazine as saying, "The contests are not an end in themselves. If that were the girls' goal they would be aiming too low. It's no sin to fail, but it is a sin to aim too low." He is absolutely right. Winning a pageant cannot be your final goal. If it is, where do you go if you do not win the crown? Even if you win the crown, where do you go after you relinquish it? You must move on. You must move up. Life does go on.

Pageants are only a stepping-stone to other goals. In the words of Sharon Brown, Miss USA 1961, "Don't lose sight of your personal goals. Enjoy the experience and use it to your advantage for the future." Enjoy the pageants. Learn from the pageants. Step up from the pageants. If you are not ready to move on, you really have not grown from your experience. Here is a sampling of what some past pageant titleholders and "also rans" have gone on to do.

Judi Andersen, Miss USA 1978. Now a familiar face, Judi has established a successful modeling career.

Loni Anderson. Competing as Miss Roseville, she lost the Miss Minnesota contest and shortly thereafter eloped with the winner's brother. (They were later divorced.) She went on to fame in "WKRP Cincinnati" and other television shows.

Susan Anton. As Miss California 1969, she became first runner-up to Miss America 1970. She then established herself in a singing career.

Kylene Barker, Miss America 1979. She used her $100,000 pageant earnings to open a fashion boutique called "d. Kylene,"

Mary Frann (Mary Fran Luecke), America's Junior Miss 1961. In 1985 Mary returned to the pageant as hostess and appears here with co-host Bruce Jenner and Amber Kvanli, America's Junior Miss 1985, from Minnesota. Mary is co-star of "The Bob Newhart Show."

Above Left. *Kelly Hu, Miss Teen USA 1985. Kelly represented Hawaii in this pageant.*

Above right. *Allison Brown, Miss Teen USA 1986. Allison is from Oklahoma.*

Left. *Lori Jo Smith, America's Junior Miss 1986. Lori Jo represented Virginia.*

Opposite. *Diane Sawyer, America's Junior Miss 1963. Diane represented the state of Kentucky in this pageant. She is now a journalist and the only woman correspondent on "60 Minutes."*

COURTESY OF AMERICA'S JUNIOR MISS, INCORPORATED

Terri Utley, Miss USA 1982. Terry is from Arkansas.

Kim Tomes, Miss USA 1977. Kim represented Texas in this pageant.

Summer Bartholomew, Miss USA 1975. Summer represented California in this pageant. She is co-host of television's "Sale of the Century."

Rina Messinger, Miss Universe 1976. Rina is from Israel.

Yvonne Ryding, Miss Universe 1984. Yvonne is from Sweden.

Lorraine Downes, Miss Universe 1983. Lorraine represented New Zealand in this pageant.

Barbara Palacios Teyde, Miss Universe 1986. Barbara represented Venezuela in this pageant.

on Palm Beach's prestigious Worth Avenue. She also has made a fitness album and has written a beauty book.

Angela Bartel. In 1964 she was Miss Wisconsin. She is now a trial judge in that state.

Jean Bartel, Miss America 1943. She runs an international travel consulting business and hosts the syndicated "It's a Woman's World."

Summer Bartholomew, Miss USA 1975. She is the co-host of "Sale of the Century." She used her earnings as Miss USA to go into a variety of businesses, including a string of fast-food franchise operations, a limousine service, and a modeling school in Los Angeles.

Dorothy Benham, Miss America 1977. Like many former Miss Americas, she married a professional athlete. Dorothy has utilized her considerable singing talents in a blossoming performing career. Her concert engagements take her around the country. She is also kept busy raising her three sons.

Karen Borowski. This former Miss Teenage Huntington Beach demonstrated her designing and sewing skills on the 1977 Miss Teenage America Pageant and won a scholarship as third runner-up. She also received an offer from Fiddler of Florida to design a junior line of merchandise to be sold nationwide.

Sharon Brown, Miss USA 1961. She owns a real estate business. She is also an artist and a pilot.

Anita Bryant. She was second runner-up to Miss America 1959, but many people think she won the contest. She went on to a singing career, and has authored several books.

Lucianne Buchanan. Representing California, she was selected as first runner-up to Miss America 1975. She toured with Miss America on two USO tours. In 1978, she was recruited by the Wilhelmina modeling agency. Lucianne has made an album as the lead singer for the rock group Mizz, has acted in the movies *The Tempest*, *The Pope of Greenwich Village*, and *Trading Places*, and made her musical theater debut with Mickey Rooney and Ann Miller in *Sugar Babies*.

LIVING THE DREAM

Patricia Hill Burnett. As Miss Michigan, she became second runner-up to Miss America 1942, Jo-Carroll Dennison. Later she founded the Michigan Chapter of NOW.

Diahann Carroll. Born Carol Diann Johnson, she won a Harlem beauty contest in 1951. She changed her name and took up a successful acting career, including a prime role in "Dynasty."

Anita Columbo. Miss Missouri 1972, Anita is now Director of Corporate Planning for Pacific Northwestern Bell Telephone Company.

Donna Dixon. Being Miss Virginia-USA 1976 helped her in pursuing her acting career. Her first acting recognition came in the sitcom "Bosom Buddies." Donna is married to actor/comedian Dan Akroyd.

Andrea Evans. She competed in the Miss Illinois Pageant, but did not win. She went on to fame as Tina Clayton on "One Life to Live."

Maria Fletcher, Miss America 1962. She has recorded an album of inspirational songs, which she wrote in collaboration with her husband.

Jineane Ford, Miss USA 1980. Not only did she move on to an acting career, appearing as a guest on "Dynasty," "Falcon Crest," and "Dukes of Hazzard," Jineane also owns a business that markets a special paste to mend broken fingernails. Jineane is also known in Tuscon, Arizona as a television newscaster.

Judith Ford, Miss America 1969. Now a mother of two sons, Judith tours about four times a year doing promotions for the Rose Growers Association.

Mary Frann. America's Junior Miss 1961, Mary went on to star in the "Bob Newhart Show." In 1986, she was the television hostess for the Miss USA and Miss Universe pageants.

Phyllis George, Miss America 1971. She became a well-known sports personality on "NFL Today." She was given close to a million-dollar-per-year contract when she briefly replaced Diane Sawyer as anchor on "CBS Morning News." Her hus-

LIFE AFTER PAGEANTS

band, John Y. Brown, became governor of Kentucky, making Phyllis its first lady.

Tawny Godin, Miss America 1976. She was married shortly after her reign ended. As Tawny Little, she became a television personality in Los Angeles. She was later married to and divorced from actor/singer John Schneider.

Myrna Hansen, Miss USA 1953. She won a contract with Universal Studios that included enrollment in the studio's acting school. Her fellow students included Clint Eastwood, Tony Curtis, and Rock Hudson. She appeared in twenty-five movies, including *Magnificent Obsession, Man Without a Star,* and *Raintree County.* She is now in business for herself, operating a travel agency in Beverly Hills.

Mary Hart. The hostess of "Entertainment Tonight" got her start as Miss South Dakota 1970 (she was then known as Mary Johanna Harum). She was a semifinalist in the 1971 Miss America Pageant.

Julie Hayek, Miss USA 1983. After her reign she returned to the University of California at Los Angeles to finish her studies for a degree in biology. She then landed a regular spot on the television game show, "Break the Bank."

Terry Lynn Huntington, Miss USA 1959. She became a regular on "Gunsmoke" and "Perry Mason."

Jane Jayroe, Miss America 1967. She became a news anchor for a Dallas/Fort Worth television station.

Bobbie Johnson, Miss USA 1964. She went on to complete her master's degree, and became an Applications Engineer in the computer department of General Electric.

Jayne Kennedy. She competed in the Miss USA Pageant in 1970 as Miss Ohio-USA. She replaced Phyllis George on "NFL Today" in 1978 after beating out nineteen other candidates, including Barbara Mougin, Miss Indiana 1977 and first runner-up to Miss America. Jayne also has several acting credits to her name. She is a former Miss USA Pageant television hostess.

Cloris Leachman. This popular actress got her start as Miss Chicago and made it into the Miss America Pageant finals in

LIVING THE DREAM

the mid-1940s. She later played the role of a pageant chaperone in the movie *All-American Beauty Pageant.*

Marian McKnight, Miss America 1957. She has built a dinner theater complex in Los Angeles. She and her actor husband have two children. At the age of 46, Marian was still running six to twelve miles every day.

Marisol Malaret, Miss Universe 1970. She is a television variety show hostess in her homeland, Puerto Rico.

Lori Matsukawa, Miss Teenage America 1974. Instead of becoming a piano teacher as originally planned, she went to Stanford University to study journalism and American Studies.

Jacquelyn Mayer, Miss America 1963. In 1970, at the age of 28, she suffered a stroke that left her partially paralyzed and speechless. She regained her speech and now speaks words of encouragement to other stroke victims.

Lee Meriwether, Miss America 1955. She applied her $5,000 scholarship to acting classes with Lee Strasberg and Curt Conway. She made her acting debut at the Philco Playhouse in two plays written for her and went on to an acting career that included a starring role on "Barnaby Jones."

Carolyn Mignini, Miss Teenage America 1965. She studied acting and singing at Boston Conservatory and New York University before moving into a career on Broadway, and in movies and commercials.

Vera Miles. As Vera Ralston, Miss Kansas 1948, she became first runner-up to Miss America. She changed her name and became a famous actress.

Mary Ann Mobley, Miss America 1959. She went on to a film career, which included appearances with Elvis Presley. She later married Gary Collins, host of "Hour Magazine" and emcee of the Miss America Pageant. Together, she and Gary led film crews into Cambodia and Vietnam to document the plight of children there.

Jane Modean. This Miss Teenage Clifton 1975 became a familiar face in modeling.

LIFE AFTER PAGEANTS

Bess Myerson, Miss America 1945. She became New York City Commissioner of Cultural Affairs.

Patsy Naugle. She was Miss Teenage San Diego 1976. Her sign-language ability was utilized at the 1977 presidential inauguration where she interpreted President Carter's speech for the deaf. She was the first signer at the Grand 'Ole Opry and wrote and performed the theme song for the Miss Deaf America Pageant in 1978.

Kim Novak. Teenage beauty pageants led her to the distinction of being the youngest model in Chicago. At the age of 20, she was chosen by an appliance firm as "Miss Deep Freeze of 1953." She was sent to California for trade shows, stayed to model, and became a movie queen once voted the world's most popular star.

Rebecca Graham Paul. As Miss Indiana 1972, this gymnast made it into the finals at the Miss America Pageant. She later received her master's degree in physical education. She now heads the Illinois State Lottery, which raises a half-billion dollars for the Illinois educational system.

Joni Marie Pennock. She was Miss California-USA 1976 and made it into the top twelve at the Miss USA Pageant. At the age of 21, she became the director of news and public affairs for a Los Angeles television station. This position involves producing a daily thirty-minute public affairs program.

Susan Perkins, Miss America 1978. She passed on her crown and once again took to the road, this time as a spokesperson for Papermate's Presto-Magix. She also married an executive of the Gillette Company.

Joan Prather. She was Miss Teenage Dallas 1967 but gained greater fame as an actress best known for her role in "Eight is Enough."

Cheryl Prewitt, Miss America 1980. She now sings professionally and runs a Christian charm school. She has also written her autobiography that tells of the faith that brought her to her title after having her leg, which was crippled in an accident, miraculously heal.

LIVING THE DREAM

Venus Ramey, Miss America 1944. She runs a Christmas tree farm in Cincinnati and deals in real estate.

Tracy Reed. As Miss Teenage Los Angeles 1967, she did not capture the Miss Teenage America title, but she became an actress whose face was familiar to viewers of "Love American Style," "Barefoot in the Park," "McCloud," and the movie *Carwash*. She frequently appears in commercials.

Debbie Reynolds. At the age of fifteen, she was crowned Miss Burbank 1948. She entered in hopes of winning a new blouse and scarf. What she ended up with was a screen test when a Warner Brothers' talent scout spotted her in the contest. From there her acting career took off.

Yvonne Ryding, Miss Universe 1984. This former Miss Sweden was already a registered nurse when she won her international title. Upon relinquishing her Miss Universe crown in Miami, Florida, that city offered her $25,000 to promote its events. This offer was made despite the fact that she spoke little English or Spanish.

Diane Sawyer, America's Junior Miss 1963. She went on to study at Wellesley College, worked as a television reporter in Kentucky, served on President Nixon's press staff, and co-anchored "CBS Morning News." She moved on to become the first woman on the "60 Minutes" team.

Charlotte Sheffield, Miss USA 1957. She received her master's degree from Brigham Young University and teaches on the college level.

Cybill Shepherd, Miss Teenage Memphis 1966 (and Miss Congeniality at the Miss Teenage America Pageant). Model of the Year in 1968, she made her mark as a television actress in "Moonlighting."

Cynthia Sikes. This actress, formerly of "St. Elsewhere," was Miss Kansas 1972.

Mary Stallings. Some people in legal circles spoke of this woman as a former Miss Maryland, but most lawyers knew her by a different title—The Honorable Mary S. Coleman, Chief Justice of the Michigan Supreme Court.

LIFE AFTER PAGEANTS

Debbie Thomason. She was Miss Teenage Beaumont 1967. She later became a Dean Martin Gold Digger and appeared in commercials.

Kim Tomes, Miss USA 1977. She returned to Texas A & M University and received her degree in physical education. She moved on to a career in real estate development. She and her prepageant boyfriend are married and have two children.

Vonda Kay Van Dyke, Miss America 1965. She majored in television at the University of California at Los Angeles. Although her pageant talent was ventriloquism, she has gone on to a singing career, consisting primarily of religious music. She has completed four albums. She also continues to appear in commercials. She is married to a minister and actively shares in his work.

Kristi Vetri. Miss Maryland 1973, Kristi later became Mayor of O'Fallon, Illinois (population 15,000).

Shawn Weatherly, Miss Universe 1980. She has gone on to an acting career that has included a semiregular spot on "T. J. Hooker" and a spot on "Dukes of Hazzard." Shawn was selected to participate as a diving novice, and the only woman, on a global diving expedition. Her year-long experiences were telecast in an eight-week series called "oceanQuest." Shawn also appeared in the movie *Police Academy III*.

Sharlene Wells, Miss America 1985. Despite being voted the most boring celebrity of 1985, she became a special events spokesperson for a Salt Lake City television network affiliate. As a student at Brigham Young University, Sharlyn was involved in sports broadcasting and community events programs.

Vanna White. She competed in the Miss Georgia-USA Pageant, but did not win. She achieved unexpected fame as a model and co-host on television's "Wheel of Fortune."

Vanessa Williams, Miss America 1984. She relinquished her crown one-and-a-half months early, after *Penthouse* published nude photographs of her. According to *People* magazine, the scandal cost her a nine-year, $100,000-per-year contract as

spokesperson for the Gillette Company. She also was removed from consideration for numerous endorsements, a starring role on Broadway, the hostess slot for the Macy's Thanksgiving Parade, two Bob Hope television specials, and an appearance with the Boston Symphony Orchestra. Vanessa has gone on to catalog modeling and a successful acting career.

Oprah Winfrey. A radio station in Nashville sponsored her in a Miss Fire Prevention Beauty Pageant. When she won the pageant, the station hired her as a part-time newscaster. Oprah later won the Miss Black Tennessee title. She went on to host the "Oprah Winfrey Show," a one-hour talk show based in Chicago. She also earned an Academy Award nomination for Best Supporting Actress in *The Color Purple*.

There are many more examples of pageant contestants who have gone on to achieve distinction in their chosen field. It is not necessarily the national pageant titleholder, or even the state pageant titleholder, who will come out farthest ahead in the end. Whether or not you win a pageant title, you must continue to reach for new dreams. As long as you keep dreaming and strive to build foundations under those dreams, you *are* a winner!

Appendix

Pageant Addresses

MISS USA
c/o Miss Universe, Inc.
6420 Wilshire Boulevard
Suite 1500
Los Angeles, CA 90048
(213) 653-1600

MISS AMERICA
1325 Boardwalk
Boardwalk and Tennessee
 Avenue
Atlantic City, NJ 08401
(609) 345-7571

MRS. AMERICA
2001 Wilshire Boulevard
Santa Monica, CA 90403
(213) 829-9902

MISS BLACK AMERICA
Box 25668
Philadelphia, PA 19144
(215) 844-8872

AMERICA'S JUNIOR MISS
751 Government
Mobile, AL 36602
(205) 438-3621

MISS WHEELCHAIR
AMERICA
600-25th Avenue South
Suite 110
St. Cloud, MN 56301
(612) 255-1882

MISS TEEN USA
c/o Miss Universe, Inc.
6420 Wilshire Boulevard
Suite 1500
Los Angeles, CA 90048
(213) 653-1600

MISS TEENAGE AMERICA
c/o *'Teen* Magazine
8490 Sunset Boulevard
Los Angeles, CA 90069
(213) 854-2222

MISS T.E.E.N.
1095 Vaughn Street
Clarkston, GA 30021
(404) 296-4745

MISS TEEN ALL-AMERICAN
603 Scharder
Wheeling, WV 26003
(304) 242-4900

MISS TEEN OF AMERICA
SCHOLARSHIP AND
RECOGNITION PROGRAM
Box 19160
Minneapolis, MN 55419
(612) 874-1580

Past Pageant Winners

MISS UNIVERSE

1952 Armi Kuusela, Finland
1953 Christiane Martel, France
1954 Miriam Stevenson, U.S.A.
1955 Hellevi Rombin, Sweden
1956 Carol Morris, U.S.A.
1957 Gladys Zender, Peru
1958 Luz Marina Zuluaga, Columbia
1959 Akiko Kojima, Japan
1960 Linda Bement, U.S.A.
1961 Marlene Schmidt, Federal Republic of Germany
1962 Norma Nolan, Argentina
1963 Ieda Maria Vargas, Brazil
1964 Corinna Tsopei, Greece
1965 Apasra Hongsakula, Thailand
1966 Margareta Arvidsson, Sweden
1967 Sylvia Hitchcock, U.S.A.
1968 Martha Vasconellos, Brazil
1969 Gloria Diaz, Philippines
1970 Marisol Malaret, Puerto Rico
1971 Georgina Risk, Lebanon
1972 Kerry Anne Wells, Australia
1973 Margarita Moran, Philippines
1974 Amparo Muñoz, Spain
1975 Anne Marie Pohtamo, Finland
1976 Rina Messinger, Israel
1977 Janelle Commissiong, Trinidad and Tobago
1978 Margaret Gardiner, South Africa
1979 Maritza Sayalero, Venezuela
1980 Shawn Weatherly, U.S.A.
1981 Irene Saez, Venezuela
1982 Karen Baldwin, Canada
1983 Lorraine Downs, New Zealand
1984 Yvonne Ryding, Sweden
1985 Deborah Carthy-Deu, Puerto Rico
1986 Barbara Palacio Teydes, Venezuela

APPENDIX

MISS USA

1952 Jackie Loughery, New York
1953 Myrna Hansen, Illinois
1954 Miriam Stevenson, South Carolina (Miss Universe)
1955 Carlene King Johnson, Vermont
1956 Carol Morris, Iowa (Miss Universe)
1957 Charlotte Sheffield, Utah
1958 Arlene Howell, Louisiana
1959 Terry Lynn Huntington, California
1960 Linda Bement, Utah (Miss Universe)
1961 Sharon Brown, Louisiana
1962 Marcel Wilson, Hawaii
1963 Marite Ozers, Illinois
1964 Bobbie Johnson, Washington
1965 Sue Ann Downey, Ohio
1966 Maria Remenyi, California
1967 Cheryl-Ann Patton, Florida (she was second runner-up and assumed the crown when Sylvia Hitchcock became Miss Universe)
1968 Didi Anstett, Washington
1969 Wendy Dascomb, Virginia
1970 Debbie Shelton, Virginia
1971 Michele McDonald, Pennsylvania
1972 Tanya Wilson, Hawaii
1973 Amanda Jones, Illinois
1974 Karen Morrison, Illinois
1975 Summer Bartholomew, California
1976 Barbara Peterson, Minnesota
1977 Kim Tomes, Texas
1978 Judi Andersen, Hawaii
1979 Mary Therese Friel, New York
1980 Jineane Ford, Arizona (she was first runner-up and assumed the crown when Shawn Weatherly was crowned Miss Universe)
1981 Kim Seelbrede, Ohio
1982 Terri Utley, Arkansas
1983 Julie Hayek, California
1984 Mai Shanley, New Mexico
1985 Laura Martinez-Herring, Texas
1986 Christy Fichtner, Texas
1987 Michelle Royer, Texas

APPENDIX

MISS AMERICA

1921	Margaret Gorman, District of Columbia
1922	Mary Campbell, Ohio
1923	Mary Campbell, Ohio
1924	Ruth Malcolmson, Pennsylvania
1925	Fay Lanphier, California
1926	Norma Smallwood, Oklahoma
1927	Lois Delaner, Illinois
1928	No pageant held
1929	No pageant held
1930	No pageant held
1931	No pageant held
1932	No pageant held
1933	Marion Bergeron, Connecticut
1934	No pageant held
1935	Henrietta Leaver, Pennsylvania
1936	Rose Coyle, Pennsylvania
1937	Bette Cooper, New Jersey
1938	Marilyn Meseke, Ohio
1939	Patricia Donnelly, Michigan
1940	Frances Marie Burke, Pennsylvania
1941	Rosemary LaPlanche, California
1942	Jo-Carroll Dennison, Texas
1943	Jean Bartel, California
1944	Venus Ramey, District of Columbia
1945	Bess Myerson, New York
1946	Marilyn Buferd, California
1947	Barbara Walker, Tennessee
1948	BeBe Shopp, Minnesota
1949	Jacque Mercer, Arizona
1950	Pageant dating system was changed—Miss America 1949 crowned Miss America 1951 in 1950
1951	Yolande Betbeze, Alabama
1952	Colleen Kay Hutchins, Utah
1953	Neva Jane Langley, Georgia
1954	Evelyn Margaret Ay, Pennsylvania
1955	Lee Meriwether, California
1956	Sharon Ritchie, Colorado
1957	Marian McKnight, South Carolina
1958	Marilyn Van Derbur, Colorado
1959	Mary Ann Mobley, Mississippi

APPENDIX

1960 Lynda Lee Mead, Mississippi
1961 Nancy Fleming, Michigan
1962 Maria Fletcher, North Carolina
1963 Jacquelyn Mayer, Ohio
1964 Donna Axum, Arkansas
1965 Vonda Kay Van Dyke, Arizona
1966 Deborah Irene Bryant, Kansas
1967 Jane Anne Jayroe, Oklahoma
1968 Debra Dene Barnes, Kansas
1969 Judith Anne Ford, Illinois
1970 Pamela Anne Eldred, Michigan
1971 Phyllis Ann George, Texas
1972 Laurie Lea Schaefer, Ohio
1973 Terry Anne Meeuwsen, Wisconsin
1974 Rebecca Ann King, Colorado
1975 Shirley Cothran, Texas
1976 Tawny Elaine Godin, New York
1977 Dorothy Kathleen Benham, Minnesota
1978 Susan Perkins, Ohio
1979 Kylene Barker, Virginia
1980 Cheryl Prewitt, Mississippi
1981 Susan Powell, Oklahoma
1982 Elizabeth Ward, Arkansas
1983 Debra Sue Maffett, California
1984 Vanessa Williams, New York
 Suzette Charles, New Jersey (assumed title when Vanessa Williams resigned two months before the 1984 pageant)
1985 Sharlene Wells, Utah
1986 Susan Akins, Mississippi
1987 Kellye Cash, Tennessee

Sample Official Entry Form to Compete for the Titles Miss USA and Miss Universe

MISS _____
(Name of State)

Rules and Regulations
Miss Universe & Miss USA Contestants

1. I certify that:
 (a) I received the title stated above in open competition in my state and that I am fully satisfied with the decision of the judges in that competition and the manner in which the competition was conducted.
 (b) The date of my birth is _____; when requested I will supply my birth certificate or other satisfactory document as proof of my age.
 (c) I am not now and have never been married, never had a marriage annulled and never given birth to a child. I am of good health and moral character.
 (d) I have never been a contestant-delegate in a previous National Miss USA or Miss Universe Pageant.
 (e) I am now and have been a resident of my state for a period of at least six (6) months prior to the date of the beginning of the competition in my state.

2. I understand:
 (a) That I will receive prepaid transportation to Host City and return;
 (b) That I will receive first class accommodation and meals at a leading hotel while in Host City during the Miss USA Pageant or Miss Universe Pageant;
 (c) That I will be chaperoned during my entire stay in Host City;
 (d) That I am competing for the titles Miss USA and Miss Universe for beauty of face and figure, poise and personality;
 (e) That during at least a portion of said Pageants, I will appear in a bathing suit.

If selected as a contestant in the Miss Universe Pageant, the foregoing shall also apply to my participation in such Pageant.

APPENDIX

3. The procedure by which Miss USA and Miss Universe will be selected has been explained to me and I am satisfied that the judging will be fair and impartial and I agree to abide by the judges' decision.

4. I hereby authorize the use of my photograph, likeness, voice recording, autograph, and name for all publicity and commercial purposes in connection with the Miss USA and Miss Universe Pageants.

5. I will include at least one long evening gown in the wardrobe that I am bringing to Host City.

6. I agree not to be photographed in any swimsuit, or permit public use of my photograph in any swimsuit, other than a "Miss USA" swimsuit until sixty (60) days after the completion of the 19__ Miss Universe Pageant. In the event I receive the titles Miss USA or Miss Universe or am one of the first four runners-up in either competition, I will not enter any agreement, without the prior written consent of Miss Universe, Inc., for services to be performed, consisting of modeling, advertising, theatrical or promotional services, or any appearances in which my title or affiliation with the Miss USA or Miss Universe Pageants is used in the United States, or if selected Miss USA or Miss Universe, then anywhere in the world, for the period ending _____. In addition, I will not, without the prior written consent of Miss Universe, Inc., appear anywhere in the United States, or if selected Miss USA or Miss Universe, then anywhere in the world, during any said period ending _____, 19__, in a swimsuit other than a "Catalina" swimsuit, but, if not selected Miss USA or Miss Universe, then such requirement shall not apply if the use is only for personal recreational purposes.

7. Miss Universe, Inc., shall have exclusively, all dramatic, musical, radio, publication, television, personal appearance and motion picture rights in connection with the presentation of the 19__ Miss USA and Miss Universe Pageants, or any portion thereof, and shall have the right to use and exploit any or all of such rights without consent from or payment to me. I hereby release any claim which I may have by virtue of my participation in the Miss USA or Miss Universe Pageants, or any use of my photograph, likeness, voice or appearance in connection with such rights, including advertising and promotional material relating to any such exploitation.

8. I certify that I am not a party to any present management contract which would in any way cover the services to be performed by me in connection with any award which I may receive as Miss USA or Miss Universe, or as one of the first four runners-up in either competition, nor have I made any agreement to share any monies or awards received with any person. I further agree that Miss Universe, Inc., shall have the exclusive right and control over all personal appearances which I may make in the United States as Miss USA or Miss Universe or as one of the first four runners-up in either competition during the period ending _____.

APPENDIX

9. I agree:
 (a) To cooperate with the chaperone and hostess assigned to me for my protection and welfare during the Miss USA and Miss Universe Pageants in the Host Cities for each of such Pageants and en route.
 (b) To punctually keep all appointments which require my presence.
 (c) While my parents or guardian may accompany me at their own expense, control over my activities during the Miss USA and Miss Universe Pageants shall rest with Miss Universe, Inc., and the chaperone and hostess assigned to me.
 (d) I will depart from the applicable Host City for my home not later than the day after the selection of Miss USA 19__ or Miss Universe 19__ unless I have received awards which entail postponing my departure for an undetermined length of time, or unless written permission to stay over is obtained from Miss Universe, Inc.
 (e) I will not incur, and am not authorized to incur, any debts on behalf of Miss Universe, Inc., or with respect to the Miss USA and Miss Universe Pageants.
 (f) That your sole obligation, unless I am selected Miss USA or Miss Universe 19__, is to accept me as a contestant, provided I satisfy all the eligibility requirements and comply with and fulfill all my obligations.

10. The photographs of me attached have been taken within the last six months.

11. If I am selected Miss Universe, or selected Miss USA and not subsequently selected as Miss Universe, you shall employ me and I hereby accept such employment, on the following terms and conditions (matter in parentheses relates to Miss USA who is not subsequently selected Miss Universe):
 (a) You hereby employ me as "Miss Universe 19__" ("Miss USA 19__"), to render services to Miss Universe, Inc., as a model and public relations representative, from the date of this agreement until three days after Miss Universe 19__ is selected. I shall receive a salary of $10,000 in such period, less withholdings, payable monthly in accordance with the payroll practices of Miss Universe, Inc. In addition, I shall receive a cash prize, one-third of which is to be paid on receipt of my title, one-third on November 1, 19__, and the balance on the third day after the selection of Miss Universe 19__ (Miss USA 19__).
 (b) I agree to furnish the following services as your employee assisting in advertising and promotion of your co-sponsors and such other individuals or companies and their products as you may designate, including but not limited to:
 (i) Participation in promotional activities; appearances during fashion shows; autographing; meeting and conversing with the public, customers and employees of co-sponsors; appearances as an apparel model or as Miss Universe (Miss USA); giving talks and interviews in theatres, clubs, department stores and restaurants, on television, radio and for newspapers.

APPENDIX

 (ii) Endorsing products and allowing my name, likeness and voice to be used in connection with the advertising or sale of products and for commercial purposes.

 (iii) Traveling and giving interviews as your schedule of appearances may require, including weekends and holidays.

(c) During the term of my employment, Miss Universe, Inc., will book all appearances, prepare my travel and working schedules and handle all arrangements in connection with my activities as Miss Universe 19__ (Miss USA 19__). I further acknowledge that as of this date I have not engaged another managing agent.

(d) You shall furnish a chaperone, selected in your sole discretion, as well as hotel accommodations and transportation facilities, while I am traveling at your request. Reasonable living expenses incurred by me while so traveling shall be borne by you. Upon the expiration of any trip requested by you, you shall return me, at your expense, to my home or to my established base of operations in the United States, whichever point is selected by you, and at the expiration of my employment as "Miss Universe" ("Miss USA") you will return me to my home, your expense, provided that my trip home is made within seven days after Miss Universe 19__ is chosen.

(e) During the term of this agreement I will not render services to any other employer, and except as required hereunder, will not make any public appearances as Miss Universe (Miss USA), endorse any product, or allow my name, likeness or voice to be used in connection with the advertising or sale of any product or service without your prior written permission, both during the term of my employment and for period of one year thereafter.

(f) If during the term of my employment I (i) refuse; or (ii) become so mentally, physically, or otherwise incapacitated that I am unable in your reasonable opinion to carry out my duties; or (iii) if I should marry; or (iv) if I am prevented from carrying out my duties because of act of God, rule, order or act of Government or governmental instrumentality, or other cause of similar or different nature beyond my control, then in any such events you shall have the right to declare this agreement terminated, and upon your giving me one week's notice to that effect, this agreement shall be terminated and neither party shall have any further obligations hereunder.

(g) It is understood that all proceeds resulting from the performance of my services hereunder are the sole property of Miss Universe, Inc., and I hereby assign and transfer to you all rights to such proceeds.

(h) The services to be rendered by me and the rights and privileges granted to you by me hereunder are of a special, unique and intellectual character, the loss of which cannot be adequately compensated in damages in an action at law. It is acknowledged that breach by me of any of the provisions of this agreement will cause irreparable injury and damage. You shall be entitled to injunctive and other

APPENDIX

equitable relief in the event of any breach by me of this agreement. Resort to injunctive and other equitable relief shall not be a waiver of any other rights or actions you may have for damages or otherwise, and all rights hereunder shall be regarded as cumulative. No waiver by you of any breach of this agreement shall be deemed to be a waiver of any preceding or succeeding breach of the same or any other covenant or provision.

(i) You are hereby authorized, in my name, or in your name, to take any action of whatsoever nature or kind, including the commencement of legal proceedings, at your expense, against any person, firm or corporation as you in your sole discretion shall determine, which uses or attempts to use, without your prior written consent, my name, likeness or voice for any purpose whatsoever.

(j) This agreement shall be governed by the laws of the State of New York applicable to contracts entered into and carried out entirely within such state.

(k) This agreement contains the entire understanding of the parties hereto and may be revised or modified only by written instrument executed in the same manner.

12. If the title "Miss USA 19__" becomes vacant and I succeed to the title, I agree to serve as "Miss USA 19__" and perform all the obligations relating to said title contained in this entry form, including the service contract provided in Paragraph 11 above. However, I acknowledge that in such event I shall not be entitled to any of the prizes awarded to "Miss USA 19__" at the time of her election, including but not limited to the cash prize referred to in Paragraph 11(a) above.

13. I acknowledge ownership by Miss Universe, Inc. and/or Catalina, Inc. and the validity of the trademarks "Miss Universe," "Miss USA," "Miss United States of America," "Little Miss Universe," "Little Miss USA," and "Miss Hospitality," and further acknowledge that the Miss Universe Pageant (meaning both the Miss USA and Miss Universe Pageants) is the exclusive property of Miss Universe, Inc., and that I will not engage in any activities which may damage or otherwise affect such trademarks and/or property rights in any manner whatsoever.

14. Any misrepresentation or untrue statement by me or any failure to comply with any of the terms, provisions, restrictions or obligations hereunder, on my part to be performed, shall, at the option of Miss Universe, Inc., result in my disqualification, loss of title and return of any and all prizes awarded, in addition to any other remedies which Miss Universe, Inc. may have, all of which shall be deemed cumulative.

I HEREBY CERTIFY that I have read this official entry form for the 1981 Miss Universe Pageant; that the answers to the above questions are true to the best of my knowledge, and I agree to be bound by all the rules and regulations listed above. Miss Universe, Inc. shall be the sole judge of the

APPENDIX

accuracy of any of the representations made herein. My signature below and your acceptance and agreement indicated by your signature below shall constitute this entrance form a binding agreement and contract between us.

DATE: _____

(Signature of Entrant)

Sworn to and subscribed before the _____ day of _____, 19__ .

_____ Notary Public

THE UNDERSIGNED hereby attest to the health and good character of the above entrant and in the event such entrant is a minor agree to all regulations stated above on her behalf. The answers to the various questions, as well as the rules and regulations, have been read, and to the best of our knowledge and belief the answers are true and correct. We further certify that the entrant will be at least 18 years of age and under 28 years of age by _____ and that she has never been married nor had a marriage annulled nor given birth to a child.

_____ _____
(Signature of Parent or Guardian) (Signature of Franchisee)

_____ _____
(Address) (Address)

Sworn to and subscribed before the ___ day of _____ , 19__ .

_____ Notary Public

Accepted and agreed to: **MISS UNIVERSE, INC.**

By: _____ _____
 Vice-President Date

Miss USA Information Form

The following form is used by Bob Barker's assistant when she interviews contestants. This form and interview are the basis for the onstage interviews of the semifinalists. The form should be typed or very neatly printed.

(If additional space is needed, please use back of the page.)

States Represented: _____
Date of Birth: _____
Full Name: _____
Nickname: _____ Why are you called this name?

Name you prefer to be called: _____
Mother's Occupation: _____
Father's Occupation: _____
Other children in your family: (Give names, ages, relationship of each)

Where were you born? _____ Where did you grow up? (If several places, list them with dates.) _____

Any unusual facts about your family . . . achievements, hobbies, etc.?

Do you have any famous relatives or ancestor? _____

Any relatives with unusual occcupations? _____

Name of school last attended: _____
Last grade completed: _____

APPENDIX

Any other jobs you have held (summers, etc.): _____

Will your trip to the pageant be your first airplane flight? _____
Will it be your first trip out of your home state? _____
Where else have you traveled? When? _____

What is your career ambition? _____

Do you hope to marry? _____ How soon? _____
Would you like to have a family? _____ How large? _____
Can you cook? _____ Sew? _____ Type? _____
Drive a car? _____ Have your own car? _____
Have any unusual talents? _____ Describe: _____

Have you won any previous titles (If so, name the event, where held and the year.) _____
Have you won any scholarships or scholastic awards? _____ Please list:

Any other awards or honors and the dates received. _____

In what sports do you actively participate? _____

What are your hobbies? _____

List any special training you have had . . . in music, dramatics, art, etc.: _____

List any unusual interests or accomplishments, any other information of interest not included on the preceding pages: _____

OPINIONS AND PREFERENCES:
What do you think you will enjoy most during the pageant? _____

Why would you like to become Miss USA? (Use back of page if necessary.)

Do you have any pets? (List pets and their names.) _____

APPENDIX

Do you have a lucky charm? _____ If so, what is it? _____
List your favorite in each of these categories:
Color: _____ Flower: _____ Food or dish: _____
Author: _____ Song: _____
Magazine: _____
Movie Star (Male) _____ (Female) _____
Television Star (Male) _____ (Female) _____
Television Program: _____
Sport: (Spectator) _____ (Participant) _____
Recording Star (Male) _____ (Female) _____
Recording Group: _____
National Official: _____
What person would you most like to meet and why? _____

What are some of the current fads in your area? _____
What is the most unusual thing you have ever done? _____

What was your most embarrassing moment? _____

Comparison of the Miss USA Award Packages for 1976, 1981, and 1986

The Prize Package For the 1976 Miss USA Pageant Was Officially Listed As:

MISS USA

 $7,500 cash award

 $7,500 personal appearance contract

 $2,500 Sarah Coventry Cash Scholarship

 1976 Toyota Celica GT liftback

 A natural Blackglama Ranch mink coat from the Flemington Fur Co.

 $2,500 specially designed gold and diamond watch from Schiaparelli

 Wardrobe of sweaters, shirts, and pants from Organically Grown by Arpeja

 Wardrobe of sportswear from Elli Modes Cortefiel designed by Europe Craft

 Wardrobe of Sarah Coventry jewelry

 Miss USA trophy

 Wardrobe for personal appearances

 Trip to Hong Kong

 Miscellaneous gifts

FIRST RUNNER-UP

 $1,000 U.S. Savings Bond

 First runner-up trophy

 Miscellaneous gifts

APPENDIX

SECOND RUNNER-UP
 $500 U.S. Savings Bond

 Second runner-up trophy

 Miscellaneous gifts

THIRD RUNNER-UP
 $300 U.S. Savings Bond

 Third runner-up trophy

 Miscellaneous gifts

FOURTH RUNNER-UP
 $200 U.S. Savings Bond

 Fourth runner-up trophy

 Miscellaneous gifts

SEMIFINALISTS
 Seven remaining semifinalists receive:

 $100 U.S. Savings Bond

 Miscellaneous gifts

MISS PIXABLE
 (Now called Miss Photogenic) $500 Sarah Coventry Cash Scholarship

AWARDS TO ALL CONTESTANTS
 $50 U.S. Savings Bond (exclusive of twelve semifinalists)

 Official Catalina swimsuits by Catalina, Inc.

 Tennis Fashions by Top Seed

The Prize Package For the 1981 Miss USA Pageant Was Officially Listed As:

MISS USA
 $22,500 cash (Miss USA cash award, Maybelline cash award, Sasson cash award)

 $10,000 personal appearance contract

 The opportunity to represent the United States in the 1981 Miss Universe Pageant in New York City

APPENDIX

An exciting Mazda RX-7

Canada Majestic Demi-Buff mink coat designed by Natural Furs

MonArk deluxe sport boat by MonArk Boat Company

Complete luggage collection by Sasson

A specially designed gold and diamond pendant from Zale's Jewelers

Five-year supply of Maybelline cosmetics

All-season clothing wardrobe by Sasson

Miss USA trophy

All her clothing requirements during the year of her reign

Exclusive New York City apartment during the year of her reign

FIRST RUNNER-UP
 $1,500 cash award

 First runner-up trophy

 Miscellaneous gifts

SECOND RUNNER-UP
 $1,350 cash award

 Second runner-up trophy

 Miscellaneous gifts

THIRD RUNNER-UP
 $1,200 cash award

 Third runner-up trophy

 Miscellaneous gifts

FOURTH RUNNER-UP
 $1,000 cash award

 Fourth runner-up trophy

 Miscellaneous gifts

APPENDIX

SEMIFINALISTS (nonfinalists)
 $250 cash award

 Miss USA plaque

 Miscellaneous gifts

MISS AMITY AWARD
 Trip to New York for the 1981 Miss Universe Pageant

AWARDS TO ALL CONTESTANTS
 Official Miss USA swimsuit by J. C. Penney Company

 Maybelline cosmetic kits

 Outfits by Sasson

 Footwear by Au Petit Jean

 Crown pins by Sarah Coventry

 All contestants, other than the twelve semifinalists, will receive a $100 Savings Bond

The Prize Package for the 1986 Miss USA Pageant Was Officially Listed As Follows:

MISS USA WILL RECEIVE MORE THAN $175,000 IN CASH AND PRIZES
 Specific awards, including $90,000 in cash awards, are:

 $25,000 personal appearance contract

 $15,000 Miss USA cash award

 $10,000 cash plus five-year supply of cosmetics from Maybelline

 $10,000 cash plus traveling wardrobe featuring Miss USA fashions by J. C. Penney

 $10,000 cash plus five-year supply of suntan products from Coppertone

 $ 5,000 cash plus an all-season footwear wardrobe from Kinney Shoes

 $ 5,000 cash plus a portable video system (autofocus video camera and cassette recorder deck) and 35mm single-lens reflex camera outfit from Minolta

APPENDIX

$ 5,000 cash plus elegant Fernando Pena evening and daywear from Secret antiperspirant

$ 5,000 cash plus five-year supply of hair care products from Ivory

A Paramount Pictures screen test in Hollywood, California

A luxurious Blackglama mink coat designed by Flemington Furs

A fully equipped, sporty 1986 Mazda 626

A sporty American 180 Runabout by Wellcraft Marine Corp., powered by a 90 HP outboard by Yamaha, with a trailer from Shoreline, a Starnes Company

A 5'2" ebony high-gloss grand piano from Baldwin Pianos

Two first-class, round-trip tickets to any single Eastern Airlines destination of her choice

All her clothing needs during her reign

A luxury Los Angeles apartment shared by Miss Universe during her reign

The beautiful Miss USA trophy

The dazzling Miss USA crown from the International Gem & Jewelry Show

The opportunity to represent the United States in the 1986 Miss Universe Pageant in July

FIRST RUNNER-UP
$2,500 cash scholarship award

First runner-up trophy

Miscellaneous gifts

SECOND RUNNER-UP
$2,000 cash scholarship award

Second runner-up trophy

Miscellaneous gifts

APPENDIX

THIRD RUNNER-UP

$1,500 cash scholarship award

Third runner-up trophy

Miscellaneous gifts

FOURTH RUNNER-UP

$1,000 cash scholarship award

Fourth runner-up trophy

Miscellaneous gifts

SEMIFINALISTS

Five remaining semifinalists receive a $250 cash award and a Miss USA plaque

GIFTS TO ALL CONTESTANTS

A Courrèges disc camera and film from Minolta

Official Miss USA crown pins from the International Gem & Jewelry Show

A special Miss USA tote bag and cosmetics from Maybelline

Fashion swimwear, cover-ups, active sportswear and dresses from the official Miss USA collection by J. C. Penney

Fashion footwear from Kinney Shoes

Secret gift pack

Ivory hair care products gift pack

Coppertone suntan products gift pack

$150 cash award and official certificate to all contestants other than ten semifinalists

BEST STATE COSTUME AWARD, MISS AMITY, MISS PHOTOGENIC

Each special category winner wins a trophy

APPENDIX

MINOLTA PHOTO CONTEST
 First-, second-, and third-place winners of the Miss USA delegates' photography contest will receive, respectively, a Minolta Maxxum 5000 camera with an f/1.7 lens, case and flash, and two Minolta Freedom III cameras with cases.

About the Authors

Polly Peterson Bowles. This former Miss Teenage Minnesota used the scholarship she won as second runner-up to Miss Teenage America 1977 to help finance her bachelor of arts degree in international relations and economics. The day that she graduated from college, she was crowned Miss Minnesota-USA 1981. In the five years after she competed in the Miss USA Pageant, Polly continued her involvement in her community, made her musical theater debut, worked for Congress, earned her juris doctor degree with honors, was admitted to both the California and Minnesota Bar Associations, and now practices law with a major Minneapolis law firm. Polly's pageant experience came full circle on August 23, 1986, when she married a man she met while on a Miss Teenage Minnesota appearance.

Barbara Peterson Burwell, Miss USA 1976. After relinquishing her title, Barbara returned to Minnesota to complete her education in political science, speech and communications, and American studies at St. Olaf College. While still a student, she appeared in commercials and traveled throughout the Midwest as a spokesperson for the Ford Motor Company. She then traveled globally in a marketing/promotions capacity for Carlson Companies. After meeting people from all over the world, Barbara married a man who lived five minutes away from her childhood home. She continues her career as a public relations executive and sits on the board of directors for Snowmass Village Properties. Her charity commitments include sitting on boards for the American Lung Association, the United Arts, and the Cystic Fibrosis Foundation. She has been active with the United Way.